Undoing the Image

1. Body Without Organs,
Body Without Image:
Ernesto Neto's Anti-Leviathan

**2. Becoming-Matisse: Between
Painting and Architecture**

3. Duchamp Looked At
(From the Other Side)
i. Descending Painting
ii. Picking up the Thread
iii. Given Readymades

4. Three Entries in the Form of
Escape Diagrams
i. DB Entry [Daniel Buren]
ii. GMC Entry [Gordon Matta-Clark]
iii. GB Entry [Günter Brus]

5. Boîte HO [Hélio Oiticica]

Undoing the Image

Of Contemporary Art

Éric Alliez

with the collaboration of
Jean-Claude Bonne

Volume 2:
Becoming-Matisse:
Between Painting and Architecture

Translated by Robin Mackay

URBANOMIC

Published in 2018 by
URBANOMIC MEDIA LTD,
THE OLD LEMONADE FACTORY,
WINDSOR QUARRY,
FALMOUTH TR11 3EX,
UNITED KINGDOM

Originally published in French as *Défaire l'image. De l'art contemporain*
© Les presses du réel, 2013.
This English language translation © Urbanomic Media Ltd.
All rights reserved.

Liberté • Égalité • Fraternité
RÉPUBLIQUE FRANÇAISE

Centre national du livre

Publication of this book is supported by the
Publications Assistance Programmes of the Institut Français
and by the Centre National du Livre.

BRITISH LIBRARY CATALOGUING-IN-PUBLICATION DATA

A full catalogue record of this book is available
from the British Library.
ISBN 978-1-9164052-0-2

Distributed by The MIT Press, Cambridge, Massachussetts
and London, England.

Type by Norm, Zurich.
Printed and bound in the UK by
TJ International, Padstow.

Contents

Becoming-Matisse: Between Painting and Architecture 1

Principles of the Fauvist Break with Aesthetic Formalism 3–7; Critical Pictoriality of the Decorative (Interior with Aubergines, *1911*) *7–16; Undoing Representation: Matissean 'Collage' and Cubist Collage (Matisse vs Picasso) 16–24; Limits of a Semiology of Cubism 24–30; Defenestration of the Painting-Form 30–36; Matissean Vitalism and Bergsonian Vitalism: Expression, Construction, and Intuition 36–46; The Brazilian Connection: Duration, Colour, and* Vivência *in Hélio Oiticica 46–49; Pragmatics of Murality and Bio-Environmental Mutation: Becoming-Dis/Architectural of Painting, Becoming-Nonhuman of Figures, Becoming-Cosmic of Space (The Three Versions of the* Dance, *1931–1933) 49–66; Beyond 'Site-Specificity' 66–69; The Cut-Outs: 'An Art That is No Longer in Any Way Art' 69–71; The Architectural Quarrel of Constructivisms: Matisse's* Bees *(1952–1955) vs Theo van Doesburg's* L'Aubette *(1927–1928) 71–77; Back to School with Matisse: A Dispositif 77–86; Aleatory Materialism, Processual Constructivism, and Swarm Machination 86–89; The Failure of Gestaltist-Aesthetic Dialectic in the Two Dancehalls of L'Aubette 89–95; The Mondrian Case (Paris–New York) 95–103;* Victory Boogie-Woogie *vs* The Bees, *with a Return to the Question of the Studio-Installation: Schematizing Diagrammatism and Chaosmotic Diagrammatism 103–107.*

Bibliography 109
List of Figures 117
Index 119

This second volume continues the work co-authored with Jean-Claude Bonne in *La Pensée-Matisse* (2005), and which has since been extended in four additional articles on Matisse (the most recent of which is forthcoming). Which is to highlight that, in the case of this volume, the collaboration was a close one, of equal partners. This work together followed the common thread of a friendship that might, in its turn, be called 'Matissean', and which has accompanied every stage of the composition of the trilogy which, along with *La Pensée-Matisse* and *Undoing the Image*, includes *L'Œil-Cerveau* (2007), also translated by Robin Mackay (*The Brain-Eye: New Histories of Modern Painting*, 2016).

On the occasion of the publication of this second volume, I would like to thank Robin warmly for his complicity and for the flair with which he has tackled this series of remarkable translations without dispelling the 'disquieting strangeness' that must haunt any *pas de deux* between art and philosophy.

É.A.

Becoming-Matisse:
Between Painting
and Architecture

Not to brag about it, but I really was the first.
Henri Matisse, letter to his daughter Marguerite, 17 July 1929

In our view, what constitutes Matisse's untimely singularity is the radical nature of his audacious break with a History of Art conceived intensively and extensively in terms of Form, across a *longue durée* of which modernism took itself to be the ultimate finality: the reduction of painting to its essence within the optic of a pure flatness hailed as an affirmation of the medium's autonomy. We capitalise 'Form' here in order to suggest how, beyond the internal organisation of the linear, chromatic, and plastic constituents of a work, it is the very *concept* of 'form' that is at stake. After all, this is the concept that modernist formalism will turn to when, on an inevitably post-Kantian basis, it posits the 'reflexivity of form' as the principle of aesthetics and of its autonomy. And from this perspective, the Fauves' break with art history will seem doomed to inevitable failure— no wonder, since it is submitted to the very category with which it breaks. The very principle of Fauvism was the *destruction* of Form[1]—hence its explosion of figurative space, its 'anti-visual' character, its absence of stylistic unity,[2] its 'schizophrenic' tendency[3]...the destruction of form, along with a refusal of the received alternative between Modernism and Tradition.[4] But in this topsy-turvy world, Fauvism would apparently have come up against its limits—both 'pictorial' and 'spatial'—in confronting the

[My thanks to Matt Colquhoun, Jonathan Shaw, Nathalie Bouchard, and Katherine Pickard for their help in researching and preparing this volume—trans.]

1 See the general presentation of this question and the arguments developed in our previous work, É. Alliez and J.-C. Bonne, *La Pensée-Matisse. Portrait de l'artiste en hyperfauve* (Paris: Le Passage, 2005).

2 Not so easily reducible to a 'mixed-technique Fauvism' (J. Elderfield, *The 'Wild Beasts': Fauvism and its Affinities* [New York: Museum of Modern Art, 1976], 14). Indeed, remember that the lack of any unified style (even on the part of Matisse himself during the few short years of 'historical' Fauvism [1905–1907]) has been taken as proof of the impossibility of a synthesis of the major tendencies of the previous century's modern art—meaning that Fauvism is 'essentially conservative', as Edward Fry's crucial verdict has it.

3 See A. Wright, *Matisse and the Subject of Modernism* (Princeton, NJ and Oxford: Princeton University Press, 2004), 74–86.

4 Recall that the word 'modernism' had been current since 'the symbolist era', and had even been used as the title of a journal—*Le Moderniste*—edited by Gabriel-Albert Aurier (23 issues published between 6 April 1889 and 28 September 1889).

question of form;[5] so that the critic can blithely assert that Fauvism was 'historically' superseded by the visual syntax of cubism, while elevating the latter into the modernising principle of an art en route to modernist abstraction.

According to Clement Greenberg, this is the crucial function of cubism, which he identifies with 'the age of "experiment"' and sees as 'the only style adequate to contemporary feeling'[6]—a conception that moves him to present us with the caricature of a Matisse 'precubist in essence if not by inflection',[7] and even a Matisse who made his best works 'between 1914 and 1917', under the influence of cubism.[8] In a late article (dated 1966) on the Matisse retrospective at MoMA, Greenberg further develops the idea that not only was Fauvism 'superseded' by cubism, it was left 'unfinished' by Matisse himself—until he ended up...belatedly *finishing it off* with the largest *and most abstract* of his paper cut-outs. Greenberg's conclusion deserves to be cited in full:

And it would seem that Fauvism, when its conclusions were finally drawn, arrived in the same place that Cubism already had: *altogether flat abstract art.*[9]

Reduced to such an abstraction, Fauvism's excess, both phenomenal and theoretical,[10]

5 See J.-C. Lebensztejn, 'Tournant', in *Le Fauvisme ou « l'épreuve du feu »*. *Éruption de la modernité en Europe*, exhibition catalogue, Musée d'Art moderne de la Ville de Paris (Paris: Éditions Paris musées, 1999), 41 (cited in Alliez and Bonne, *La Pensée-Matisse*, 'Cubisme et Abstraction: de la destruction du fauvisme', 25). This critique is on every point *contemporary* with Fauvism: 'They [the Fauves] treat painting as a random, inconsistent sampling, and colour as a *formless matter*' (F. Monod, 'Le salon d'Automne', *Art et décoration* 12 [December 1905], emphasis ours). Furthermore, on this point the most severe critiques were (understandably) reserved for Matisse: an *art without syntax* (A. Gide, 'Promenade au Salon d'Automne', *Gazette des Beaux-Arts* 582 [December 1905]).

6 C. Greenberg, 'The Decline of Cubism', *Partisan Review*, March 1948, reprinted in J. O'Brian (ed.), *The Collected Essays and Criticism, vol. 2, Arrogant Purpose: 1945–1949* (Chicago and London: Chicago University Press, 1986), 212–13. Cubism was therefore 'the most epochal school of painting since the Renaissance' and, in Picasso, even prefigured 'the furthest extremes of abstract art' ('Reply to George L.K. Morris', *Partisan Review*, June 1948, reprinted in *Collected Essays, vol. 2*, 245). Without any explicit reference to Fauvism, Greenberg further maintains that cubism is 'a means, not of inhibiting emotion but of controlling and so exploiting it' ('Review of Exhibitions of the American Abstract Artists, Jacques Lichitz, and Jackson Pollock', *The Nation*, 13 April 1946, *Collected Essays, vol. 2*, 72).

7 C. Greenberg, 'Review of an Exhibition of Henri Matisse', *The Nation*, 5 March 1949, reprinted in *Collected Essays*, vol. 2, 292.

8 C. Greenberg, 'Matisse in 1966', *Boston Museum Bulletin* 64 (1966), reprinted in J. O'Brian (ed.) *The Collected Essays and Criticism, vol. 4, Modernism with a Vengeance: 1957–1969* (Chicago and London: University of Chicago Press, 1993), 220.

9 Ibid.

10 The denunciation of the *excess of theory*—and, consequently, of *abstraction*—presiding over Fauvism was a leitmotif of the critics (André Gide, Maurice Denis, Louis Rouart...) in 1905.

over this finalised history, and more generally over the very idea of History (of art), is
definitively lost.

In an analysis centring on *Le Bonheur de vivre* (1906), Alistair Wright analyses the disintegration of the 'architecture of the pictorial field' in this painting which gives the impression of being 'a failed painterly act': an assault on the Arcadian mythology that the French tradition claimed as its 'historical' source and its pedigree. But if this is the case, then it is the linear-organic sequence of the history of art itself that is demolished by Matisse's *cold* 'de(con)struction'.[11] For what Fauvism opens up is a new idea—not historico-dialectic, and consequently not 'avant-gardist'[12]—of the temporality *of* art and of temporality *in* art. It is this idea whose operation Matisse will pursue ever more profoundly, by way of a becoming that produces nothing but itself, displays nothing but itself, in the events that it materialises via intensive construction. So that, with Fauvism, it is *becoming that furnishes the matter for art* and that *exhibits itself* as such, in constructions that put into play, into tension, a 'bloc of sensations' completely disidentified with form.

It is worth recalling here that, placed under the Apollonian sign of the 'new Laocoon' to whom Clement Greenberg had granted his imprimatur,[13] the falling back of sensation onto a *pure* form disconnected from the object's formation (and consequently from the 'matter of sensation') will be the primary cause and effect of 'formalism' qua metacritical regulation of modernist visibility.[14] In this sense, we might agree that 'Lessing (via Winckelmann) produced the framework for modern criticism',[15] so long as we acknowledge the Kantian horizon of this whole process, which—as we know—makes the existence of 'formal' aesthetic judgments depend upon their *contemplative disinterest*. 'The paint, the disinterested paint',[16] as Greenberg insists, in the guise of an explanation for his belated admiration for Matisse (with due recognition of the debt to

11 A. Wright, 'Arche-tectures: Matisse and the End of (Art) History', *October* 84 (Spring 1998), 45–63.

12 Although *historically speaking*, Fauvism would have to be counted as the first avant-garde by date (1905).

13 C. Greenberg, 'Towards a Newer Laocoon', *Partisan Review* 7 (July–August 1940), reprinted in J. O'Brian (ed.), *Collected Essays and Criticism, vol. 1, Perceptions and Judgments: 1939–1944* (Chicago: University of Chicago Press, 1988), 23–38.

14 On the modernist necessity of formalism (in its shortest version), see C. Greenberg, 'Necessity of "formalism"' [1971], in R.C. Morgan (ed.), *Late Writings* (Minneapolis and London: University of Minnesota Press, 2003), 45–9.

15 Cf. C.A. Jones, *Eyesight Alone: Clement Greenberg's Modernism and the Bureaucratization of the Senses* (Chicago and London: University of Chicago Press, 2005), 56.

16 C. Greenberg, *Matisse* (New York: Abrams, 1953), np. (commentary on plate 19, *Les Plumes blanches*).

Kant),[17] the 'cold hedonism' with which he credits the painter[18] signifying 'a hedonist alignment with medium'.[19] In this perspective, the medium has to be understood as the *plastic substrate of form*, instead of and in the sublimated place of a hedonism of the subject of the picture that would make the presentation (*Darstellung*) of form—or the *form of form* (the 'artistic formant', as Malevich would say)—fall back on the representation (*Vorstellung*) of form[20] and the form of representation. A rather formal hedonism, then, in the service of an 'independent beauty' for which quality *is* the 'content' *of* form, which is at the same time matter.[21] This entails a whole aesthetic reframing of Fauvism, when on the contrary precisely what Fauvism had done was to free painting of all interiority, in the sense of a fixation (both physical and ideational) on medium, on that *presentation* in terms of a *format* that would incorporate its materiality into a formal unity, imprisoning each art within the discipline of a specific Art-Form external to all the others, and prohibiting their decompartmentalization.[22]

What Fauvism did was open up painting from the inside to the Outside, to the multiplicity of forces and to their multiplication, in an unprecedented conjunction of the arts. Although since the mid-nineteenth century at least art had aspired to break down the barriers between the fine arts and the minor arts and to bring together painting, architecture, and the decor of everyday life, Matisse will have been the first to have grasped that a becoming-life of art could only be achieved through a true becoming-other of painting, and that painting's *critical* (and not merely physical)

17 Greenberg gave a seminar on the *Critique of the Faculty of Judgment* at Black Mountain College during summer 1950.

18 C. Greenberg, 'Review of an Exhibition of Joan Miró', *The Nation*, 7 June 1947, reprinted in *Collected Essays, vol. 2*, 155.

19 Cf. J. O'Brian, 'Greenberg's Matisse and the Problem of Avant-Garde Hedonism', in S. Guilbaut (ed.), *Reconstructing Modernism: Art in New York, Paris and Montreal, 1945–1964* (Cambridge, MA and London: MIT Press, 1990), 153 (reprinted in modified form in J. O'Brian, *Ruthless Hedonism: The American Reception of Matisse* [Chicago: University of Chicago Press, 1999], chapter 7). For a critical discussion of hedonism in Matisse, see Alliez and Bonne, *La Pensée-Matisse*, 12–13.

20 Greenberg formulates it as follows in 'Modernist Painting' (1961): 'What [modernist painting] has abandoned in principle is the representation of the kind of space that recognizable objects can inhabit' (*Collected Essays, vol. 4*, 87).

21 For one might think here of Konrad Fiedler's celebrated aphorism: 'In a work of art, it is the form itself that must constitute the matter [...]. This form, which at the same time is matter, must express nothing other than itself.' (Aphorism 79 in K. Fiedler, *Schriften zur Kunst* [2 vols. Munich: Fink, 1971], vol. 2, 60–61). And this is precisely its *quality*.

22 Following Greenberg's argument again, in its definitive formulation—also definitively Kantian in spirit—in 'Modernist Painting' (1961): '*The task of self-criticism* [which Greenberg identifies with 'modernism's tendency to self-critique'] became to eliminate from the specific effects of each art any and every effect that might conceivably be borrowed from or by the medium of any other art. Thus would each art be rendered "pure," and, in its "purity" find the guarantee of its standards of quality as well as of its independence' (*Collected Essays, vol. 4*, 86).

expansion would have to entail a becoming-architectural—not without certain effects upon architecture itself, which would be placed in tension, so that from their conjugation would result a new *milieu* that in turn enables a new experience, carrying art away, beyond 'itself'.

(This is a rigorously *different* trajectory to the one that was to take the Russian avant-garde from the plastic conquest of pure pictorial forms (with the metaphysics of the artistic creation of a 'pure space' as the truth of cubist abstraction) to the artwork's dialectical relation to the real, which inscribes it into history as *cubist revolution*—in order to lead it to its final end. This history (in the form of a trajectory) of Russian constructivism begins by investing and overturning the internal logic of formal labour by negating the idealist object-form of the autonomy of the painting in favour of the 'new realism' of the materialist object-form: that of a *coexistence* of the pure formal and the utilitarian apt for conversion to the real of a concrete space-time, and which lends its consistency to the Monument of the new world in the passage from Cubism to Constructivism: Tatlin's *Monument to the Third International*. Trapped in an impossible in-between, *precisely that which Matisse will refuse at all costs*, we then find Malevich insisting that '[o]ur contemporaries must understand that life will not be the content of art, but rather that art must become the content of life, since only thus can life be beautiful'.)[23]

∗

It is from the inside of painting, and from its very processuality, that Matisse would set in motion a becoming-other of the painting, making it radiate out beyond its frame; an experiment that would ultimately draw painting out of itself. In an unprecedented fashion, he will invest the plastic difference of time and the heterogeneous temporality of the event in art, in a singular performative which, in each of his works, pays so little regard to the image of a 'given/giving'[24] that it does away not just with the reality of a

23 Cited by J.–P. Bouillon in 'Le cubisme et l'avant-garde russe', in 'Actes du premier Colloque d'Histoire de l'Art Contemporain tenu au Musée d'Art et d'Industrie, Saint-Étienne, les 19, 20, 21 novembre 1971', *Le Cubisme*. Centre Interdisciplinaire d'Études et de Recherches sur l'expression contemporaine, *Travaux* IV, Université de Saint-Étienne, 1973, 153–223: 209. In the above we retain the essential point of this article, in an inevitable retroactive movement, namely that the Russian avant-garde is the one and only 'site' (revolutionary Russia) where *cubist evolution* transforms into *cubist revolution*: '[because] if it is only a matter of purely formal modifications, and indeed rather ephemeral ones, taking place in the closed, flat field of easel painting, then the term ["revolution"] can only be an abusive metaphor' (ibid., 163).

24 As in the model of a phenomenology of presence that ideally involves the teleological essence of art in a relation with its self-referentiality. It did not escape Michael Fried that this movement of bringing-to-presence—where the presence of the art depends on an art of presence—presided over Greenberg's whole argument. 'Presentness is grace', he writes at the conclusion of his 1967 essay 'Art and Objecthood' (M. Fried, *Art and Objecthood* [Chicago: University of Chicago Press, 1998], 168).

presence beneath representation, but with the ideality of the *image* itself, in favour of being 'conscious only of the forces [one] use[s]' when 'driven by an idea which [one] really only grasp[s] as it develops along with the painting's progress'.[25] Far from all 're-portage' of the image, mental or otherwise, in an opticality that would purify it, abstract the sensation from it, for Matisse the necessity of this approach is a function of the impossibility of any *différance* between the conception and its most tangible *realisation* (*concretion*). Or, once again, since there 'is no separation between the thought and the creative act',[26] the only conception that matters is one that *surfaces*, entirely imma-nently, in a continuous becoming whose principle of construction can only be perceived in tandem with that which it constructs, outside of any kind of labour of form for form's sake. A processual materialism, need it be emphasised, that is diametrically opposed to the postromantic exasperation to which some would wish to reduce Fauvism.

A pivotal work from summer 1911, *Interior with Aubergines* [fig. 1], will serve us as exemplary testimony to this setting-in-becoming, which Matisse describes as 'decorative' in a sense that is entirely his own since it implies a radical new relation be-tween art and its outside, one that touches on the problematic of the decorative itself. To carry out this operation, not only will Matisse have to break with the image-Form and the canvas-Form of painting, he will also have to extricate painting from its intrin-sic pictoriality (against the grain of the legend of a *pure* Matisse, 'champion of colour' for colour's sake). What he brings to the fore under the name of 'decoration' is a way of constructing the painting in which its supposed motifs (whether 'decorative', 'figurative', or 'abstract') are subjected to differential relations of intensity between colours-signs in such a way as to ensure a circulation both turbulent (kinetic energy) and continuous (potential energy), a circulation that runs through the whole painting and radiates out of it—a generalised expansiveness, founded on the intensive rather than the extensive. The end result is the forestalling of any kind of centred organic or hierarchical composition. It is this truly radioactive decorativity of Matisse's painting that renders virtually possible, and even *demands* (in a particularly noticeable way

25 H. Matisse, 'Notes d'un peintre sur son dessin', *Le Point* 21 (July 1939); 'Notes of a Painter on his Drawing, 1939', in J.D. Flam (ed.), *Matisse on Art* (Berkeley and Los Angeles, CA: University of California Press, revised edition, 1995), 129–32: 132 [translation modified] [H. Matisse, *Écrits et propos sur l'art*, ed. D. Fourcade (Paris: Hermann, 1972), 163 (hereafter EPA)].

26 H. Matisse, remark reported by André Verdet in *Prestiges de Matisse* (Paris, Émile Paul, 1952); 'Interview with Andre Verdet, 1952', in Flam (ed.), *Matisse on Art*, 209–17: 211 [EPA, 47n11]. A vision of the global state of the work must be kept in mind at every moment: 'All must be considered in interrelation during the process—nothing can be added' ('Sarah Stein's Notes, 1908', in Flam (ed.), *Matisse on Art*, 44–52: 50 [EPA, 71]). 'I never know in advance what I am going to do' (remark to J. and H. Dauberville, 1942, EPA, 47n11).

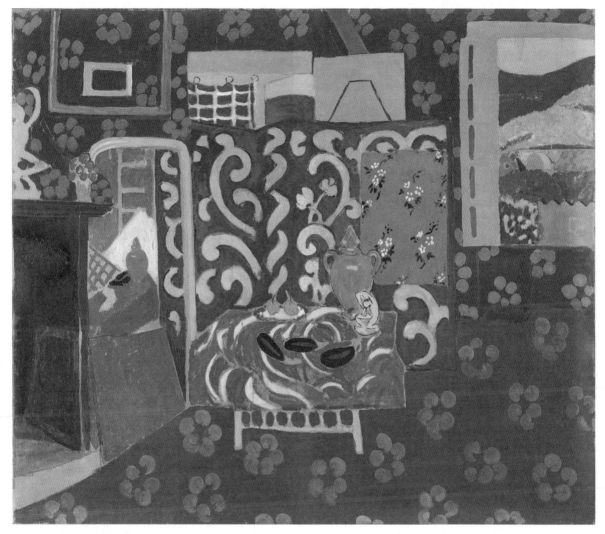

1. Henri Matisse, *Interior with Aubergines*, 1911, tempera on canvas, 212 x 246 cm (Musée de Grenoble).

in this painting) a new alliance with architecture. And it is this alliance that he will go on to implement, very pragmatically, as we shall see, with the *Dance* mural at the Barnes Foundation.

But Matisse's oeuvre is not all of a piece, and he never repeats himself. It is as if, in the wake of every great coup, he gathers up his (other) resources and risks putting everything back into play once more, in new relations of forces. Although we cannot detail here the precise role played by *Interior with Aubergines* in the becoming of what we call 'Matisse-Thought', we must at least give a summary justification for choosing this particular work. A large format painting (tempera on canvas, 212 × 246 cm), it presents the advantage of being both one of the most self-consciously decorative and one of the most reflexive of Matisse's works prior to his move into environmental mural painting (the only thing not yet in place is the question of how to integrate the 'human' into the decorative—a question that had been central for the Moscow *Dance* [1909], and to which Matisse would return with the American *Dance*). *Interior with Aubergines* sees Matisse conducting a proliferation of experiments with pigment and different modes of construction, and staging a confrontation of several orientations between which his art had become divided (and between which he felt the need to choose). This is something he had done in the past by making two different versions of the same painting (*Young Sailor* in 1907, *Le Luxe* in 1907, and the two *Dance*s of 1909 and 1910). A year after the Moscow *Dance*, whose decorativity, dominated by the assemblage of a few large areas of flat colour, had signalled a certain simplification of painting, with *Interior with Aubergines* we arrive at a very complex construction in which Matisse seems to have tried to mobilise as many resources as possible, no matter how heterogeneous. To set out the terms of the problem simply, we might say that *Interior with Aubergines* attempts to forcibly bring into play a *critical pictoriality* founded on the tensivity of the chromatic textures of its 'motifs', within a decorativity whose expansive rhythm excludes in principle any consideration of effects for their own sake. This pictoriality is also, in some sense, a way for Matisse to settle accounts with the 'modern-style' decoration whose mechanically reproduced patterns furnished bourgeois interiors of the time, and which he hated with a vengeance. So it is important to see how, without sacrificing any of its energy, the decorative processuality of *Interior with Aubergines* integrates this pictoriality and even draws on some of its resources, all the better to deregulate the economy of its effects from within.

Interior with Aubergines is painted in tempera on canvas, a technique rarely used by Matisse where the pigment is dissolved in a water-based animal glue, making it possible to obtain opaque, matt colours that dry rapidly. As a result it is an extremely flexible

medium, one that enabled the painter to create bright, flat colours, the fluidity of the paint precluding any use of impasto.[27] Almost the entire surface is covered with constellations of colour patches bursting out in every direction, the underlying planes heightening the discontinuous expansion of the whole. This variegated dislocation makes the depicted room and its objects into a tumultuous patchwork that defies any kind of scenic coherence, any intelligible scenario, any allegorical reading. Continually swept away and set back in motion again, the eye finds no fixed point upon which it might halt and try to piece the image back together again. The table, the screen, the view from the window, the mirror and its frame—all of the decorative 'motifs'—take on the consistency and abrupt rhythm of the coloured bands and arabesques of which they are mere vectors, and which run across them or pulsate through them like waves advancing, intersecting, rebounding, or diffusing freely outward. But paradoxically, this dissipation is subject to a rigorous ordering which, rather than being the result of some kind of composition that would guarantee the unity of the whole, only holds in and through the force-play [*jeu en force*] of colours-signs.[28] Evidently this is an experimental painting, a variation on a series which included, in the same year, *The Pink Studio* and *The Red Studio*—a series that sought to deframe not just the work, but the artist's studio itself.[29]

One of the principal sources of this painting's dynamism is the pulsing of the planes that traverse it diagonally. The oblique, divergent thrust of the two planes of dark blue and green in the lower left corner is forcibly articulated with a sequence of bright colour planes with multiple decorative markings *stretched out* between the left and upper right. This powerful transversal axis comes into tension with the two large underlying planes, black-brown (for the wall) and dusky brown (for the carpet), that

27 In 1922 Matisse gave the painting to the Musée de Grenoble (where it remains to this day). Dominique Fourcade has reconstructed a very plausible account of the history and meaning of this donation of 'a work that testified to the essence of his research' at a time when he was still very poorly represented in French museums (D. Fourcade, 'Rêver à trois aubergines', *Critique* 324 [May 1974], 467–89: 468). Fourcade indicates that the tempera technique, more flexible than oil, opens up 'different and greater possibilities than the classic technique of mural painting; its use on canvas, which does not have the same power of absorption, is far more problematic. Whence the fragility of *Interior with Aubergines*, which from the start posed some delicate problems of conservation and restoration.'

28 On this point we disagree with John Elderfield who, addressing the group of paintings to which *Interior with Aubergines* belongs, maintains that 'the very geometry of the pictorial support [is] again used to cohere the separate parts and to provide a point of visual stasis', while within the painting, 'strong overall scaffolding [...] both distinguish[es] and integrate[s] the parts'. J. Elderfield and S. d'Alessandro, *Matisse: Radical Invention 1913–1917* (New Haven, CT and London: Art Institute of Chicago/Yale University Press, 2010), 112.

29 Matisse told Pierre Courthion that this painting was 'an interior of my studio, with a view over a mountain to Collioure.' P. Courthion, S. Guilbaut (ed.), *Chatting with Henri Matisse: The Lost 1941 Interview*, tr. C. Miller (London: Tate Publishing, 2013), 119. Cited by Fourcade, 'Rêver à trois aubergines', 470.

envelope it and penetrate it, and whose constellation of blue flowers sets the whole surface of the painting expanding. The multidirectional chromatic contrasts of these two dispositifs set the charge for a detonation whose repercussions will run through the whole canvas—how true it is that forces can only work against (or with) other forces.

The angle formed by the green drawing board and the blue flank of the fireplace (beneath which we discern the ghostly form of a *stretcher* symptomatically evoking the tension of the canvas)[30] suggests a potential volume that is contradicted by the rectilinear mantelpiece. But in fact, rather than a 'contradiction', what we have here is a forced connection between coloured bands (a kind of *expansive contraction*). The forthright leftward hook of the yellow frame makes the mirror seem frontal, yet the reflection of the green drawing board at the bottom of the fireplace suggests that its base is oblique. Matisse gives us a plethora of such out-of-phase discrepancies: between the drawing board and its reflection, between the mirror placed in front of the screen (or contiguous with it) and its improbable reflection of the same screen. Similarly, the left rear corner of the room can no longer be made out at all. Thus the painting's flatness is subjected to a kind of flexibility that we must understand in terms of tension and 'disparation' (in the sense that the tension is not resolved) rather than deformation.

The expansiveness at work here is an affair of interpenetration that plays out across the whole of the painting, and even between the 'interior' and exterior. The arrow-shaped knee of the yellow ochre statuette on the mantelpiece reinforces the penetration of the mantel shelf into the mirror, while on the contrary the curve of its raised arm seems to scoop some of the blue petals out toward the exterior,[31] and the figure's feet (if that is what they are) give it the allure of a coiled spring or a poised dancer, the curves and angles of this pose coming together into an assemblage with the curves of the mirror and the rectangles of the neighbouring frames. And the red mantelpiece which, in the opposite direction to the void of the hearth that opens onto the outside, extends right into the bright green band reflected in the mirror, also 'pushes' into the mirror one set of blue petals, set within a little quarter-circle of the black-brown ground—yet another intrusion of an unassignable reflection ensuring that the planes are hooked into one together even as they continue to slide apart. At the point where the mantelpiece virtually intersects with the line of the mirror's yellow frame on its way back down, there blossoms a bouquet of red flowers(-orbs) with bright green stalks, like sparks from an electrical discharge galvanising the surrounding flowers with blue petals(-orbs). Between the yellow statuette and this bouquet, Matisse (probably using grattage) allows

30 One irresistibly thinks of the subliminal balustrade of *French Window at Collioure* (1914).

31 The reason for this gesture, formally anecdotal, can only be fully understood in relation to the expansiveness of the brown ground upholstered with blue flowers.

some blue to show through from beneath the brown band. This whole region therefore consists of a knotting of forcibly embedded planes, stretched-out bands, and explosive colour-patches whose rigorous construction generates the constitutive tension of the entire painting.

The rest of the painting attests to the fact that decorativity, expansively constructed, is indeed one of the fundamental reality conditions for the *muralisation* of painting. Most of the surfaces, quasi-rectangular but generally askew, are themselves also placed in tension by the forced conjunction of the various degrees of relief suggested by folds—creases in the tablecloth, folds in the screen, the angles of the floor and walls, the frame of the open bay window—and the implacable flatness of the decorative motifs that supposedly cover their surfaces. The various floral 'decors' and their 'supports' have no descriptive function as such: they only make sense in relation to a painting that is decorative through and through, in the site of its deployment.

The polyvalence and transversality of the decorative are repeatedly charged with renewed impetus, from one support-plane to another and from one register to another. The three dark violet aubergines carry with them in their dance the curves of the elongated bright yellow, dark ochre, and violet leaves, which accelerate their movement and distend the plane of the tablecloth. Neither the aubergines nor the floral patterns respect the pleats of the cloth, instead superimposing over it another plane defined solely by their own modulations. Indeed, the three aubergines are situated right *on the* (elided/ eluded) *fold* of the tablecloth's drape so that their oblong bodies, sliced through by a bright violet highlight and punctuated by a raw green stalk, stand out from the bright red of the cloth—as if they are being juggled between the flat space of the painting and the foreground. The decorative elements race ahead as if, peeling off from their supports, they want to take over the whole 'interior', which they will then deconstruct and reconstruct; as if they might even reach out into the space of the room where the spectator stands. Thus decorativity refutes any idea of a 'still life' and, in accordance with a *decorativity virtually generalised to the whole environment*, denaturalises the circumstantial and heterogeneous assemblage of these supports with the vegetable compositions with which Matisse chose to embellish his 'interior'. (As we shall see, at the Barnes Foundation Matisse also took into account the relation of his mural painting to the landscape visible through the bay windows above which the *Dance* is painted.)

The sustained contrast between the reds of the tablecloth and the dark green of the screen reaches the point of its highest virulence in the clashes and repercussions (or quasi-seismic aftershocks) between the configurations of their respective 'motifs': the oversized, twirling bluish-mauve swirls of the screen responding, with an abrupt leap in scale and a more alternating and angular rhythm, to the turbulence of the aubergines and the tablecloth's floral patterns. Under cover of a pseudo-perspectival

foreshortening, the red tablecloth's folds propel it forcibly into the green screen, which 'responds', to the right of the tablecloth, by displaying the talons of two large scrolls (which—force against force—doubly drive forward the *break* of the tablecloth at this point). This double claw also hooks the horizontal tablecloth onto the vertical rectangle of fabric (or imitation wallpaper), its dark ochre ground scattered with groups of white flowers, that is pasted conspicuously onto the screen. This wallpaper and the orientation of its bouquets both reinforce the great diagonal with which we began. Its frontal plane does not rigorously coincide with the slightly oblique planes of the two panels of the screen from which it stands out. Matisse introduces many almost subliminal mini-tensions of this kind, and they surreptitiously work through and with the more visible tensions, continually suggesting new connections that incorporate the 'spectator' into the *deployment of contracted virtualities* in the *diagrammatic demonstration* to which *Interior with Aubergines* gives rise. This meshing, the machinic force of which ceaselessly foils any possibility of re-forming an 'image' precisely to the extent that here content and expression attain their utmost relativity, both becoming functives of the same function and materials of the same matter, is complemented by other elements: in its turn, the statue of an 'Écorché' on the table, whose curves enter into the generalised decorativity (as practiced by Matisse from the time of his Fauvist transduction),[32] convokes the register of sculpture and even the sub-register of the (studio) 'model', to which however the painting grants only a purely differential constructive status.[33] (For the diagram or differential of forces knows and recognises only material traits [of content] and functional traits [of expression] 'which draw one another along, form relays, and meld in a shared deterritorialization'[34] of every recognisable sign and register.) This statuette hooks the tablecloth—some of whose floral patterns belong to the same declension of colours running from cream to ochre—onto the great dark-grey-beige vase with pink-mauve highlights, whose curved handles in turn hook the green screen into the floral fabric.

The tensions and pressures at work between tablecloth and screen are activated by a small ignition device situated practically at the centre, straddling their intersection: the ultramarine border of a plate, oversaturated in contact with the plate's white ground, heightens the reds and oranges of the tablecloth, while the raw green of two fruits

32 A constant theme of *La Pensée-Matisse*.

33 An écorché after Puget (or, according to some, after a casting of a sixteenth-century Florentine sculpture in use in artists' studios of the period). The bronze that Matisse sculpted in 1903 is all tensions and muscular torsion. In *Interior with Aubergines*, Matisse has completely excluded these aspects, keeping only the flexion of the body, outlined in discontinuous brown-black lines over the bright flat beige of an almost amorphous silhouette.

34 G. Deleuze and F. Guattari, *A Thousand Plateaus*, tr. B. Massumi (Minneapolis: University of Minnesota Press, 1987), 586.

(matching the stalks of the aubergines) heightens the dark green of the screen into which they point. As opposed to any purely pictorial effect, this detonator acts even and above all when one does not focus on it as if it were a highlight: without the impact of its shockwave, the painting would lose the focus of its irradiating force; but if it were to *fix* the attention, that irradiation would no longer be so effective.[35]

Elsewhere, the force of the decorative comes, paradoxically, from its highly irresolute nature. Far from being the result of a clear, high-contrast outlining of homogeneous coloured decorative signs-forms on continuous painted grounds, on the screen, for example, the mauve lines of the scrolls are very thinly painted, allowing the raw ground of the canvas to show through in the surrounding reserve, which is sometimes outlined by a thick black mark and sometimes left raw, giving the scrolls an elasticity that incessantly perturbs the screen's field of green. Similarly, the width of the screen's gently concertinaed panels agrees with the play of the scrolls, which diverge, converge, spin off, and bloom without ever being fixed in any regular pattern that would allow the field of the screen to be grasped in one single synthesis.

Jean Leymarie wrote that *Interior with Aubergines* was 'a startling prefiguration of the final culmination' of Matisse's paper cut-outs, adding:

> I remember Matisse's joy in 1952, when I said [...] to him that his Grenoble masterpiece, with its mural arrangements and its decorative freshness, heralded the floral cut-outs with which he adorned the walls of his room at that time.[36]

Aside from the fact that Matisse's late cut-outs were by no means designed to *adorn* the walls of his room, this is an interesting observation. It is particularly applicable to the scrolls on the screen, whose play, free of any concern for imaging, enables Matisse to distance himself from the decorative patterns featuring large flowering branches that he evokes with these scrolls, only to transpose them into the expressive colours-forces of a pure vitality. It is indeed this same vitality that will preside over the paper cut-outs that are the most abstractly *deterritorialized* and therefore liberated from a formally *deterritorializing* labour still being carried out *from the interior* of a 'painting'. If there is a 'heralding' here, a 'prefiguration', it is in the sense of a prior (and thus historically necessary) labour that paved the way for a more and otherwise radical moment when colour and drawing would become totally inseparable.

35 On this aspect of Matisse's painting in relation to the 'circulation-tension-expansion system' that 'imposes an absent-minded, peripheral gaze on us', see Y.-A. Bois, 'On Matisse: The Blinding', *October* 68 (Spring 1994), 61–121 (in particular 83–4).

36 J. Leymarie, 'Les grandes gouaches découpées de Matisse à la Kunsthalle de Berne', *Quadrum* VII (1959), 110–12, cited in Fourcade, 'Rêver à trois aubergines', 474.

The complex flatness of *Interior with Aubergines* begins with the energetic relations between colours, in order to assemble and display [*monte/montre*] the processual toppling of 'signs'—signs demoted from the status of forms (or signs-forms, in all the senses of the word 'form') to that of signs of forces (or better, signs-forces) so as to enter the fray as immanent vectors of a generalised diagrammatism that emancipates the painting both from re-presentation (signifiant formatting [*mise en forme*]) and from the (de-forming) pictoriality of an autoreferential space (as modernist truth of *alloverness*)[37] in order to commit (in force) to the virtual investment of the murality of the surroundings—an investment that Matisse will soon assume directly, without the mediation of the canvas.

*

Before going any further with *Interior with Aubergines*, in order to further explicate the critical problematization of the notions of form and sign (determinative for Matisse's plunging into crisis of the canvas-form), we should like to compare this problematization to the way in which form and sign are put to work in the cubist collage that will erect itself as the avant-garde of a 'change of forms' (in Jean Laude's words). The first point being to examine whether the abrupt juxtaposition of heterogeneous decorative surfaces in Matisse's painting can be compared to a collage, as Jack Flam suggests when he sees in 'the piece of flowered ocher wallpaper to the right of the large green screen [...] a remarkably collage-like effect'.[38] Flam's observation seems all the more persuasive if we examine how the composition of Picasso's November 1912 painting *Guitar, Sheet Music and Wine Glass* (papiers collés, gouache, and charcoal on paper, 48 × 36.5 cm), considered one of the very first if not the first true collage, includes a piece of ochre wallpaper with small flowers 'so close [to that of *Interior with Aubergines*] that one may ask whether Picasso had not wanted to make [...] an ironic reference to Matisse's interior' [fig. 2].[39] The headline of the newspaper inserted into this composition, *La bataille s'est engagé[e]*, which could be understood in various ways, would then be

37 This 'modernist' argument is taken up by J.M. Bernstein in an article that tries to place Matisse on the side of the Deleuzian body without organs—something Bernstein can only do by relating the latter to Merleau-Ponty's phenomenology (of art): J.M. Bernstein, 'In Praise of Pure Violence (Matisse's War)', in D. Costello and D. Willsdon (eds.), *The Life and Death of Images: Ethics and Aesthetics* (London: Tate Publishing, 2008), 37–55. In her 'Response to J.M. Bernstein', while Judith Butler does not directly address this question, she does recall the difficulties involved in reframing the Body Without Organs on the surface of the canvas alone (ibid., 60–61).

38 J.D. Flam, *Matisse: The Man and his Art, 1869–1918* (London: Thames and Hudson, 1986), 314. As is widely known, Picasso and Braque worked a great deal during 1911 and 1912, comparing and contrasting their work. Braque would have been able to see the *Interior with Aubergines* during a visit he made to Matisse at Collioure during summer 1911.

39 Ibid.

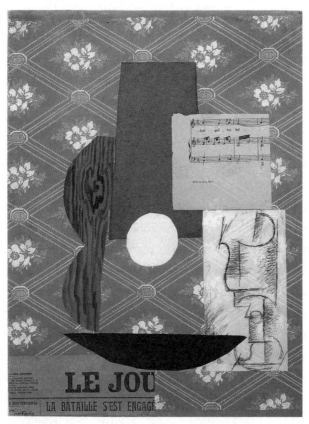

2. Pablo Picasso, *Guitar, Sheet Music and Wine Glass*,
November 1912, papier collé, gouache, and charcoal on paper,
48 x 36.5 cm (McNay Art Museum, San Antonio).

'a declaration of competition with Matisse': *the battle is joined*.[40] And indeed, the decorative had become an important bone of contention in artistic practices (at least since Gauguin and the Nabis, for Picasso) and in recent theoretical discussion (Gleizes and Metzinger's *On 'Cubism'*, for example).[41] As for the collage, Picasso ushers in a new era here with his 'papiers collés', the form that was most inventive and most disruptive for

40 Remark by J.D. Flam during discussions documented in L. Zelevansky (ed.), *Picasso and Braque: A Symposium* (New York: Museum of Modern Art/Abrams, 1992), 153. Here Flam comes back to the relation between Picasso's painting (which he describes as 'one of the great pieces of early twentieth-century art criticism') and Matisse's art, and summarily characterises the difference between their respective understanding of the decorative: 'Picasso used machine-made wallpaper as a *mock* decorative element. In evoking a Matissean motif, he is setting an ironic distance between Matisse and himself' (Ibid, 162).

41 *On 'Cubism'* was published in 1912, as was Kandinsky's *On the Spiritual in Art*, which also takes up a position against the decorative. The subject of the decorative was to be the object of public debates even in political milieus, where it was conflated with the question of nationalism (see Zelevansky (ed.), *Picasso and Braque: A Symposium*, 64, 74, and particularly Patricia Leighten, 167).

the painting of its time. The comparison with Matisse must therefore be staged in terms of the twofold question of the collage and the decorative, particularly in its mural aspect (precisely that of *wall*paper).[42]

Traditionally, the 'collage' is understood in two, not necessarily connected, senses. Technically speaking, for Braque and Picasso it consisted in the application onto canvas (or some other traditional substrate of painting: wood, paper, board…) of various materials (sand, iron filings, oilcloth, rope, sawdust…) that are not traditionally those of painting, but can be painted. From a strictly processual point of view, whether or not an alien material is introduced into a painting, the term 'collage' applies to any operation that aims to produce, on the interior of the work, a functional discontinuity in the double sense of the term: a deliberate break in the coherence of a system of signs, but one that authorises a new mode of functioning based precisely upon this very discontinuity.[43] It is in this second sense that Jack Flam speaks of a 'collage effect' in relation to the *Interior with Aubergines*. If we take the term broadly enough, then, Picasso was practising collage well before and after the papiers collés period (which ran from autumn 1912 to 1914), and we can easily recognise different forms of it across multiple arts. But what matters here, for our comparison with Matisse, is the specific type of collage that Picasso was practising when he included decorative papers in his compositions.

In *Guitar, Sheet Music and Wine Glass*, the collage properly speaking consists in the assemblage of the eight papiers collés, very heterogeneous both pictorially and semiotically, that make up the entire picture. A flowered wallpaper printed with a lozenge-shaped frame provides the 'decorative' background of the composition, its flatness coinciding with that of the support while its mechanical 'grid' suggests the flattening of planes and the abandonment of analytic cubism's (austere) gradations of colour. As is generally the case in the papiers collés, the picture exhibits a striking *ambivalence* between its supposed verticality qua 'mural' covering, and the horizontality implied, if not by the position of the guitar (which may be hanging up), then certainly by the position of the newspaper laid flat on it as if upon a table, so that the aforementioned 'wallpaper' could just as well be a patterned table top.[44] If this is Picasso's way of showing

42 As Gordon Matta-Clark will recall with his *Walls Paper* (1972), which we analyse in Volume 4, I, 'GMC Entry'.

43 According to William Rubin, Braque made the first papier collé, but Picasso made the first collage: the faux bois wallpaper Braque often used to simulate trees no doubt advertises its exteriority in relation to the rest of the compositions in which it is inserted, but it does not truly alter their overall coherence (W. Rubin, *Picasso and Braque: Pioneering Cubism* [New York: Museum of Modern Art, 1989], 40). The same is true of the Juan Gris's collages, some of which were even earlier. Picasso's more diverse papier collé compositions present the most radical discontinuities.

44 On the paradoxical conjugations of verticality and horizontality in this papier collé, see Y.-A. Bois, 'The Semiology of Cubism', in Zelevansky (ed.), *Picasso and Braque: A Symposium*, 188.

his indifference to the purely visual coherence (in the perspective sense) of the positioning of objects in space, it is the coexistence of horizontality and verticality in the same signs-forms that allows him to significantly broaden the field of deployment of the painting and its in-formative function.

On top of the decorative wallpaper, seven other pieces of paper form an equally disparate combination of signs—a disjunctive conjunction of ill-fitting pieces of different puzzles of the same subject[45]—suggesting a still life with a guitar in a corner of the painter's studio.[46] All of these pieces are systematically affected by various ambivalences: the criss-cross motif of the aforementioned wallpaper is integrated into the guitar as its soundboard (in a kind of 'crossed' play with the strings) and/or the bottom of its body. The leftmost element of the body is painted (in gouache) in an imitation of a faux bois wallpaper—a kind of 'détrompe l'oeil'[47]—and is placed upside down, so that its matter can be associated with that of a table, its position with the suggestion of a movement or rotation of the guitar.[48] The elements in this type of composition are not required to make up any predefined whole or to occupy any fixed position.

In this work, the colour (which, following a period of austerity, would later undergo a certain reinvigoration in cubism under the auspices of Ripolin) is totally artificial—a colour at once deaestheticized, printed (which tends to align it with the newsprint), and completely unrelated to the local colour of the object (and here we could make a comparison with Matisse). This denaturalisation and downgrading of pictoriality renders colour anonymous, stripping it of its traditional iconic, plastic, and expressive associations. The blue functions only to detach the sign-form of the guitar neck from the colour of other signs: the yellow ochre of the ground, the chestnut-brown of the fake wood, the white of the sheet music, etc. Here colour has no pictorial function: it functions only as an arbitrary sign of colour, as Rosalind Krauss has explained very well.[49]

45 'Nothing indeed is more striking,' writes Yve-Alain Bois, 'than the radical heterogeneity of the various elements put together on this *papier collé*, as if Picasso had wanted to emphasize the point at the outset' ('The Semiology of Cubism', 187sq).

46 One might think here of the photograph of a (destroyed) assemblage made at the beginning of 1913 in Picasso's studio (on Boulevard Raspail in Paris), composed of cut-up newspapers, a guitar, a cardboard violin, the composition of a large figure (at the bottom) and a table upon which are arranged various objects (a bottle, a glass, a pipe...), see P. Daix and J. Rosselet, *Le Cubisme de Picasso* (Paris: Ides et Calendes, 1979), no. 578, 299.

47 Clement Greenberg evokes 'trompe l'oeil' repeatedly in his article on 'The Collage' (1959), reprinted in *Art and Culture* (Boston: Beacon Press, 1961), 70–83, inevitably analysing it as that which 'establishes undepicted flatness *bodily*' (75).

48 Leo Steinberg defines this kind of association as a kind of hypallage, and analyses a fine example in Picasso (see L. Steinberg, 'The Prague Self-Portrait and Picasso's Intelligence', in *Cubist Picasso* [Paris and London: Flammarion/Thames & Hudson, 2007], 116).

49 'Not the sensation of color but the sign for color.' R. Krauss, *The Picasso Papers* [London: Thames and Hudson, 1998], 180.

If, in all of this, colours prove to be entirely arbitrary while their combination is not, it is because colours function essentially as the formal discriminants of signs (or what we call signs-forms). As Greenberg emphasises (and it is an important point), this is reinforced by 'the growing independence of the planar unit in collage as a *shape*' , i.e. a *form*.[50] In Matisse, on the contrary, the arbitrariness and denaturalisation of colours frees them from any subordination to form or to the aestheticizing pictoriality upon which, as shapes, they traditionally depend, in order to release powerful colours-forces[51] to play in expansive tensivity across the whole field of the painting—and even to radiate beyond it.

Finally, the piece of newsprint is the only element that is completely decentred in relation to the rest of the composition. The headline, or rather words extracted from a headline—LA BATAILLE S'EST ENGAGÉ[E]—have given rise to innumerable interpretations.[52] Without entering into the minutiae of this question, let us point out that the 'battle' may well turn above all on the question of the newspaper, in so far as it will *play out* [*se joue*] between the two protagonists with whom Picasso is himself in debate on this subject, namely Mallarmé and Apollinaire—as Krauss has indicated so as to clarify why Picasso chose this particular material. In which case, the ingenious coupling of (the positions of) the newspaper and the sheet music would now refer to the opposition between the Mallarméan universe of the 'Book', in which the Word 'arises musically',[53] and the morning Prose of the newspapers invested and committed to the page by Apollinaire in 'Zone' [1912]. By introducing into his paintings '*the* medium [...] of modernity itself,[54] the newspaper, Picasso would seem to favour Apollinaire over Mallarmé, who excludes it from the 'mystery' of a stellar prismatic poetics on account of the 'universal reportage'

50 Greenberg, 'The Collage', *Art and Culture*, 79.

51 Something Matisse continually insists upon in his interviews whenever he touches on the question of colour: 'Colours are forces...'.

52 The most frequently invoked are the competition that arose with Braque over the collage, the conflict of the new and the old style, a challenge thrown down to the fine arts and to his rival Matisse, and of course the growing preoccupation with the Balkan wars (the newspaper is dated 18 November 1912), not forgetting the idea of 'play' evoked by the JOU of JOURNAL (see Rubin, *Picasso and Braque: Pioneering Cubism*, 28). Krauss also mentions the calibration of the circulation of signs to the epoch of the circulation of 'news' (*The Picasso Papers*, 62 and 81). Based on another suggestion by the same author ('The Motivation of the Sign', in Zelevansky (ed.), *Picasso and Braque: A Symposium*, 261–86), the irruption of the newspaper into the papier collé could also be understood in 'dialogical' terms (274)—that is to say, as a confrontation of dissonant voices—a conception Bakhtin develops in the direction of a pragmatic subversion of 'linguistics'.

53 S. Mallarmé, 'Avant-dire au *Traité du Verbe* de René Ghil', in Mallarmé, *Oeuvres complètes*, vol. 2 (Paris: Gallimard, 2003), 678.

54 Krauss, 'The Motivation of the Sign', 278.

polluting the flow of ink with the grey monotony of its columns. Except that the dispositif produced by Picasso might be more rigorously conceived of as an extension, to the newspaper, of the Mallarméan spacing of the letter, in a graphic, plastic, and scriptural form that presents itself as an alternative which, while undoubtedly 'modern', is classical enough when compared to the futurist cacophonies toward which Apollinaire is now turning.[55]

By pasting papers with flat or flat-coloured motifs onto a support whose plane they render conspicuous, Picasso envisions the construction of a specific spatiality that is as processual as possible (not illusionist), yet is ambiguous or polyvalent and thus paradoxical. For him, this construction of spatiality is one of the fundamental aims of the representation of objects and their relations, once it is no longer a question of treating it in terms of visual depth. All of the planes in *Guitar, Sheet Music and Wine Glass*, from the brightest to the darkest, seem to thrust forward or drop back in relation to their adjacent planes, like a freeform 'braiding' 'in the thickness of the plane', in Hubert Damisch's words.[56] The almost orthogonal relationship between the central trapezoid of the guitar body and neck and the metastable black circular segment enters into strong tension with the obliqueness of the decorative crosspiece of the ground, which, inversely, is stretched out horizontally. This decorative weave and the scattering of the floral motifs that pattern it (in which we rediscover the paradigmatic grid of the Panthéon's cupola, even down to the hexagonal 'buttons')[57] play a most paradoxical underlying role: given their rigorous criss-cross patterning, they act as a stabilising factor, but they constitute a destabilising factor for the composition, traversing it extensively, accentuating its lines (of force) with a potential dislocation. But then, in yet another paradox, the sign-plane of the wallpaper, at the centre of the guitar body, functions simultaneously negatively and positively: it withdraws into the position of a ground (because it appears as a reserve between the signs-planes of the guitar around it), but also comes forward into the position of a figure (since the crosspiece printed on it reunites these signs-planes which were otherwise on the verge of falling apart). At almost the geometrical centre of this ensemble and therefore of the picture itself, the white circle glued over the papers that it overlaps, corresponding to the sound hole of the guitar, constitutes the masterful

55 All the positions and all the terms of this debate are well exposited by Krauss, ibid., 275–82.

56 On the (structural) problematic of the thickness of the plane, see H. Damisch, 'La peinture est un vrai trois', in *Fenêtre jaune cadmium ou les dessous de la peinture* (Paris: Seuil, 1984), in particular 275–305. On the problematic of flatness (of the plane-volume) in modern sculpture, see M. Rowell, *The Planar Dimension: Europe, 1921–1932* (New York: Solomon R. Guggenheim Foundation, 1979).

57 See Volume 1, *Body Without Organs, Body Without Image: Ernesto Neto's Anti-Leviathan*, 50–54.

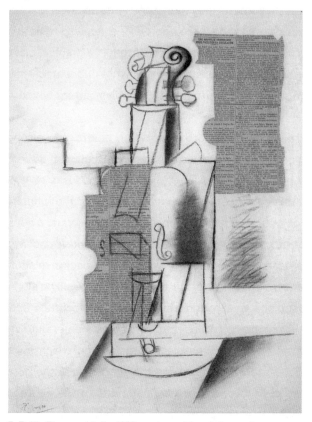

3. Pablo Picasso, *Violin*, 1912, papier collé and charcoal on paper,
62 × 47 cm (Musée national d'Art moderne, Paris).

culmination of this composition.[58] It is the centre and the pivot around which all the
other planes gravitate and draw together, but also oscillate and float, and even break
apart from one other. This centre appears to be above the two neighbouring planes of
paper in terms of *tactile thickness* but, perceived as a reserve between them, functions
optically—yet another paradox—as a hollowed-out volume affecting all the planes at
an undefined *depth*, even seeming to pierce right through the plane of the painting itself
(an effect that is not present in Picasso's guitar sculptures). In the face of all these
threats, the decorative weave of the underlying wallpaper is, as we have seen, an

58 Rosalind Krauss has related it to the discovery of the spatial value of tubular eyes in the
 Grebo mask that Picasso owned, and to the guitars sculpted in sheet metal and cardboard
 that preceded and followed *Guitar, Sheet Music and Wine Glass* (see '1912', in H. Foster, R.
 Krauss, Y.-A. Bois, B. Buchloh [eds.], *Art since 1900: Modernism, Antimodernism, Postmod-
 ernism* [London: Thames and Hudson, 2004], 117). Yve-Alain Bois has highlighted the impor-
 tance of the Grebo mask for the cubism of the papiers collés and guitar sculptures ever since
 the publication of the first version of 'Kahnweiler's Lesson' in 1987, the definitive version of
 which appears in *Painting as Model* (Cambridge, MA and London: MIT Press, 1990), 65–97.

equivocal parade—a circus ring within which a juggler practises the most unexpected and perilous manoeuvres at the risk of bringing the whole thing down with him.[59]

But how are we to understand the presence, within this ensemble of flat papers, of an 'analytic' drawing—the drawing of a wine glass that makes up the right half of the guitar body—whose few suggestions of *depth* pull against the insistent frontality of the picture? The juxtaposition of these two types of signs is common in Picasso's papiers collés. Krauss addresses a similar but more obvious 'contradiction' in another celebrated papier collé of December 1912 entitled *Violin*, which brings two large newspaper cut-outs together with charcoal outlines of the instrument, comprising oblique lines and gradated dark planes implying a plurivocal play of depth [fig. 3]. In what seems rather a surprising argument, Krauss, while not denying them, argues that these effects are 'superfluous' to the frontality of the newspaper, which is supposed to prevent 'the re-constitution of the object's perspective, foreshortening, all of those things'; they must, she insists, be considered as an 'irony', and are to be 'read [...] overwhelmingly as or-thogonals'.[60] Here the analysis finds itself at a crossroads. Krauss's position shares with Bois's analyses the idea that this cubism of paper cut-outs accomplishes a radical semi-ological revolution, in the sense that it replaces sensible signifiance with 'linguistic'-type signifiance.[61] The status and distribution of certain signs is no longer founded on iconic-ity; only minimal iconic indices still allow the eye to recognise a visual reality. Instead, in analogy to the principles of structural linguistics, they are now based upon arbitrary, oppositional, and negative differences between one sign and all other signs (whether contextual, substitutable for that sign, or excluded by its use).[62] We must indeed recog-nise that, in his papiers collés, Picasso effectively succeeded in maximally artificializing the construction of his painting in order to subtract it from all internal or external self-evidence, or, in other words, from any identifiable image-effect. In order to do so he

59 One might think of this subsequent declaration of Picasso's: 'I want an equilibrium you can grab for and catch hold of [...] just the way a juggler reaches out for a ball.' (cited in F. Gilot and C. Lake, *Life with Picasso* [New York: Anchor/Doubleday, 1964], 119).

60 Krauss, 'The Motivation of the Sign', 264, 289. 'In the visual fields of these collages [...] no illusioned depth distracts us from the pure frontality of the visual screen' (ibid, 262. But then what exactly is the purpose of these 'patches of modeling' [ibid] and these oblique lines?)

61 Krauss sometimes prefers to say 'proto-linguistic' (ibid., 262) so as to emphasise that it is a question of a semiological domain that presents only *analogies* with the functioning of lan-guage and that its study thus entertains only a methodological analogy with linguistics. Bois expresses similar precautions ('The Semiology of Criticism', in Zelevansky [ed.], *Picasso and Braque: A Symposium*, 169–208: 215).

62 If it is true 'that words operate in the *absence* of their referents' (ibid., 263, emphasis ours), this does not imply that the meaning of an enunciation can do without the *existence* of a possible referent (nor can the apprehension of a referent do without a meaning that makes it a sign rather than a raw datum).

reduced, but did not entirely do away with, the iconicity of certain of his signs-forms and certain relations between them, or (as in the case of the faux bois) disconnected this iconicity from a literal or functional context.

In explicating her semiological thesis, Krauss focuses her analysis of *Violin* on the strictly frontal iconic and non-iconic 'signifiers' that correspond to 'the signified /depth/', in the absence of all visual illusion or visual impression of depth. For example, she takes as an example of iconic signifiers the drawing of the two clearly identifiable sound holes of the violin. Their noticeable difference in size must be *read* as a conventional way of enunciating the signifieds 'depth' and 'turning in space' (a way of *writing* them pictorially) without showing them, since these spatial properties are *signified* yet visually absent. One might think here of the linguistic mechanisms by means of which Duchamp's *Large Glass* functions—a work that is in itself visually unintelligible, and which can therefore legitimately be considered to participate in a certain prehistory of conceptual art. And yet if Picasso *is able* to *signify* 'depth' in this way, it is because he assembles and shows us [*monte/montre*] something else.

Although it cannot be denied that, in the case of the sound holes of the violin, afore*said* depth has a conventionally declarative and semiological, non-iconic side to it, the procedure can only *signify* this depth because it functions with and against an analytic-type iconicism—that is to say via marked (but not structurally oppositive) differences, within a context that *visually brings depth into play*, albeit in the form of ambivalent indications of oblique planes and lines, proximity, and lighting.... Without which it would be impossible to decide whether Picasso, *rather than signifying depth* in this way, had not simply wanted to *show* two sound holes of different size and aspect, as he does for example with the two halves of the violin body, avoiding making them symmetrical (following the cubist collage's principle of the de-coordination of 'syntax').[63] Perhaps this is a good place to remind ourselves, with Deleuze and Guattari, that '[e]very semiotic is mixed and only functions as such; each one necessarily captures fragments of one or more other semiotics (surplus value of code)'.[64]

Krauss also sees the graphical properties of the blocks of black newsprint and the whites of the two pieces of newspaper in *Violin* as non-iconic signifiers. The relations between these 'signifiers' can be described as structural or oppositional, in so far as they are essentially linked to the strictly complementary cutting up of two fragments of the same page, the utilisation of opposite sides of them (so that the *reverse* of the sheet

63 Something that can be judged just as well on the basis of Picasso's works as on his own affirmations: 'I stress the dissimilarity [...] between the left eye and the right eye. A painter shouldn't make them so similar' (cited in Gilot and Lake, *Life with Picasso*, 60; for other remarks on the necessity of 'asymmetry' when painting things symmetrical in nature, ibid., 118sq.).

64 Deleuze and Guattari, *A Thousand Plateaus*, 136.

used, below and to the left, to signify the *fore*-ground of the violin serves to signify, above and to the right, the *back*-ground of the still life)[65] and the inverse spatial relations of those pieces of newspaper with the surfaces of white paper connected to them (in one case the plane of the newspaper comes forward, in the other it withdraws). On this basis Krauss asserts the existence of purely differential couples of 'signifieds' corresponding to these effects, namely the frontality of a first opaque plane on the left, where the compact lines take on the status of 'wood grain'[66] *vs*. the distancing of the other fragment, which expresses the palpitation of a depth or an atmospheric transparency.

But the structural formulation of the properties of this still life with a violin does not depend upon a complete arbitrariness of the sign; in reality, it is motivated by visual analogies so ingeniously (and brilliantly) convoluted that, in fact, it cannot be understood without passing through a semiological moment. The semiological 'revolution' produced by the Picasso of the papiers collés—incommensurate with the fragmentations and recompositions of representation in analytic cubism, as hermetic as they may be—consists in the fact that it utilises the optical or graphic properties of materials totally alien to painting and traditional drawing, détourning them from their literal sense (as a line of writing), their usual context (a daily newspaper), and their original function (the legibility of the newspaper) to relate them instead to the representation of the properties of objects to which they are, strictly speaking, totally unrelated (here, the qualities of a violin body and the ambient light). The visual analogy (or motivation) is indeed real, but so lateral or indirect that it must pass by way of linguistic trickery, or some such mental mediation, in order to ensure that it will make sense—so that (in this respect at least) one is quite entitled to speak of a semiology of Picasso's pictorial 'language' which aims to signify certain properties of nature.[67] He pushed to the utmost the affirmation of the visually conventional nature of painting, and consequently denounced or deconstructed the pseudo-naturalism of the iconic conventions of representation. And yet, let us restate, his own semiological conventions only function when placed alongside forms that evoke the violin, its volume, and its spatial surroundings: without this context (and the oblique lines in particular), we would have nothing but a couple of

65 Picasso *irregularly tore* the right border of the uppermost piece of newspaper, which therefore could only function as a figure by the same token as the clear outline of the other piece.

66 Coming back to the analysis of *Violin* in her book *The Picasso Papers*, Krauss clarifies that the compact lines here pose as 'the graining of wood' of the instrument, and therefore come to signify 'the *density*, the *opacity* of a physical object' (27).

67 'What strikes us most strongly in nature is the difference of textures: the transparency of space as opposed to the opacity of an object in that space [...]' (remark of Picasso's reported in Gilot and Lake, *Life with Picasso*, 75 [translation modified]).

pieces of newspaper pasted onto a white ground, and would not be able to determine with any clarity the relation that holds between the two planes. On the other hand, the newspaper also functions as an autofigurative sign that can be associated, via a new kind of hypallage—local proximity—with the violin (placed on a table alongside it).[68] Which is not at all to say that Krauss's analysis is illegitimate, but that the relational system she presents as autonomous cannot function unless it is coordinated with spatial and semantic dispositifs that are heterogeneous to it, and do not form oppositional couples with it.

In short, far from being 'superfluous' to the semiological signs, these analytic signs contribute to the heterogeneity of the cubist collage. If, in spite of everything, it remains possible to associate these signs with one another, it is because their arbitrariness allows them to be grasped metaphorically—in the broad sense that the forms, along with their textures, can be *seen as* the analogical signs of other things from which they may be semiologically as different as possible, as in the case of the cut-out piece of newspaper read/seen as part of a guitar.[69] Bois brings out this point perfectly well. Emphasising the difference on this question between Picasso and Matisse, who seeks to 'identify himself' with his motif (according to one of the painter's expressions, whose meaning we will clarify below), Bois notes that, on the contrary,

> [i]t is not 'identification' that interests Picasso, but interpretation: whatever he paints, he has to see it as something else. [...] The metaphoric seeing-as is essential to Picasso's art [...] (it is the common denominator of all his practices [...]). [...] [T]he remarkable economy of Picasso's semiotic system issues from a conversion of metonymic signs (of fragments [...]) [...] into metaphor. [...] [F]ollowing certain combinatory rules, anything can be made into a sign for anything else.[70]

Or *almost* anything else.[71] It is metaphoricity that *transforms* forms into 'signs-forms'

68 The same association between the guitar and the newspaper obtains in *Guitar, Sheet Music and Wine Glass*.

69 To Françoise Gilot's question, Picasso responds: 'There's good reason [for incorporating diverse objects into my sculptures]. The material itself, the form and texture of those pieces, often gives me the key to the whole sculpture. [...]. My sculptures are plastic metaphors. It is the same principle as in painting. [...] a painting shouldn't be a *trompe-l'oeil* but a *trompe-l'esprit*. And the same goes for sculpture too.' (Gilot and Lake, *Life with Picasso*, 321). These incorporated objects, like the papiers collés already before them, therefore, do not function like Duchampian readymades, which exclude in principle all deliberate metaphoricity.

70 Y.-A. Bois, *Matisse and Picasso* (Paris: Flammarion, 1999), 27–8.

71 On the subject of these these paper cut-outs, Yve-Alain Bois declares that 'signs take on a life of their own, *almost* entirely disconnected from the identity of the object as a referent' (emphasis ours), adding that, '[a]s a result of this disconnection, the signs "migrate" in all

(and here we come back to Rancière's analysis).[72] The cubist 'collage' therefore does not simply give a 'foretaste' of a future moment when the painter will himself no longer paint,[73] the moment when, with Duchamp, it will 'purely and simply put an end to painting', as Aragon will have perceptively predicted;[74] it also announces something else that is to come, also in Duchamp: an internal identification of the functioning of the image via language—in his case, a constructivism of the signifier.

Picasso's papiers collés collages bring to the fore signs-forms whose different (or semiologically differential) combinations have to enable the resolution of equivocation (or even apparent a-signifiance)[75] by instigating (on this formal level as well as on a material level) the metaphorization of sense. This hyper-artificial metaphoricity can be understood as a deconstruction of the convention of the representation-form of traditional easel painting, which to some extent always dissimulates its artificiality beneath a certain iconic illusionism.[76] But this deconstruction itself is just the flipside of a re-construction that advertises its own artificiality. As Picasso declares on the subject of cubism: 'we abandoned colour, sensation, and everything [...] to search again for an architectonic basis in the composition, for an austerity that would be able to reinstate order', in opposition to Impressionism and Expressionism—adding that 'the papier collé was really the important thing [...]'.[77] In his late cubism, Picasso pushes the function of the metaphor to the point of the most abstract machinations. Nothing could be more foreign to Matisse than this metaphorization that is characteristic of signs-forms—or indeed the use of the literal signs-forms of things. For in *identifying* with the 'motif', whether real (like those of his studio) or imaginary, what Matisse seeks are not forms or deformations for themselves, but an interiorization-experience

kinds of directions, and Picasso can give free rein to his poetic manipulations and activate his metaphor of the guitar as head, and the head as guitar.' ('The Semiology of Cubism', 191. No doubt—yet Picasso cannot make a guitar into a metaphor for anything whatsoever, nor vice versa; any more than he can a bicycle saddle and pair of handlebars (which he makes into his celebrated bull's head).

72 See Volume 1, 'Preface: Diagrammatics of the Contemporary', 34–8.

73 François Gilot cites as one of Picasso's 'favourite aphorisms': 'If I telegraph one of my canvases to New York, any house-painter should be able to do it properly.' (Gilot and Lake, *Life with Picasso*, 221). The conceptual/conceptualist *fortune* of this remark need hardly be emphasised. A remark unimaginable coming from Matisse, although he too would call on a 'house painter' in the process that would lead him to the cut-outs.

74 L. Aragon, *Les Collages* [1965] (Paris: Hermann, 1980), 51

75 Picasso goes so far as to claim a quality of 'pure painting' for cubism (Gilot and Lake, *Life with Picasso*, 72, 76).

76 In an acute critique of Greenberg's modernism, Leo Steinberg demonstrates that all (non-academic) art has always sought to exhibit the *artifice* of its procedures, thus testing the limits of its competences (L. Steinberg, *Other Criteria: Confrontations with Twentieth-Century Art* [Oxford: Oxford University Press, 1975], 69–77).

77 Gilot and Lake, *Life with Picasso*, 75 [translation modified], 77.

of the (vital) forces that constitute this motif (in its heterogenesis) or animate it (in its constitutive heterogeneity). The painting will have to construct the sign-becoming of these forces, in processual relation with all other signs-forces.[78] In this sense, identification is *identification with the diagram* (as the most intensive explication of the sign's implication in the heterogeneous).[79]

Following a path other than abstraction (which takes its lead from cubism), Picasso's collage participates in the contemporary movement to escape the image-form of representation;[80] he even precipitates this movement, by abandoning both the iconic continuity upon which the logic of the image-form was (largely if not uniquely) founded, and the pictorial homogeneity with which the earlier period of so-called analytic cubism had not yet broken. And, like Matisse, but via other paths and with different motives, Picasso discovers the benefits of the disjunctive synthesis. For Matisse also operates a double deterritorialization of painting-painting (formalist and aestheticizing) and representational painting, but in a manner which, in our view, is more radical, in so far as it is based not on the heterogeneity of signs-forms but on a challenge to the formality of form itself, a challenge conveyed by the diagrammatic distribution of forces in the heterogeneity of signs. Rather than limiting his decorative assemblages to the heterogeneity of a collage that is merely internal to the painting (or, in Picasso, its opening out onto sculpture), in *Interior with Aubergines* Matisse incites himself to place *decorative* painting in direct relation to its outside, which amounts to an exit out of itself, in a critical process that is as intensive as it is extensive.

The decorative therefore means something different in Matisse than it does in Picasso. In Picasso's collages such as *Guitar, Sheet Music and Wine Glass*, the 'decorative' wallpaper has no privileged status in relation to the other elements, which are 'never used literally but always as an element displaced from its habitual meaning into another meaning to produce a shock between the usual definition at the point of departure and its new definition at the point of arrival'.[81] In reality, the wallpaper is as ambivalent as any of the borrowed materials. In the collage, Picasso plays with the distance

78 'The Matissean sign,' as we argue in *La Pensée-Matisse*, 'is construction (on the basis) of forces that it expresses and which affect it (*affectio*) as the immanent cause of its *intensity*' (333). Here we could mention Matisse's long work of identification with the *unraveling* of a snail, at the end of which the animal would have involuted from its drawn forms into the abstraction of a pure energetic field (*Snail*, 1952, cut-out, 286 × 287 cm) (ibid., 343–49).

79 A Deleuzian leitmotif if there ever was one: 'Signs involve heterogeneity...'—Deleuze, *Difference and Repetition*, tr. P. Patton (London: Bloomsbury, 2014), 22.

80 For only the epigones of Gleizes and Metzinger would desire to 'inscribe the *total Image*' in the cubist painting by mixing it with Bergsonian 'duration', cf. A. Gleizes, 'L'Art et ses représentants—Jean Metzinger', *Revue indépendante* 4 (September 1911) (italics in the original); J. Metzinger, 'Note sur la peinture', *Pan*, October–November 1910.

81 Gilot and Lake, *Life with Picasso*, 69.

between their literal (or normal) sense and their new, radically unprecedented sense.

This is obvious for the newspapers, the bottle labels, posters, and trimmings, the department store advertisements and graphic designs...their literality *degrades* the nobility of High Art through a mise-en-scène and a mise-en-abyme of the reality of the more trivial, not to mention commercial, arts. As for the wallpaper, similar to those which furnished many interiors of the time, the literal employment of its pattern in a 'painting' is also a gesture of defiance and derision in relation to the learned practices, refined effects, and traditional values of painting. 'Finally the "beautiful piece of painting" has been smashed', as Carl Einstein writes.[82] (If for his part Matisse admits a certain pictoriality in his *Interior with Aubergines*, it is, as we have seen, only on the critical condition that its materiality is deformed, and its effects constructively integrated into the decorative energetics of the work.) But at the same time, in Picasso (as opposed to Matisse's supposed decorative aestheticism) the bland commonplace taste of the wallpaper is ingeniously, contortedly reappropriated for the benefit of the 'painting', as a decorous 'ground' for the prosaic ambience of a still (anti-)life of the cubist studio (whose spectator—a reinterpreter of Picasso's 'interpretation'—must mentally reassemble it).[83] Both Matisse and Picasso devalue, but détourn for their own ends, the cliché of the decorative pattern and, more generally, the ennobling or valorising pretentions of the decorative—something that, for both of them, implies a challenge to pictoriality and iconicity. In Picasso this debasing of the decorative correlates with the adoption of readymade colours or the imitation of readymade colours (as in the case of the faux bois) in the glaringly artificial *papiers collés*. Rejecting the (pictorial) elevation of the decorative to the rank of High Art, Picasso operates a détournement or ludic recuperation of the decorative under the auspices of patterns whose 'bad taste' he places in the service of a popular tone that is not at all incognizant of their commercial seductions. By driving this movement to the point of its self-transcendence (Greenberg's term), he can ingeniously exploit the graphic, plastic, and chromatic properties of decorative patterns for the expression of textures and spatial tensions between planes (while maintaining their displaced reference to the external world). But by this very token, here the 'decorative' is merely sampled in the (reductive) form of patterns, only to see itself reinscribed into what is no more than a newly broadened conception of the painting[84]— whereas Matisse invests the decorative in a specifically energetic and generalised (not just 'plastic') mode that implies a radical challenge to the painting by way of its (*not just*

82 C. Einstein, *Georges Braque* [1934] (Brussels: La Part de l'oeil, 2003), 124.

83 Duchamp will replace this material and spatial heterogeneity with the heterogeneity of machinic relations upon a signifying base: see Volume 3, *Duchamp Looked At* (*From the Other Side*).

84 Here Greenberg rightly evokes 'the seamless fusion of the decorative with the plastic [...] in Picasso and Braque' ('The Collage', *Art and Culture*, 81).

physical but critical-diagrammatic) expansion into the environment. With Picasso's collage, then, representation is broadened and displaced, but this movement still remains internal to the painting-Form. The painting merely finds itself endowed with a new 'epistemological' function—the metaphorization of the world—that supposedly performs its *highest* modernity,[85] and sets out to both undo *and* remake representation (or even better, as T.J. Clark has it, to 'counterfeit' representation).[86]

<div align="center">*</div>

In *Interior with Aubergines* [see fig. 1, p.9] Matisse directly confronts the idea of the pattern when he superimposes over the freeform 'decorative' scrolls of the screen the panel of little flowered bouquets whose staggered distribution evokes immediately enough the *image* of industrial wallpaper (or fabric) with a repeating motif. Taken up in a subtle oscillation, however, this image is *undone* [*défaite*]—rather than counterfeited [*contrefaite*]—by the way in which it is invested by the diagram's factual *possibilities* [*possibilités de fait*]. The bouquets are animated by multiple little singularities, and seem to levitate across the panel. By coupling the reciprocal tensions of the two surfaces in question, Matisse plays on their maximal heterogeneity, multiplying tenfold the expansive force of the dispositif. Between the great blue-mauve foliage that presses and presages [*pressent(ent)*] the flowered panel from below and left, and the two divergent floral patterns above, the minibouquets act like sparks setting off a powerful explosion (without them, the screen's floral pattern would lose all of its vigour, which only plays out fully on the scale of the entire painting—and on the scale of relations of relations). The flowered wallpaper thus actively reinvigorates the tensions between the planes.

On the right, an uncertain landscape is enframed on three sides by a window which, from the interior of the painting, 'opens up' (onto) the exterior. Here, barely distinct elements with discontinuous rhythms and artificial colours are arranged in superimposed planes: the underside of a yellow bridge, a blue fence, the undulations of a hilly terrain, flat, bushy greenery alongside what may be red soil...not so much a 'landscape' as the pretext for a patchwork combining more or less globular patches (in its lower left corner) and homogeneous areas of colour. This singular assemblage, almost all of whose colours—red, brown, green—can also be found in the rest of the painting, allows Matisse to compare the various types of decorativity used on the interior of the

85 T.J. Clark has thus been able to show that nothing could be more prejudicial to the analysis of cubism than to ignore what he calls the 'metaphorical point: that high Cubist pictures give a metaphorical account—a florid, outlandish and ineradicably figural account—of what the pursuit of likeness now looks like, in a situation where all versions of such a pursuit have proved impossible to sustain.' T.J. Clark, *Farewell to an Idea: Episodes from a History of Modernism* (New Haven, CT and London: Yale University Press, 1999), 221.

86 Ibid., 218–19.

studio-painting to their bringing back into play in the question of the opening of the decorative onto the outside. Along with the flatness of the construction, the continuity between interior and exterior lends the landscape the feel of a tapestry filling the entire area of the window. Its almost abstract, fiercely antinaturalist aspect (the artificial *is not* something natural that has been solicited) drives its decorative diagrammatism toward a far stronger deterritorialization than that of the studio's interior. The conclusion to be drawn being that the decorative, if it is to be extended to the studio (to the environment), cannot take on the aspect of a studio painting. The highly visible geometrism of the various types of frames in the window constitutes, within the generalised decorative constructivism, another term articulated with the coupling of colour patches. The rectangular glazed frame of the left casement, opened back onto the brown ground, is cut into by elongated, regularly spaced patches that firmly hook the window frame into the plane of the painting. This frame supports and stabilises the staggered series of decorative planes on the diagonal of the painting, its opening to the right relaunching the decorative out to the exterior. The door panel visible above the screen, in the same cream tones as the window, is topped by an oblique beam that anchors these same planes to the left, with this tension between right and left inscribed in a minor key in the brown outline of a truncated pyramid traced into the door.

In the mirror diagonally opposite the window, the 'painting' enters into a mise en abyme, this time not in confrontation with the exterior, but by reflecting/being reflected from the interior. The blue flower on a brown ground on the left, and a section of the screen on the right, replicate in the mirror one of the principal dispositifs of the painting. It is therefore perhaps not inappropriate to mention here the role that Leonardo da Vinci sees the mirror as playing in relation to painting:

> I say that in painting you have to keep a flat mirror at hand and often look at your work in it; you will then see it inverted (*al contrario*) and it will seem as if it came from the hand of another master. Thus you can better judge its faults.[87]

As if another hand were reworking the painting—not so much manufacture as manu*tension* (a tense 'handling' indeed)—the mirror reshuffles the cards in every direction, producing a staggered decorativity that opens up a new, diagonal view into a chaotic pandemonium of planes and patches, objects and tangled locales that have become unknowable, *recognised* as unrecognisable. This dispositif of the mirror pushes yet further the formal and chromatic deterritorialization of the interior opened up by the window, which, although it assembled the same decorative components, did not directly oppose the interior to itself. The aubergines are no longer anything more than two or

87 Leonardo da Vinci, *Codex Atlanticus*, fol. 340 r°; cited in Damisch, *Fenêtre jaune cadmium*, 14.

three crude patches on a tablecloth that is now a plain fabric, and a vague crooked bright ochre patch takes the place of the statuette, while unexpectedly there rises up the tiled surface of a floor (or a drape like that seen through the door in the background) and a section of raw light from which stands out the reflection of the vase, which alone seems to have conserved its poise but has exchanged its reddish-grey for a dark yellow ochre—a colour echoing that of the flowered panel and serving as a relay for it, in its contrast at a distance with the dark blue of the hearth. As if he had thought, 'you can better judge...', here Matisse holds up to himself a mirror in which he tests out an even more chaosmotic setting-in-variation of the decorative, a true critical test for his painting wherein he assembles the relation between different modalities of the decorative into a kind of reflexive synthesis of Fauvism: flat areas of colour (the blue of the neighbouring hearth, the green of the drawing-board, the red of the tablecloth), rhythmic patches (breaks in the scrolls, anonymous aubergines), geometrical rhythms (the uncertain reflection of some tiles, the bars of the window, a ladder?) What he is testing out here is the idea that the different extensive modalities of colours are a function of the rigorously quantitative ordering of their intensities, to which the painting must be submitted. Thus, the large size of the blue plane of the hearth compensates for its weak luminosity, enabling it to stand its ground against the abundance of bright colours: it functions as a powerful reserve of pure intensive-colour-matter, reinforcing the large buttons of blue-violet five-petalled flowers spread all around. The yellow that heightens the tone of the table's feet joined by a strut with irregular openwork spurs on the dark brown ground (as if branding it with an hot iron). Sideswiping the tablecloth, the yellow of the mirror's frame seems to gush out of its red magma, drawing up the surrounding yellows and yellow ochres with a rectitude which, in conjunction with all the other rectilinear elements (bays, frames, beams, door, hearth...), tautens the plane of the painting and creates a *suspension* bridge between right and left. In contrast, it also overtensions the scrolls into which it cuts and which rear up against it; but the asymmetrical curves of its upper angles hold their own against to the scrolls of the screen, thus announcing that they possess *in themselves* the principle of their differentiation (*unframing* as diagrammatic truth of the mirror stage).

Abrupt leaps in scale, (false) 'perspectives' that cannot be coordinated with each other, colour clashes and combinations arbitrarily overlapping figures, discontinuities between different regimes of the decorative—these are so many indexes of a fierce indifference to any autonomous (figurative or figural) image effect, answering only to the mission of raising the decorative construction of the painting to its highest power. The play of colours is valued above all for the tensions it fabricates across the whole painting, not as a foil for their intrinsic, mimetic, or expressionist chromatic qualities. The eminently decorative plastic and chromatic weave (de)constituted into arabesques,

bands, and various rectangles, grids, folded surfaces, patches, and rhythmically ar-ranged marks, the 'objects' and their 'places': not one of them is painted for itself or for the benefit of a 'painting' that it would compose together with the others by pro-posing a *pictorial image*. The supposedly decorative or figurative 'motifs' are completely denat-uralised (indeed, 'demotivated') by their diagrammatic assemblage. They have an en-tirely relative value as signs-forms only in so far as they designate the habitat—first and foremost the environment of the painter—as a site for the expression of a decoration not meant to showcase or celebrate it by aestheticizing it—to adorn it, according to the traditional idea of the decorative—but to *vivify* it by animating it with incessantly re-newed rhythms, in an unbridled constructivism. These signs-forms are therefore relayed into signs-forces that are the immanent expression of the aesthesic energetics stimu-lated in the spectator by their chaosmotic yet orderly ('organised', as Matisse says) construction. This is why the painting's abstract vegetalism and, more generally, its entire decorative processuality, is not at all some kind of purely formal or descriptive affair. Here abstraction does not mean painting taking itself as object by abstracting itself from figuration.[88] The painting may not be 'structured' as an image at all, but nei-ther can it be reduced to a pure 'hedonistic' play of colours for colours' sake; and as for form, figurative and/or figural-abstract, it gives way to colours-forces in constant *vital confrontation*, which *push back* forms and, like *tensors, push beyond the painting*. Ab-straction is intrinsic to the machinism that works (in) what is not-yet painting and (into) the beyond of painting, and works from one painting to the other, on the basis of the defenestration of the Painting-Form that they operate wherever it is constructively brought into play. A non-formal yet real abstraction of the ontological reality of vital forces which each of Matisse's paintings reassembles in a singular fashion, in so far as each one operates an intensive deterritorialization of painting's matter and form of ex-pression—via the de-motivation of motifs and the (tendency toward the) de-pictoriali-zation of colour—and its content—via the détournement of the allegorical description of an artist's studio into an implementation of Matisse's decorative project. So that there is no longer any distinction between form of expression, or better, traits of inten-sive expression, and form (or traits) of content: on this diagrammatic plane, both are equally *falsified and forced* [*faussées, forcées*]. The differential tensivity that

88 In our view, Matisse's force consists precisely in his *subtraction* from the dilemma in which he supposedly finds himself, defined by Fourcade in relation to this painting as follows: '*In-terior with Aubergines* [...] and with it practically the entire oeuvre of Matisse, is located at the crossroads of the paths of art in so far as it is a meeting of an ancient preoccupation—to paint a still life—and a new one—to distance oneself from the traditional subject and in-stead take as one's subject (as has been said a hundred times) painting itself. What is prop-erly characteristic of Matisse is his endless pursuit of this confrontation' ('Rêver à trois au-bergines', 480).

singularises and animates matters is as one with their decorative destination—nothing more or less than the vivifying placing-in-tension of the painting in such a way that it *extends itself* into the surrounding space[89]—rendering problematic the question of the frame and, beyond it, that of easel painting.

Now, what do we find painted near the top left corner of this interior if not, precisely, an empty yellow and ochre *frame* through which we see the brown-black ground and which, since it has only three visible sides, remains open to the exterior. It contains, comprises, or cuts into some of the crude blue periwinkle florets that constellate the surrounding space, as if they were resisting being 'framed' in it, bouncing off it and overflowing it on all sides. On the inside of this frame is another smaller, closed frame, empty of any motif, purely suspended over the ground (something we often see in Matisse). In this zone Matisse therefore problematizes the limits of the painting and its opening toward the exterior in relation to the question of the frame. The twofold dispositif to which he submits the frame literally 'voids' the painting of anything other than a mural decoration that will either overflow the frame or disregard it entirely, positing itself as the only true (or desirable) object of painting—which implies a categorical refusal of any painting that is not purely decorative.[90] But by staging its unframing by the decorative, isn't this easel painting compelled to negate itself as such?

And indeed here a kind of coup de grace is delivered to the easel-painting form from its very interior, precisely by the large pattern of five-petalled periwinkle florets crudely painted with a pivoting touch and somewhat unequally aligned all around. They boast the following peculiarity: attached to no particular support, floating like a flimsy veil on the common ground of the brown-black wall and the brown-red floor (themselves confused with the plane of the painting), they have no real relation of scale except with the size of the painting itself. So the painting becomes the pure field of their deployment—except that they claim to escape from it. They are the endpoint of the successive processes of deterritorialization that depropriate the painting of any assignable object, and even seem to depropriate the painting itself. They confer upon it the strongest power of irradiation, since their discharges of energy generalise and liberate all the others. As if they took the smallest decorative 'motif' of the painting—the tiny flowers of the wallpaper, also five-petalled—to a maximum of expansion (in the sense

89 On Matisse's conception of the decorative, see more specifically here Alliez and Bonne, *La Pensée-Matisse*, 70–73.

90 No doubt as a way for Matisse to extend or relaunch the expansion of the painting, the canvas was mounted successively in two large false frames painted with five-petalled flowers (like those in the painting but with a different chromatic relation to the ground). These true false frames, which are not unique to Matisse but clearly attest to the direction in which his painting is going, can only have been discarded by the artist himself, probably because of their ambiguity (on these frames see Fourcade, 'Rêver à trois aubergines', 471–4).

that we speak of a universe in expansion). They reverberate and radiate in all directions in the painting and from the painting to its outside, in advance of the viewer. The *all-over* expansion, at once centrifugal and acentric, 'internal' to the painting, is also an *all-around* expansion.

Such expansiveness cannot be assimilated to the 'demythified, secularised' auratic function that Walter Benjamin attributes to the ornamental: 'What designates the authentic aura [is] the ornament, the ornamental inclusion in the circle where the thing or the being finds itself closely enclosed in a case' (he cites the late canvases of Van Gogh as an example). [91] This is a conception that Georges Didi-Huberman describes as 'radically modern, materialist, and formalist (and therefore radically antispiritualist)'[92] but which, for our part, we would describe as typically modernist. Of course, we are told that this 'auratic dimension supposes a certain power of the object as such' and 'is always accompanied by an almost cinematographic movement and metamorphosis of its qualities'. Yet it is inherent to a 'conception of aesthetics articulated upon the phenomenon of the *intoxication of forms*' and the movement with which it is associated, 'constricted on its *Urphänomen*', is 'a centripetal, voracious, focalising *mass* movement, a wide-angle movement considered as a gulf of the gaze'[93]—as opposed to the direction in which Matisse is working.

Interior with Aubergines thus establishes that a practice of painting which, while not properly mural, seeks to entertain a real relation and continuity with the wall upon which the painting is hung, must necessarily be decorative—and must ultimately become mural in virtue of its *machining* murality, as this painting suggests, in a dispositif whose complexity undoes the conditions of possibility of the easel painting. For by deframing every viewpoint on and every staging of an 'interior', it induces painting to break with its own interiority—something that, for Matisse, was a preliminary to and a condition for the wholesale exit from easel painting and the passage to architectural painting. Here perception is recruited as the deterritorialized agent of colours-forces brought into play and placed into tension in an 'interior' that describes nothing, tells us nothing, that does not take any form (even in an '*altered constriction* of resemblance' demonstrating 'the indefectible interlacing of *formation* in *deformation*'),[94] but instead captures and ex-poses the *becoming-intense of a multiplicity composed of heterogeneous elements whose relations construct a being of sensation without either reducing or formalising the elements thus placed in tension*. Its duration is no longer extensive (a distribution of

91 Cited in G. Didi-Huberman, *Quand les images prennent position, L'oeil de l'histoire, 1* (Paris: Minuit, 2009), 225.

92 Ibid.

93 Ibid., 225, 226.

94 G. Didi-Huberman, *Devant l'image* (Paris: Minuit, 1990), 184.

objects 'telling the story' of a life in an interior), it is entirely and intensively processual: a diagrammatization of all the forces that explode the Painting-Form. The generalised tensivity of the space thus opened up to the expressive matter of *duration* and to its plastic condition of real experience, results from its appropriation by the processuality of a vital energetics that replaces an aesthetics of composed/decomposed—but *constricted*—forms within a space (a space reserved for the *work* of Art). Matisse: 'For me, a color is a force. My pictures are made up of four or five colors that collide with one another, and the collision gives a sense of energy.'[95]

<p style="text-align:center">*</p>

For Matisse, everything began with Fauve painting (1905–1906), of which he declares himself to have been the origin ('truly, I was the first'),[96] and of which he will say much later (in 1949): 'It was not everything, but it was the foundation of everything.'[97] The break with the easel-Form of painting and with its forms of historicity, which we have just seen at work in *Interior with Aubergines*, was only made possible for Matisse by the discovery he associated with Fauvism—namely, that painting is about the *construction* of colours in relations of forces whose *expressive* power is intrinsically vital—vital or vitalist. So Matisse is not, as has sometimes been thought, concerned with liberating colour from its formal or iconic conventions and its traditional symbolic associations so as to affirm its purely pictorial expression (that 'absolute of colour' which, via its 'pure opticality', will lead to modernist formalism), but with liberating painting from the pictoriality of colour so that its processuality converges with the expressive-intensive construction of a vital energy.[98] ('Fauve painting is not everything, but it is the

95 Matisse to Pierre Courthion, *Chatting with Henri Matisse*, 143.

96 In the letter to his daughter of 17 July 1929, cited in the epigraph, in which he mixes his 'I' with a more collective 'we' (and cites Derain): 'We were worked by new needs', 'the conversations on new means' (Archives Matisse).

97 It is on this phrase that Matisse's preface, meant for Georges Duthuit's book *The Fauvist Painters*, opens (G. Duthuit, *The Fauvist Painters* [New York: Wittenborn, Schultz, 1950]; *Les Fauves* [Geneva: Éditions des Trois Collines, 1949]). The preface was not included in the book, but extracts were published in the advance notice for the book, as recalled by Rémi Labrusse in his critical edition *Les Fauves* (Paris: Éditions Michalon, 2006), xxix. For the cover of the original edition Matisse made a maquette in gouached cut-out paper of the letters 'Les Fauves' (the cover was to be silkscreen printed by hand). Could he have indicated any more clearly the debt to Fauvism—a *permanent Fauvism*—even *in* the cut-outs? Besides, as he states in his preface: 'It is the same man who lives and acts today, his aspirations transformed, but emerging from the same depths.'

98 We write in *La Pensée-Matisse*: 'If in fauvism colour is a question of *force*, it is irreducible to the process of the *liberation of colour* underway in modern art, roughly since Impressionism—a liberation understood by a certain modernist formalism as the 'natural' vector of *the autonomy of the pictorial*.' And we show 'that to inscribe fauvism into this perspective, so entirely marked-out in advance, rather than liberating colour, leads to a certain subjection of

foundation of everything: *it is energy*', writes Matisse at the beginning of his preface to Georges Duthuit's *Fauvist Painters*.)[99] In a 1901 letter to Vlaminck, Derain, who would stay with Matisse in Collioure during the Fauve summer of 1905, suggests what is at stake here, as yet inchoate: 'I believe that lines and colours have *relations whose parallelism to the vital foundation is powerful enough to allow one to glimpse their reciprocal and infinite existence....*'[100] So much so that 'the canvas became a crucible for making living things'[101]—with the result that the scandalous room VII—the 'cage aux Fauves'— would be exalted as the 'centre of life' of the 1905 Salon d'Automne.[102] In 1908, taking stock of Fauvism in his 'Notes of a Painter', Matisse makes a profession of vitalist faith that resonates with the ideas that Henri Bergson was developing during the same period, and which certainly played a part in stimulating the painter's thinking.[103] In this text, having declared 'What I am after, above all, is expression', Matisse immediately forestalls a misunderstanding by adding that the 'thought of a painter must not be considered as separate from his pictorial means'. He therefore puts forward the following proposition: 'I am unable to distinguish between the feeling of life and my way of translating it.'[104] In accordance with this principle of the immanence of expression to means, Matisse goes on to explain that he does not render this feeling of life in his paintings through recourse to *living* psychological expressions (such as 'passion'), nor by adopting expressive

colour; and that Matisse precisely freed *them*—yes, colours *plural*, and not *colour*—from their assignment to the pure pictorial' of which abstraction would be the obligatory vector (23). It is moreover interesting to note that Georges Duthuit would refuse Robert Motherwell's preface for the American edition of *The Fauvist Painters* because Motherwell 'is so committed to abstraction'. He adds: 'If he writes something for the beginnning of my, of our work, it will certainly be to say that everything that happened in the Fauvist moment served only to lead to cubism, and from there to Mondrian [...]'. The planned preface was reduced to a long note, in which nonetheless one can indeed read: 'Fauvism represents that aspect of Henri Matisse's work in which he began [...] to move toward abstraction' (cited by Labrusse, *Les Fauves*, xxxii–xxxiii).

99 Ibid., xxix.

100 Derain, letter to Vlaminck from the end of 1901 (dated 24 [september 1901?]). Cf. letter 6 in A. Derain, *Lettres à Vlaminck*, ed. P. Dagen (Paris: Flammarion, 1994), 52, emphasis ours.

101 According to Derain's words, reported by Georges Duthuit, 'Le fauvisme' (*Les Cahiers d'art*, 1929–1931), reprinted in G. Duthuit, *Représentation et présence. Premiers écrits et travaux 1923–1952* (Paris: Flammarion, 1974), 213.

102 Michel Puy, 'Les fauves', *La Phalange*, November 15, 1905; reprinted in *Pour ou contre le fauvisme*, ed. P. Dagen (Paris: Éditions d'art Somogy, 1994), 148.

103 If we are to believe a declaration from 1944, Matisse was continually reading Bergson: 'I passed the day reading Bergson, something I have always done imperfectly at home, attracted by the drawings and paintings around me' (H. Matisse, letter to Camoin, September 1944, cited in C. Grammont, 'Les yeux fermés—Henri Matisse et les dessins en aveugle', in *Une fête en Cimmérie. Représentation du visage dans l'oeuvre de Matisse*, exhibition catalogue [Musée Matisse de Nice, RMN/Mairie de Nice, 2003], 17n.29.)

104 H. Matisse, 'Notes of a Painter, 1908', in Flam (ed.), *Matisse on Art*, 30–43: 38 [translation modified] [EPA, 42].

38

gestures (such as 'a violent movement')[105] (thus confirming that Fauvist expressivity is not to be confused with Expressionism, even if it contributed to the latter).[106] He then sets out his conception in full:

> The entire arrangement of my picture is expressive: the place occupied by the figures, the empty spaces around them, the proportions, everything has its share. Composition is the art of arranging in a decorative manner the diverse elements at the painter's command to express his feelings.[107]

Interior with Aubergines is indeed quite an exemplary case of this Matissean equation expression=construction=decoration.[108] Because the construction-expression must be decorative—that is to say, it must be intrinsically linked to 'the surface to be covered' (a surface that will become mural in the Barnes Foundation *Dance*)—it 'will have a necessary relationship to its format' (which is why it cannot be mechanically enlarged by squaring).[109] This decorative relation to the support—and through it to an outside immanent to painting—is imperative, because 'drawing [evoked here as an example of "composition, the aim of which should be expression"] must have *an expansive force which vivifies the things around it*'.[110] A precocious and all-important formulation of a discovery linked to the Fauvist vitalism that, in Matisse, presides over the opening up of painting to an outside that will compel it to make itself environmental. Quite logically, then, when he handles colours subsequently he will do so in a way that allows him to distance himself from the outset from their merely aesthetic employment 'to obtain [...], by using their kinship or contrast, agreeable effects'—an anticipative rejection of the hedonism of the medium that Greenberg will impute to him. In the same movement, he refuses to limit his painting to 'record[ing] the fugitive sensations of a moment...' as the Impressionists do, because 'a rapid rendering of the landscape represents only one moment of its *duration*'.[111] In this mention of duration we find a first point of articulation between Matisse and Bergson.

105 'Expression, for me, does not reside in passions glowing in a human face or manifested by violent movement' (Ibid., 38 [EPA, 42]).

106 The exhibition 'Le fauvisme ou « l'épreuve du feu ». Éruption de la modernité en Europe', Musée d'art moderne de la Ville de Paris (29 October 1999–27 February 2000) participated in this confusion (exhibition catalogue, Paris: Éditions Paris musées, 1999).

107 Matisse, 'Notes of a Painter, 1908', 38 [EPA, 43].

108 'Expression and decoration are one and the same thing.' Letter from Matisse to his daughter Marguerite Duthuit, November 29, 1943 (EPA, 308). This can only be understood as an affirmation of the identity between expression and construction (on this point, see Alliez and Bonne, *La Pensée-Matisse*, 65–73).

109 Matisse, 'Notes of a Painter, 1908' 38 [EPA, 43].

110 Ibid [translation modified].

111 Ibid., 36 [EPA 43, 45] (emphasis ours) [translation modified].

Recall that, at the very moment when Matisse, along with Derain and Vlaminck, affirms the vitalist difference of Fauvism, in a chromatic dynamiting of forms that leaves intact only the '*basically vital parallelism*' of lines and colours, Bergson, in his courses at the Collège de France, the object of growing public infatuation during the period 1904–1905, is addressing certain properly philosophical questions that he will develop in *Creative Evolution* (1907). Apart from the interaction between the 'method of *intuition*' and the 'method of *construction*', and an analysis of the notion of 'force' (via a critical commentary on Herbert Spencer's *First Principles*), in these courses the central issue to be tackled in *Creative Evolution* becomes ever more clearly discernible: life, particularly in its relation to the will and the question of freedom.[112] This treatise on Bergsonian method that was to 'permit a glimpse, on some essential points, of the possibility of its application'[113] followed *Matter and Memory* (1896), in which the philosopher had developed a 'metaphysics of matter' that revealed to its readers, 'pervading concrete extensity, *modifications, perturbations*, changes of *tension* or *energy* and nothing else'.[114] A method of immanence opposed to all 'division of matter into independent bodies with absolutely determined outlines'.[115] (At this point we must grant Léon Vauxcelles's charge against Matisse: 'You tell us that painting [...] must *resolutely distance itself from the object*. No, a thousand times no; all the great masters, from El Greco to Manet, from Poussin to Cézanne to Van Gogh, your patrons, have tried to represent the object.')[116] Setting out from a '*pure* experience, which is neither subjective nor objective',[117] from a *duration* which in *Creative Evolution* will become the continual creation of novelty, but also from that *sensation of becoming* that he ceaselessly promoted and which, as he said early on, is no longer that of our 'organised small body (organised precisely with a view to immediate action)' but that of 'our huge inorganic body' ('the site of our

112 The 1904–1905 course on 'Modern Philosophy' was entitled 'Evolution of the Problem of Freedom'. We follow the presentation of the course in H. Bergson, *Mélanges* (Paris: PUF, 1972), 648–9.

113 H. Bergson, *Creative Evolution*, tr. A. Mitchell (New York: The Modern Library, 1944), xxiv. This is doubtless not unconnected to the book's immediate success, which 'considerably surpassed the narrow circle of philosophers, invading the press at large and the public at large', as Albert Thibaudet reports in his 1923 *Le Bergsonisme*, cited by F. Azouvi, *La Gloire de Bergson. Essai sur le magistère philosophique* (Paris: Gallimard, 2007), 136. 'From 1907–1908,' he states, 'The influence of *Creative Evolution* made itself known in extra-academic spheres' (141).

114 H. Bergson, *Matter and Memory*, tr. N.M. Paul and W. Scott Palmer (New York: Zone, 1991), 201 (all italics are Bergson's unless otherwise stated). 'Matter thus resolves itself into numberless vibrations, all linked together in uninterrupted continuity, all bound up with each other, and traveling in every direction like shivers through an immense body' (208).

115 Bergson, *Matter and Memory*, 196.

116 L. Vauxcelles, 'Le Salon d'Automne', *Gil Blas*, 30 September 1905; reprinted in *Pour ou contre le fauvisme*, 108–9 (emphasis ours).

117 H. Bergson, Letter to William James, 20 July 1905 (reprinted in Bergson, *Mélanges*, 660).

potential or theoretically possible actions'),[118] Bergson profoundly renews the vitalist current's *consciousness of being* by letting himself be guided by an *intuition*[119] that leads into 'the very interior of life', toward one and the same activity grasped from different directions by material and spiritual energy. It is a question here of differences of tension on the ground of the univocity of being as moving, living continuity: 'Life and consciousness, two terms probably coextensive with each other in our universe';[120] 'life, that is to say consciousness launched into matter', as we read in *Creative Evolution*.[121]

Refusing the 'dilemma that a thing either is or is not extended', [122] in *Matter and Memory* Bergson had come to recognise that it is differences in tension—that is to say, differences in the quantity of successively contracted disturbances of matter—that determine the differences of quality between our sensations and set the rhythm for the continuity-in-motion of our duration.[123] Here the intuition of the philosopher who posits that 'the interval between quantity to quality' might 'be lessened by considerations of *tension*'[124] converges remarkably with the constant intuition of the painter for whom *it is the difference in the quantity of colours that yields their intensive and extensive qualities*. In a formula which, in our view, constitutes his most technically precise definition of Fauvism, Matisse unshrinkingly affirms: 'At the time of the Fauves, what created the *strict organization of our works was that the quantity of colour was its quality*'[125]—a principle he constantly upheld and which confirms that his vital-vitalist constructivism is as far as can be from the anarchistic cliché of Fauvism.

118 As Bergson will posit in *The Two Sources of Morality and Religion* (1932), tr. R. Ashley Audra and C. Brereton (London: MacMillan, 1935), 222.

119 It is in the 'Introduction to Metaphysics' published in 1903 in the *Revue de la métaphysique et de morale* that Bergson introduces the term *intuition*. As Azouvi recalls, 'few of his texts have had met with such response, and in so many diverse milieus' (Azouvi, *La Gloire de Bergson*, 102).

120 Bergson, in an open letter to Léon Brunschwicg, 25 February 1903 (*Mélanges*, 585).

121 Bergson, *Creative Evolution*, 199.

122 Bergson, *Matter and Memory*, 53.

123 'Differences of quantity' (real movements) are 'quality itself, vibrating, so to speak, internally [i.e. in duration] and beating time for its own existence thorugh an often incalculable number of moments.' Ibid., 202.

124 Ibid., 183. Bergson comes back many times to 'the relation between quantity and quality' (Ibid., 182–7 passim, 318–40), appealing to both science and the testimony of psychology.

125 H. Matisse,'Statements to Tériade: On Fauvism and Color, 1929', in Flam (ed.), *Matisse on Art*, 83–87: 85 [*EPA*, 98] (italics ours). On the quantitative foundation of the qualitative and the relations between the intensive and extensive in Matisse, see *La Pensée-Matisse*, 75–84 and, in English, 'Matisse-Thought and the Strict Quantitative Ordering of Fauvism', tr. R. Mackay, in R. Mackay (ed.), *Collapse* vol. 3 (Falmouth: Urbanomic, 2012), 206–29.

Oriented toward creativity as the élan vital of difference inasmuch as it passes to the act,[126] 'life in depth', according to Bergson, 'designates what art makes us feel at times and what philosophy (the true one!) should make us feel at all times'.[127] For isn't it '[t]he intention of life, the simple movement that runs through the lines, that binds them together and gives them significance [...] [that] the artist tries to regain, in placing himself back within the object by a kind of sympathy, in breaking down, by an effort of intuition, the barrier that space puts up between him and his model'?[128] To the very letter, this last statement could have come from Matisse himself. And reciprocally, Matisse's formula and above all the movement it describes—'firstly form, then life; here form no longer counts'[129]—responds literally and intimately to the movement of Bergson's thought, inviting us to pass from the intelligence that sees the real according to 'a stable view which we call a form' to the intuition of the 'fluid continuity' of life for which 'there is no form, since form is immobile and the reality is movement'. Thus one must say of living things that 'the very permanence of their form is only the outline of a movement'.[130] It is this movement that Matisse invests, in an energetic leap that liberates him from the 'historical' limits of Bergsonism's relation to art. For, with a certain resonance with a 'fin de siècle aesthetic' combining Impressionist mobility with Symbolist ideality, Bergson himself, who appreciated Rembrandt,[131] Corot, and Turner above all,[132] but declared that he held Jacques-Émile Blanche to be the greatest living painter,[133] knew nothing of the cubists and disapproved of 'revolutionary forms in art'.[134] And indeed one can imagine how, by dint of oscillating between mechanism and finalism, his 'technical' conception of the 'exigencies of matter upon which [the artist] operates' and which do not concern 'creation itself'[135] (even though they are involved in its means...) would have

126 Deleuze's definitive formulation in the 1956 article 'Bergson, 1859–1941': 'Élan vital is difference inasmuch as it passes to the act'. Reprinted in G. Deleuze, Desert Islands and Other Texts 1953–74 (Los Angeles: Semiotext(e), 2004), 22–31: 28.

127 Letter from Bergson to Lionel Dauriac, 19 March 1913 (Mélanges, 990).

128 Bergson, Creative Evolution, 194.

129 Matisse to Georges Duthuit (31 August 1927), cited in Georges Duthuit, Écrits sur Matisse (Paris: Rémi Labrusse, 1992), 284.

130 Bergson, Creative Evolution 328, 142 (emphasis ours).

131 See M. Verne, 'Un jour de pluie chez M. Bergson', L'Intransigent, 26 November 1911.

132 Both are mentioned in 'The Perception of Change', H. Bergson, The Creative Mind, tr. M. L. Andison (New York: Dover, 2007), 138–51.

133 I. Benrubi, Souvenirs sur Henri Bergson (Paris and Neuchâtel: Delachaux and Niestlé, 1942), 88.

134 Villanova, 'Celui qui ignore les cubistes', L'Éclair, 29 June 1913.

135 Something Bergson argues in the 1920s in 'The Possible and the Real', The Creative Mind, 96–112. He confesses however that he did not have enough time to 'document' the problems of aesthetics as he would have wished, even divulging, with a laugh: 'If I come back to earth

prevented him from practically raising his aesthetic intuition to the level of philosophical intuition. For him, the fixation of individual-artistic forms, i.e. their actualisation, signifies the interruption (=fall) of the generative action of the forces of élan vital.[136] The created can never live up to the vital exigency of creation, the vital from which it proceeded 'before its dispersal into images'; but 'art bears upon images',[137] and painting's exemplary status owes precisely to the fact that, with the internal perception of the artist, it reanimates *the imitative function* and enables it to fulfil its 'highest ambition' by detaching it from the 'needs of practical life'.[138] At which point we touch, in turn, upon the 'Nietzschean' affirmation of Fauvism,[139] which would reverse the terms of the problem, but would also offer the thought of the Great Noon a powerful alternative to the antagonism between romanticism and classicism. For it will be a matter of displacing this *imaginative-imitative* necessity by demarcating oneself from the 'idealist' dimension of the metaphysical horizon of Bergsonism, which remains attached to 'a certain immateriality of life',[140] so that the creative force (re)invents *plastic art* as its *most material* transformation in the constitutive processuality of construction. But even though Bergson continues to come up against this necessity, and can conceive of no definitive way out of it except through music (the most immaterial and the least *fabricated*, the most dynamic and the least

again, I would certainly deal with them.' Cf. I. Benrubi, 'Un entretien avec Bergson', 19 December 1934, in *Essais et témoignages inédits* (Neuchâtel: La Baconnière, 1941), 368.

136 'It is true that this aesthetic intuition, like external perception, only attains the individual' (Bergson, *Creative Evolution*, 194). It is the preserve of the 'mystic' to extract creation from the human, all too human limits of the world by making it coincide with the overabundance of life of the creative principle raised to the *universal*', cf. Bergson, *The Two Sources of Morality and Religion*.

137 Letter to H. Höffding, 15 March 1915 (republished in *Mélanges*, 1148). In this letter Bergson defends himself against the notion that he identifies philosophy with art, asserting that 'philosophical intuition, after being engaged in the same direction as artistic intuition, goes much further: it takes the vital before its dispersal into images, whereas art bears upon images.'

138 But it would be asking too much of nature to project a complete detachment.... For '[w]ere this detachment complete, did the soul no longer cleave to action by any of its perceptions, it would be the soul of an artist such as the world has never yet seen'. H. Bergson, *Laughter*, tr. C. Brereton and F. Rothwell (New York: Dover, 2005), 76. See also, once again, 'The Perception of Change' (*The Creative Mind*, 138–69), 144: '[N]owhere is the function of the artist shown as clearly as in that art which gives the most important place to imitation, I mean painting'. For 'the loftiest ambition of art [...] consists in revealing to us nature' (*Laughter*, 76).

139 We reconstruct its historical genesis in *La Pensée-Matisse*, 50–56.

140 Bergson, *Laughter*, 77. It follows from Bergsonian intuition as such, entirely founded on the reality of *interior life*, that one must begin by identifying the 'material' necessities of our practical life in order to reinstate its *metaphysical* sense.

imitative, the most 'temporal' and 'disinterested' of the arts),[141] he nonetheless thinks artistic creation as a *becoming* that brings 'sympathy' with matter (the lowest degree) together with an 'intuition in duration' of its highest exigency. We might adduce as proof, unpicking it like those auditors and readers who delighted in 'bringing the philosophers words together with the works of painters that he himself would probably not have admitted into his aesthetic',[142] the following passage from *Creative Evolution*:

> The finished portrait is explained by the features of the model, by the nature of the artist, by the colors spread out on the palette; but, even with the knowledge of what explains it, no one, not even the artist, could have foreseen exactly what the portrait would be, for to predict it would have been to produce it before it was produced, an absurd hypothesis which is its own refutation.[143]

Matisse would not disagree:

> A work of art is never made in advance, contrary to the ideas of Puvis de Chavannes, who claimed that one could not ever visualize the picture one wanted to paint too completely before starting. There is no separation between the thought and the creative act.[144]

Related to its processual-material conditions of 'production' by the constructed discharge of vital energy inherent to its chromatic means, this is the *primary* reason why Fauvism oversteps the Painting-Form, in a critique in act of the Art-Form (identified with an art of Form cut off from Life, or only authorising a relation to this Life by way of formal mediations). Spurred on by what we call *Matisse-Thought*, it participates in a *Nietzschean Bergsonism* (the Nietzschean wasp and the Bergsonian orchid) that

141 Something that did not escape Albert Thibaudet's attention: 'If M. Bergson were one day to formulate [his aesthetics], it would probably be an aesthetics of the musician' (A. Thibaudet, *Le Bergsonisme* [Paris: Gallimard, 1923], vol. 2, 59). Bergson would go as far as to declare in 1912 in an interview that the most remarkable French writer of his times was Maurice Barrès, because he was 'less a novelist than a musician of words'. H. Bernstein, *With Master Minds* (New York: Universal Series, 1913), 100.

142 Including Georges Duthuit, from whom we borrow this citation (in 'Le Fauvisme', 222). He continues: 'The Fauves, in their own way […]'.

143 Bergson, *Creative Evolution*, 9.

144 Response to a question from André Verdet (*Prestiges de Matisse*), EPA, 47n.11. 'Interview with André Verdet, 1952', in Flam (ed.), *Matisse on Art*, 201–217: 211. 'Notes on drawings from the series *Thèmes et variations*' (1942): 'My route had nothing foreseen in advance: I was led, I did not lead. I always go from a point of the object of my model to another point which I always see uniquely alone, independently of the other points towards which my pen will subsequently be directed. Isn't it that I am solely directed by an interior élan that I translate as its formation proceeds rather than from the exterior that my eyes fix […] by inventing my route in order to arrive at it. A route so interesting, isn't it the most interesting, of action?' (EPA, 164).

incites the signs-forces of art to expand into life—and vice versa.[145] Precisely that vitalist de-formation of Art that Nietzsche calls *aesthetic physiology*[146] or 'Physiology of art',[147] and which we are now *forced* to posit at the origin of the Bergsonian idea according to which *every vitally experienced feeling will, in its free development, take on an aesthetic character.*[148] This 'aesthetic character' will be radicalised in its aesthesic difference from 'normal perception' and projected beyond the *aesthetic closure*[149] by its excess over the beauty of form[150] and the indefinite 'enlargement' of its object in an inseparably *problematizing, differenciating, and temporalizing-processual* perspective that attests to the *sub specie durationis* power of the 'in-the-making' as opposed to the theatre of the 'ready made' (*sub specie theatri*).[151] This also explains why, in Matisse, the sign does not preexist qua sign-force, since it is a function of its relations of force with all other signs; considered outside of its conditions of action, it is no longer any more than a sign-form.[152]

(In truth, the full development of this conception, as we will verify below, passes via Matisse's American *experience/experiment* at the beginning of the 1930s and the Barnes Foundation *Dance* mural, in its great resonance with John Dewey's book-manifesto

145 Reserving its possibility of realisation for philosophy (*his* philosophy), Bergson wrote: 'But one can conceive an inquiry turned in the same direction as art, which would take life *in general* for its object [...]' (*Creative Evolution*, 194). Further confirmation that 'it is indeed one of the direct effects of *Creative Evolution* that it imposes this affinity [Bergson-Nietzsche] as self-evident' (Azouvi, *La Gloire de Bergson*, 173).

146 The 'domain so unexplored and obscure [...] of *Aesthetic Physiology*' appears in *Genealogy of Morals*, third dissertation, §8. Note that Julius Meier-Graefe, in his article on 'Matisse and the end of impressionism' (1923), likened the 'pictorial elements' of *Bonheur de vivre* (1906) to mere 'physiological stimuli', testifying to the loss of the historical/aesthetic sense of the tradition, a loss linked to the 'perception associated with the large city' (according to Wright, 'Arche-tectures', 60).

147 Cf. F. Nietzsche, *Will to Power*, third book, IV ('For a physiology of art'), §361: 'Art makes us think of states of animal vigour [...] through images and the desires of intensified life; —it is an over-heightening of the feeling of life, a stimulant to life.'

148 'So that'—Bergson clarifies further on the same page—'the feeling of the beautiful is no specific feeling' (Bergson, *Time and Free Will*, tr. F.K. Pogson (New York: Dover, 2001), 41.

149 Mark Antkliff has made an initial approach to this question, on a strictly Bergsonian basis, in his article 'The Rhythms of Duration: Bergson and the Art of Matisse', in J. Mullarkey (ed.), *The New Bergson* (Manchester: Manchester University Press, 1999), 184–208.

150 See once again Nietzsche, *Will to Power*, third book, IV, §374 for the denunciation of 'artists of decadence, who are in sum *nihilists* in the face of life, (and) flee into the *beauty of form*'.

151 Bergson uses this expression in *Laughter*, 54.

152 '[...] [I]n a composition the object becomes a new sign that is part of the whole *while retaining its own force*. In a word, each work is a collection of signs invented during the picture's execution to suit the needs of their position. Taken out of the composition for which they were created, these signs have no further use.' (H. Matisse, 'Testimonial, 1951', in Flam (ed.), *Matisse on Art*, 207–9: 208–9 [translation modified]. This 'Testimonial' collects together comments recorded by Mario Luz, published in *XXe siècle*, January 1952 [EPA, 248]).

Art as Experience, published in 1934.[153] The Matisse-Dewey encounter displaces and intensifies, on the plane of art, this confluence between Bergsonism, Nietzscheanism, and pragmatism instigated by *Creative Evolution*, the publication of which was warmly welcomed by William James.[154] We might also see it as taking up the baton, on a more *experiential/experimental* plane, from that work of which there apparently remains no trace but which, in May 1912—during an interview with the American journalist Herman Bernstein—Bergson claims to be writing, a work that 'will address ethics and aesthetics, the principles of morality and those of art'. He goes on to mention a work of Dewey's on ethics, which he finds 'very interesting, very original, and quite new'.)[155]

What we find here, modified by the 'thinking of a painter' that could not have developed 'outside of his own means', is the Bergsonian conception of a duration that extracts itself from the mediation of homogeneous space to reinstate to movement— and to the movement of the work in the process of being made—a *rhythmic extension* that lives and vibrates in all of our sensations. This was an idea whose importance for his own work Matisse immediately recognised, as is testified by the passage in 'Notes of a Painter' where he takes up the philosopher's argument almost to the letter: one must distance oneself 'from the literal *representation* of movement' (emphasis Matisse's) and from its rendering 'by means of an instant' in order to 'suggest the idea of dura-tion'.[156] Thus it is not a matter of producing a 'forced expression', nor of grasping, as in classical statuary, the instant when 'the development of the members and tensions of the muscles will be shown to the greatest advantage'.[157] In other words, the expression of movement does not consist in producing an image—as we shall see with the Merion and Paris *Dance* murals; it must involve placing the intensive and extensive relations between colours (and therefore also between lines) under 'the strongest tension' so as to render sensible the élan vital that animates the mobile and the immobile alike (as in

153 Initially a series of ten lectures Dewey gave at Harvard in 1930–31 within the framework of a 'Lectureship [...] founded in memory of William James', as the philosopher writes in his pref-ace.

154 See William James's letter to Bergson, 13 June 1907, *Mélanges*, 725–6 ('Your book is a mar-vel [...] and [...] your theories demand immediate attention'). On the public and much disput-ed nature of the kinship between Bergsonism and pragmatism, see again Azouvi, *La Gloire de Bergson*, 147–9. To the point where Bergsonism has been said to have a 'clearly transat-lantic origin' (Gaston Rageot, in 1905)!

155 Bernstein, *With Master Minds*, 96–7. A little before this reference to Dewey (whose works the French philosopher had followed for some considerable time—see the 1902 lecture on 'Intellectual Effort'), Bergson delivers a vibrant homage to the recently deceased William James: 'One of the great men, of all countries and all times' (94). More generally, on the re-ception of Bergson in the US, see P. Soulez and F. Worms, *Bergson. Biographie* (Paris: Flam-marion, 1997), 132–9.

156 Matisse, 'Notes of a Painter, 1908', *Matisse on Art*, 37 [EPA, 45–46]

157 Ibid., 37 [45].

Interior with Aubergines). A vital idea of duration, then, which, as Matisse had understood perfectly well, made it necessary to forge a new relation between *tension* and *extension* given that, as Bergson says, '*all* sensations partake of extensity', *concrete extension*.[158] Whether formulated in its philosophically rigorous form or perceived more intuitively, this exigency could not agree more with that of the painter who wants to 'reach that state of condensation of sensations which makes a painting'[159] and which, through its tension, will endow the painting with its expansiveness.

*

At the risk of interrupting our Matissean line of thought with a detour via entirely different reference points—but one that provides a trans-historical confirmation of our argument—let us indicate that this Bergsonian intuition of a constitutive *duration* will be directly mobilised, at the end of the 1950s, by Hélio Oiticica, in the exploration of what he will call 'colour-time [*côr-tempo*]'. Oiticica carried out this exploration, and theorised it, in the *Noyaux* and the *Penetravels* we mentioned in Volume 1 in relation to Ernesto Neto's installation.[160] In these works the notion of 'colour-time' is conceived as a pivoting, expansive movement of the pictorial plane associated with an absolute surpassing of the painting-Form of Art in a *temporalization of space,* according to a movement that leads *de dentro para fora* ('from inside to outside'):

> I no longer have any doubt that we have entered the era of the end of the painting. [...] It is no longer possible to accept a development 'inside the painting' [...]. Far from being 'the death of painting', this is its salvation, for its death would be if the painting were to continue as it is, and as the 'support' of 'painting'. It is so clear right now: painting must exit [from the painting], it must complete itself in space—not apparently, superficially, but in its deepest integrity.[161]

This exit will be achieved by the formal disintegration of the painting and the material transformation of painting into something else: the Non-Object ('no sentido da

158 Bergson, *Matter and Memory*, 216. 'Thus, by the idea of *tension* we have striven to overcome the opposition between quality and quantity as, by the idea of *extension*, that between the inextended and the extended. Extension and tension admit of degrees, multiple but always determined' (ibid., 247 [376]).

159 Matisse, 'Notes of a Painter, 1908', *Matisse on Art*, 36 [EPA 43]. Recall that for Bergson, every sensation is already a condensation or 'contraction' of innumerable 'disturbances', and that the rhythm of duration is made up of the moving and rhythmical continuity of the 'multiple degrees' of these disturbances.

160 See Volume 1, 46–7.

161 H. Oiticica, *Aspiro ao Grande Labirinto (Seleção de textos)*, ed. L. Figueiredo, L. Pape, W. Salomão (Rio de Janeiro: Rocco, 1986), 27 (Manuscript of 16 February, 1961).

transformada pintura-quadro em outra coisa: [...] o não-objeto', writes Oiticica at the
very beginning of this passage).[162] It is this movement, as implemented in the *Noyaux*
and *Penetravels*, that is metaphysically identified with 'duration' itself (the term recurs
throughout Oiticica's writings of this period, the beginning of the 1960s). Already in a
manuscript dated December 1959, in the entirely Bergsonian argument from which the
citation given above is taken, we read: 'Duration (interior time) appears [...] in the move-
ment that leads from inside to outside' through which 'the artist temporalizes space'—
failing which, space would be nothing but 'rationalised matter'. The passage opens with
the factual observation that art today tends toward the Metaphysical—a Metaphysics
that cannot be other than...Bergsonian (Bergson is named at the end of the first para-
graph).[163] 'When colour is no longer subjected to the rectangle, nor to any representa-
tion whatsoever on this rectangle,' he explains, 'it tends to "corporify itself"' (*a se cor-
porificar*—Oititica's neologism), it becomes temporal, creates its own structure, so that
the work becomes the 'body of colour'[164] with 'the inclusion of time in the structural
genesis of [a] work' in which the spectator participates, no longer 'in contemplation [...]
but incited to act so as to obtain a pluridimensional perception of the work'.[165] In this way,
time, as 'active element', as 'duration', becomes the 'primordial factor in the work',[166]
while 'man, before the work, discovers his vital time in so far as he implicates himself in
a univocal relation with the time of the work',[167] in so far as he becomes involved in a
'*vivência*' of colour whose 'polarities' will be experienced—as in Matisse (as we shall see
below)—not so much 'contemplatively' or 'organically' as 'cosmically'.[168] It is important
to emphasise that Oiticica aims to distinguish the word *vivência*—a term he introduces
here in this highly Bergsonian context—from its most well-worn vitalist meaning, at the

162 The term was coined by poet and critic Ferreira Gullar in his 'Theoria do Não-Objeto' (1960).
 Gullar was the author of the 'Neoconcretist Manifesto' which opened the 'First neoconcre-
 tist exhibition' at the Museum of Modern Art in Rio de Janeiro (March 1959).

163 Oiticica, *Aspiro ao Grande Labirinto*, 16; English translation in M.C. Ramírez (ed.), *Hélio Oi-
 ticica: The Body of Color*, exhibition catalogue (London and Houston: Tate Publishing, 2007),
 190. See also Ramírez's important article 'The Embodiment of Color "From the Inside Out"'
 in the same catalogue (27–73). To the detriment of the far more specific and usual phenom-
 enological references (largely owing to Ferreira Gullar), Ramírez manages perfectly to fore-
 ground the importance of the reference to Bergson (duration, intuition, élan vital, etc.) in
 Oiticica's manuscripts 'between 1959 and 1965'. As for the other relays (besides Matisse)
 alluded to, the reference is above all to Mondrian and Klee.

164 Manuscript by Oiticica dated 5 October 1960 (see the exhibition catalogue *Hélio Oiticica*,
 Galerie nationale du Jeu de Paume, Paris, June–August 1992 [henceforth JdP], 33).

165 H. Oiticica, 'Couleur, temps, structure' (JdP 35).

166 Ibid.

167 He adds: 'Here he is closer still to the *pure vitality* that Mondrian sought' (Ibid., 36).

168 Oiticica observes that with the *non-object*, 'a tendency to *live* colour, in a fashion that is not
 entirely contemplative nor totally organic, but cosmic, manifests itself', ibid., 37.

very moment when the constitutive differential-relational nature of colour (colour as relation of forces) is analysed in terms of 'signification' (or of signs-forces, in our own vocabulary) given that, for colour, the sign-form is excluded; and that through colour, space has to function 'integrally with the sign', no longer depending on 'form' or on 'optical phenomena', and must temporalize itself in the expression of construction.[169] Could it any longer be in doubt that this is what the 'temporal vitality' (*vitalidade temporal*) proposed by Oiticica is meant to remind us of? It is as a 'vehicle of *vivências* of every sort' that colour is a 'signification'[170] with a status inseparably energetic and metaphysical—in the very precise sense defined by Bergson, at the end of his 'Introduction to Metaphysics', as pertaining to '*the whole of experience*' (in italics).[171] The latter may be the closest translation of *vivência*, in which case the metaphysics of élan vital that animates it might—by way of a very short circuit—be identified with the liberation of art impelled by this vitalist and anti-formalist constructivism, so characteristic of Oiticica's 'neo-concretism'.[172] A constructivism that must be understood within the perspective of the environmental integration of painting into architecture that dominated the artistic milieu of Rio de Janeiro during the 1950s, but also in relation to a break with the Brazilian constructivism that determined its 'objectivity' on the basis of a post-cubist reading of modern art (under the influence of Max Bill's geometrical 'rationalism', very important in São Paulo). 'Carioca' neoconcretism will end up redefining the artwork, in the direction of its 'constructivity' ('o sentido da constructividade'), as that 'non-object' whose spatialization depends upon the processual time of its creation as much as upon its inscription into a real time constantly reanimated by the spectator.

'Metaphysics is art itself', writes Oiticica in the manuscript of December 1959,[173] the year of the *Manifesto Neoconcreto* and of all the ruptures that determine Brazilian

169 See the two manuscripts dated 7 and 13 August 1961, JdP, 55–56.

170 Excepting the reference given in the preceding note, all of our citations are taken from H. Oiticica, 'Couleur, temps et structure', 21 November 1960, in JdP, 34–7.

171 Bergson, 'Introduction to Metaphysics', in *The Creative Mind* 170–217: 217.

172 In a 'Testimonial' of April 1962, Oiticica evokes in relation to his *Noyaux* and *Penetrables* a 'new constructivism' that owes nothing to Constructivism (capital C) itself. Nor, he clarifies, does it have anything to do with 'post-Mondrian constructivist painting' (here he has in mind the *Paulist* group) since it is a matter of 'relating oneself to the place of Mondrian as he himself did in relation to cubism', cf. *Hélio Oiticica: The Body of Color*, 260. In the article 'A transicão da cor do quadro para o espaco e o sentido da constructividade' (1962), we find a very similar passage in which Oiticica accentuates the anti-formalist aspect of his approach (*Aspiro ao Grand Labirinto*, 54; *Hélio Oiticica: The Body of Color*, 22).

173 Oiticica, *Aspiro ao Grand Labirinto*, 16: 'ela [a arte] é, ela mesma, esse Métafisico'. Cf. *Hélio Oiticica: The Body of Color*, 190. At the beginning of Paragraph B we read: 'metaphysical colour (time-colour) is essentially active *de dentro para fora*; it is temporal *par excellence*. This new sense of colour breaks with the usual relations of colour as they were presented in the paintings of the past. It is radical in the broadest sense'.

art's contemporaneity: from the point of view of a 'non-object' of art with strong Mat-
issean resonances, since it is *no longer from the outside in, but from inside out*[174] that a
new *architecturalization of colour* is affirmed, one that is inseparable from the 'direct
participation of the spectator'.[175] This solution is obviously on an equal footing with ar-
chitecture, for 'it founds space' (Gullar). Hence, rediscovering Matisse's own words,
Oiticica is able to declare: 'Never has painting come so close to life, to the "feeling of
life"'.[176] Further proof, via this Brazilian detour, that the only worthwhile Bergsonism is
one that takes us beyond Bergson....

*

Vitalist energetics will take on a new *pragmatic* dimension in the passage from easel
painting to mural painting, even though the expansiveness of Matisse's paintings from
the Fauve era onward (with the exception of the so-called Nice period in the 1920s)
already made them radiate on the wall like centres of energy. In Matisse, painting on the
mural scale will take possession of space in a different way: by treating it not just as a
site of physical radiation but as a milieu for a life with which it is to be dynamically artic-
ulated *in order to vivify it* (Matisse's word, used here in full resonance with the aesthet-
ics expanded into the intensification of the experience of life developed by 'pragmatist'
philosopher John Dewey in *Art as Experience*).[177] And this 'decorative painting merging
with architecture'[178] will not just be conceived—architected—*as a function of architec-
ture* ('site specificity') as if dependent upon it; it will, reciprocally, realise its *mural* qual-
ity as a *function*—a *dis/architecturalizing function*—of *architecture*, and will realise
itself *in* this mural quality. Because, short of presenting a mere figuration of a fictional
architecture (like a trompe l'oeil) or an 'architectonic' abstraction (following the con-
structivists), it cannot be a matter of simply respecting the murality of the support, as
the traditional decorative arts do. The process Matisse enters into is based on the most
radical possible deterritorialization of painting, such that painting is conjugated with

174 As affirmed in the *Manifesto neoconcreto* (March 1959) which Oiticica helped write. See the
 English translation of the neoconcrete manifesto in D. Ades, *Art in Latin America: The Mod-
 ern Era 1820–1980* (New Haven and London: Yale University Press, 1989), 335.

175 Oiticica, 'Testimonial' of April 1962, *Hélio Oiticica: The Body of Color*, 260. The liberation of
 painting in space is compared to an 'architecture of painting' which effectively can only be
 understood as an 'architecturalization of color' (as Mari Carmen Ramírez writes in 'The
 Embodiment of Color', ibid., 53).

176 '[...] do "sentimento da vida"' (in quotes in the original) (JdP, 43).

177 As we have argued in *La Pensée-Matisse* (265–71), the whole book can and should be read
 as a veritable homage to Matisse. See also É. Alliez and J.-C. Bonne, 'Matisse with Dewey
 with Deleuze', in E.W. Holland, D.W. Smith, C.J. Stivale (eds.), *Gilles Deleuze: Image and Text*
 (London and New York: Continuum, 2009), 104–23.

178 Letter to Simon Bussy, 7 march 1933, EA, 140n4.

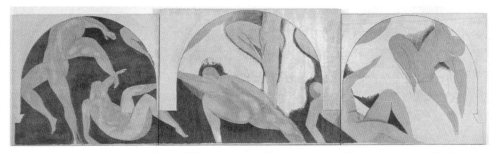

4. Henri Matisse, *The Unfinished Dance*, 1931, oil on canvas, 3 panels (Musée d'Art moderne de la Ville de Paris).

architecture and from the very conjunction of their heterogeneities there results an assemblage of a new type and of an unprecedented power. Unleashing its implicit operating procedure will lead us to redefine *in situ* the reality conditions of the 'escape diagram'[179] of painting to which the Matisse-effect is attached, since this mural-architectural painting aims primarily to highlight the private relation that obtains between the contemplative gaze and easel-painting: 'the picture enclosed in its frame [...] cannot be penetrated unless the attention of the viewer is concentrated especially on it. [...] [T]o be appreciated, the object must be isolated from its milieu (*contrary to architectural painting*).'[180]

The bio-environmental mutation realised by Matisse's architectural painting is particularly evident in the three successive large versions of the *Dance* made between 1931 and 1933 (oil on canvas on three contiguous panels), a monumental 'decorative' composition executed on the commission of Albert Barnes and designed to be placed in the large room 'full of painted pictures' at his Merion foundation in Pennsylvania.[181] The form and average dimensions of the three canvases that make up the work, which vary slightly from one version to the other, are determined by the configuration of the site

179 [*Diagramme d'échappement*: This term—employed again in the title of Volume 4, *Three Entries in the Form of Escape Diagrams*—contains an untranslatable double meaning since, as well as alluding to a relation between the diagram and *escape* or *flight*, as in Deleuze and Guattari's 'line of flight', in automotive engineering the term refers to the tuning or remapping of the valve timing of an engine's Otto cycle (intake-compression-expansion-exhaust) in order to boost its performance (*échappement* = exhaust). Here 'diagram' refers not so much to graphical representations of the cycle (although these do exist) as to the abstract relation that determines the engine's performance. It might therefore also be a fair description of the operation Alliez seeks to carry out on Deleuze and Guattari across these volumes....—trans.]

180 'Letters to Alexander Romm, 1934', in Flam (ed.), *Matisse on Art*, 113–18: 117 [EPA, 148] (emphasis ours). Which cannot be entirely unconnected to the fact that 'the truth is that Painting is a very deceiving thing'—as Matisse writes to Camoin in November 1913, after having visited the Salon d'Automne.

181 [Matisse's *Dance*, along with the rest of the Barnes collection, was moved to a new premises in the centre of Philadelphia in 2012, where the entire room for which Matisse meticulously conceived his mural (see below) has been reconstructed in full, as seen in fig. 5.—trans.]

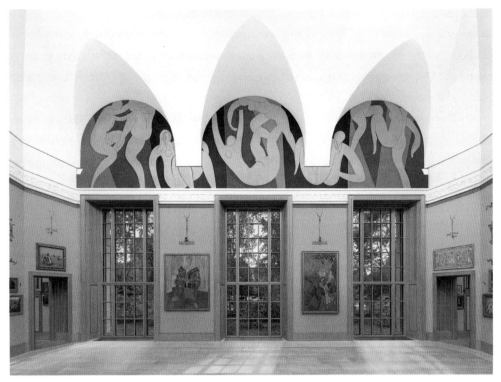

5. Henri Matisse, *The Dance*. Ensemble view, main room, south wall, Barnes Foundation, Philadelphia, 2012.

where the work was to be placed—namely, three semi-circular bays situated beneath arches but communicating behind the drops of the arches (the height of the arches is around 3.5 metres, the total width over 13 metres).

The first version, made in 1931, is known as the *Unfinished Dance* (Musée d'Art moderne de la Ville de Paris), because Matisse never completed it [fig. 4]. In spite of the simplification of the figures, their reduced volume, and the sobriety of the colours (a blue for the unfinished ground, a grey for the bodies-without-flesh), this first composition is not yet properly architectural-mural: it retains something of the feel of a large painting. The dancers are lightly modelled by small brushstrokes, something Matisse will seek progressively to eliminate in the two subsequent versions of the *Dance*. The composition sets out a series of postures, each holding its own in contrast with the others, their movements seeming to suggest a sequential arrangement. The figure stretched out horizontally at the centre could be seen as a forward projection of the vertical figure that looms over it and, in general, each dancer is outstretched toward the next. What we have here is therefore the representation of a complex action whose rhythmic unity (and it is only rhythmic) is founded entirely on the gestural, reanimating a certain (phenomenological) experimentation on *the body-image*. As in a classical painting subject to the paradigm of *istoria*, this large composition constructs, purely internally, the

spatiotemporality of a figured scene. This spatiotemporality even goes so far as to annex and subordinate architecture to its representational mode, since the space corresponding to the pendentives is treated as a quasi-theatrical frame for the scene. In small sketches, Matisse even treats each of the pendentives as a kind of pillar around which a ring of dancers moves.

The second version of the *Dance* is the one that was placed at the Barnes Foundation. Unlike in the first version, here architecture is not considered as a mere frame, but as an operative element in itself [fig. 5].[182] The painting integrates 'site-specificity', but only to play it in a different key—at the behest of a *machination* that is no less 'symbolic' than 'material', in so far as it will inevitably involve a *critical/clinical* relation to the plastico-discursive semiology of the Painting-Form staged at the Merion museum-foundation.

First of all we must set out the very specific architectural conditions with which the painting had to grapple. The lunettes of the three semicircular arches that it occupies above the windows cut transversally across the whole length of the high room's barrel vault ceiling. The penetration of the lateral arches into the central vault creates a considerable enclosing volume whose edges form ogive curves. The pendentives of these arches, immaculate white, their bases one metre wide, pose a trenchant luminous contrast to the black bands of the frieze into which they plunge so deeply. This architectural dispositif, which would be violently intrusive for any work that aimed at an overall continuity, has a far greater and more complex impact than a mere wall surface.[183] What is more, the painting is situated above three glass doors, each six metres high and around two metres wide, opening onto a garden. A gallery, also pierced by three arcades, faces the composition, which is therefore visible from two different levels. Matisse's frieze has to contend with this whole configuration.

Passing through the high doorway that leads from the Barnes Foundation's simple antechamber into the large main room, the visitor's gaze alights upon *The Dance*,

182 [An advance warning: As if to further 'highlight' the gulf between the artistic ideals of the
 Barnes Foundation and the Matisse-operation of the *Dance*, discussed in detail below, the
 official Barnes Foundation photograph reproduced here as fig. 5, showing Matisse's *Dance*
 in its new location in Philadelphia, has been immaculately spotlit so as to counteract the
 contre-jour effect of the light coming in through the glass doors, which Matisse had to take
 into consideration in planning his work (again, see below). While the photograph can there-
 fore hardly be regarded as a faithful representation of the experience of Matisse's work in
 situ, it does provide an unwitting illustration of the authors' argument.—trans]

183 Matisse at first miscalculated the width of these pendentives: he believed they were 53 cm
 wide, when in fact they were almost double this width, and therefore could not be exploited
 theatrically as in the first version. Matisse's persistence in failing to check the dimen-
 sions—a kind of Freudian slip—may be interpreted as a sort of retreat before the challenge
 of having to invent an unprecedented conjunction between painting and architecture (see
 J.D. Flam, *Matisse: The Dance* [Washington: National Gallery of Art, 1993], 45–9).

which stretches the whole length of the wall in a gigantic triptych fully articulated with the curves of the arches. But the painting is not alone in this room, and if the strongly architectural character of *The Dance* impresses itself upon the viewer from the outset, this is also a result of its absolutely startling contrast with all of the other works around it. This is a decisive confrontation, its brutal rupture denouncing all of the surrounding paintings—all the more brutally in that this is all work of the highest 'quality', all pure 'museum quality' artwork. Whereas these paintings were pedagogically hung by Barnes so as to place the 'great pictorial traditions' past and present in resonance or assonance with one other (with no regard for chronology, school, or classification) so as to show that the richness and variety of pictorial expression are so many variations on the 'elementary values of plastic art' present in all periods of painting (such is the *plastic quality* of great painting),[184] *The Dance*, in consonance with the architecture of the place it invests, in an intervention of the greatest audacity, strikes a complete dissonance with the primary objective of the Foundation: to marry these pragmatist pedagogical convictions to the formalist theories of Clive Bell and Roger Fry. Matisse's painting practice can no longer be looked at as one looks at a Renoir *and* a Cézanne (which nevertheless—whether Barnes likes it or not—are not to be looked at in the same way). In 1929 (the end of his 'neoclassical' Nice period,[185] particularly marked by an attention to Renoir rather than Cézanne), just before Barnes's commission in 1930 for this vast decorative panel, Matisse had declared to Fels: 'I don't feel at all tied to what I have done [...], *I wouldn't hesitate to abandon painting* if my supreme expression had to be realised by some other means.'[186] The Merion *Dance*—and this is the privileged moment that it constitutes in Matisse's oeuvre as a whole, and even in the history of painting as a whole—neither adds itself nor opposes itself to Barnes's Temple of Painting, but clears the way before it in order to go *elsewhere*, in the play of an exteriority in regard to the Painting-Form. Indeed, Matisse had asked Barnes to remove the two paintings (themselves quite antithetical—one by Matisse himself, the other by Picasso) that hung on the sections of wall between the glass doors, in order to establish 'the quite clear separation that [he] wanted to introduce between mural decoration and easel painting'—a request that Barnes refused.[187]

184 In the introductory text to the publication *The Art in Painting* (Merion, PA: Barnes Foundation Press, 1925), Barnes explains: 'This book [...] aims to furnish a guide for discovery of the essential plastic, that is, pictorial qualities in painting, and so to disengage what is central in art from the narrative and antiquarian aspects which in ordinary academic criticism and instruction are all that receive attention.' (cited by H. Greenfield, *The Devil and Dr Barnes* [New York and London: Penguin Books, 1987], 108).

185 As described by Yve-Alain Bois in his *Matisse and Picasso*, 33.

186 F. Fels, *Henri Matisse* (Paris: Chroniques du Jour, 1929), 35 (italics ours).

187 Letter from Henri Matisse to Pierre Matisse, 8 February 1934, cited in Flam, *Matisse: The Dance*, 60n. 133.

6. Pablo Picasso, *Peasants*, 1906, oil on canvas, 220 × 131 cm
(Barnes Foundation, Philadelphia).

Barnes's opposition to this demand is doubly interesting, since it places directly before
our eyes the tension that had long worked Matisse's own painting practice, and the
distance he wished to put between himself and the other uncontested 'master' of con-
temporary painting. Against his wishes, beneath the Merion *Dance*, then, there re-
mained in place *Peasants* (oil on canvas, 220 × 131 cm, 1906), an idyllic narrative paint-
ing characteristic of Picasso's so-called Rose Period [fig. 6]. The 'scene' features a
small-headed man with a large basket of flowers on his shoulders, his hand placed on
the shoulder of a little girl in a white dress. These two characters are accompanied in
their walk by two cows. All of the elements—the arms, legs, hooves and heads of the
animals, the overflowing garland pendulous with flowers—form an insistent pivoting
'composition' centred around the young girl's head. Although all of the figures are

supposed to be walking, they are in fact fixed to the edges of the painting in such a way that the composition marks out a completely closed-off figure. As for the colours—blue for the ground of the sky, white alongside blue on the clothes, orange and brick-red for the ground, reddish-brown for the animals…—their alternation boosts the composition's rotational motion, the sustained pictoriality of their contrasts servicing an expressivity that tends to excessively 'romanticise' an originally Gauguinian inspiration (the same inspiration that finds itself, at the very same moment, projected into the radical de-symbolisation wrought by Fauvism).[188] Formally and chromatically, then, this is a work that presents us with a perfect example of the easel-Form of Painting. We can quite well understand why Barnes was attached to this painting, which responds well to his idea of an 'educational' aesthetic, both humanist and formalist—and why Matisse would have preferred to remove this far too Apollonian painting from beneath his 'Dionysiac' warrior *Dance*.[189]

It is putting it mildly to say that Matisse's painting *Seated Riffian* (1912–1913, oil on canvas, 200 × 160 cm), the counterpart to Picasso's painting beneath *The Dance*, is radically opposed to it in tone [fig. 9, p.58]. What leaps out at us, in the *all-over* deployment of bands, stripes, and patches of colour, is the de-psychologization of this 'portrait of a Riffian' who merges into his surroundings in one and the same expansive decorative double deterritorialization: at the centre, the dark green torso-silhouette, flat but broad, half-seated on a mustard-yellow box, is decked out with anatomically dissociated limbs, dark orange in colour; it contrasts even more violently with the raspberry ground; and this dominant contrast is doubled by a less heightened contrast of yellow and green bands like a curtain or tapestry, framing a corner of blue sky. The painting is constructed so as to place in tension vertical expansion and horizontal expansion: thus the figure, larger than life, is wide but also extends from bottom to top of the canvas; the red and blue oppose each other vertically, etc. And 'box', 'sky', 'curtain' and other denotations are in truth only a manner of speaking in relation to what are given above all transcursively as planes, modulated rather than modelled, and surfaces, almost rectilinear or aggressively angular. There are only a very few drawn lines (mainly around the djellaba): the colour planes, with no outline, are separated by slight interstices that allow them to express, in a quantitative energetics, their pure force of expansive construction. The face—a sensitive zone if ever there was one—is swollen with green, orange, and yellow patches whose contrasts respond in a minor key to others, desubjectivating it in order

188 See the chapter 'Gauguin, or the Eye of the Earth', in E. Alliez, with J.-C. Martin, *The Brain-Eye: New Histories of Modern Painting*, tr. R. Mackay (London: Rowman and Littlefield, 2016), 253–320.

189 Note that the Matisse/Picasso combat was still ongoing at the time, the beginning of the 1930s, but according to an entirely different regime, with Picasso's *Acrobats* ('rather stiff and mannered', as Jack Flam observes, when compared to Matisse's dancers).

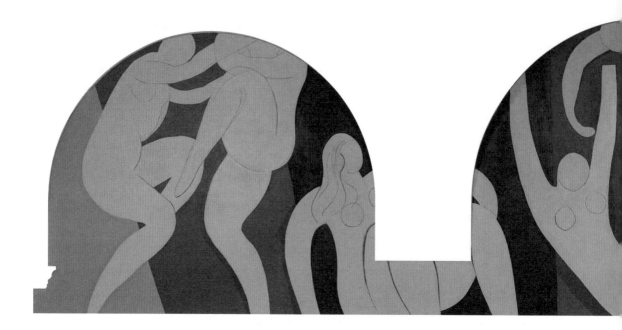

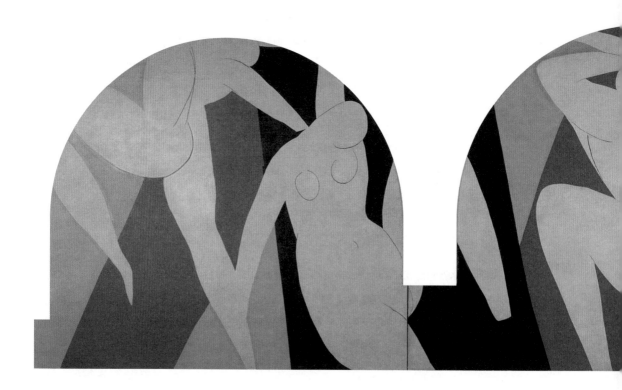

7. Henri Matisse, *The Merion Dance*, 1932–1933, oil on canvas, 3 panels, 339 x 441 cm; 365 x 503 cm; 308.8 x 439 cm (Barnes Foundation, Philadelphia).

8. Henri Matisse, *The Paris Dance*, 1931–1933, oil on canvas, 3 panels, 340 x 387 cm; 355 x 498 cm; 335 x 391 cm (Musée d'Art moderne de la Ville de Paris).

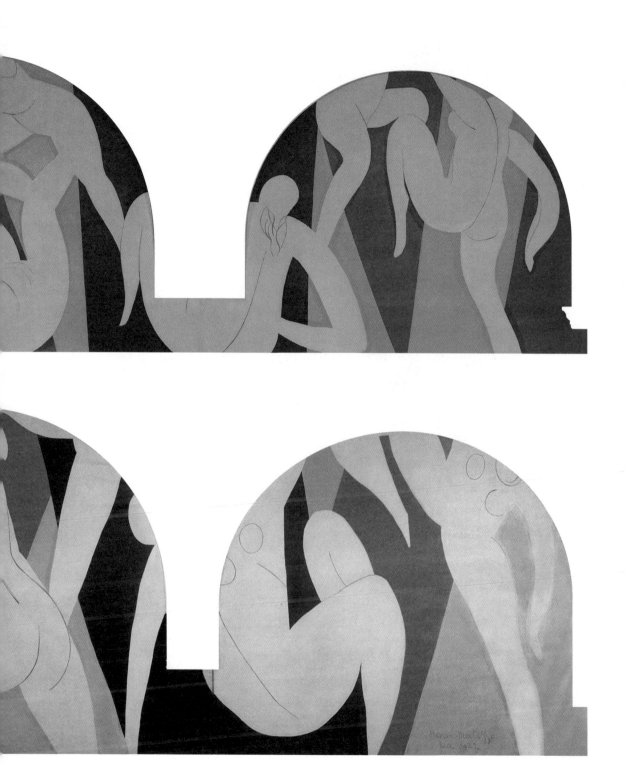

9. Henri Matisse, *Seated Riffian*, 1912–1913, oil on canvas, 200 × 160 cm (Barnes Foundation, Philadelphia).

to make it enter into 'a great [decorative] association' with its surroundings, as Matisse will say of the relation of his dancers—even more dehumanised, more de-faced—to their architectural site.

It is worth dwelling a little on Barnes's disappointment with *The Dance* [fig. 7], so profoundly contrary to his sensibilities, because it is such fine testimony to the success of the détournement Matisse had carried out in his work. Barnes's hostility can be read indirectly but unmistakeably in the book he dedicated to *The Art of Matisse* at the time when *The Dance* was being produced but was not yet in place, and he had seen it only in studies and photographs (significantly, he gave up his initial plan of delaying the publication until the painting had been completed so as to have time to study it in situ).[190]

190 Cf. Greenfield, *The Devil and Mr. Barnes*, 170.

Barnes finds that Matisse's decorative art is essentially a matter of 'the intellect', lack- 59
ing 'the spontaneity of an expressive form' and 'a plastic reality' that is truly living (that
is to say, in Barnes's terms, 'human' and 'organic'). He reproaches Matisse for having
learnt very little from Giotto, whose frescoes in Padua the painter had gone to see when
seeking inspiration for the difficult task ahead of him:

> Matisse gets nothing at all of Giotto's deep mysticism, and little or nothing of the human
> dignity of Giotto's figures. A group of figures in Giotto plays the role of a group not only
> plastically but as a human or dramatic assemblage. [...] Matisse's groups are seldom much
> more than a set of pictorial units.[191]

Consequently, lacking the charm and pictorial surface richness of his contemporaries—
Cézanne, Renoir, and Soutine—Matisse 'lacks the supreme values of painting'[192] (only
the Nice period, relatively well-represented at Merion, truly finds grace in Barnes's eyes
for 'the feeling of intimacy' to which it testifies). The elimination of 'human' value pro-
moted by Matisse goes directly against what Barnes looks for in painting.

This retreat of the human can immediately be sensed in the Merion *Dance* when
it is compared to the previous version: the forms of the eight dancers are more simpli-
fied and are treated in grey flat surfaces with no modelling. Another striking difference
is the appearance, in place of the unfinished blue ground, of large, vertical but more or
less sloping bands, ten in number, alternating between red and blue (in the three lu-
nettes of the vaults, above the glass doors), and black (around the drops of the penden-
tives). These roughly parallel bands or opposing slopes rhythmically articulate the whole
field from which the dancers are cut out.

The four colours of the composition, totally depictorialized, have a matt, muted
aspect to them (Matisse had had to embolden the lines with charcoal to give a sharp-
er aspect to his composition when he transposed it from paper onto canvas).[193] It is
understandable that Barnes should have chided Matisse for 'the impression of mech-
anisation' given by his art, adding that '[h]is surfaces are dry and hard: the paint-
ing itself is just as uninteresting as that of a fence'.[194] He is even less keen on 'the
relative aridity of his surfaces which, particularly in his late work, tend to lack the
richness of coloured accords.'[195] We might agree in calling them dull in so far as they

191 A.C. Barnes and V. de Mazia, *The Art of Henri Matisse* (Merion: The Barnes Foundation
 Press, 1933), 202–3.

192 Ibid., 20.

193 Letter from Henri Matisse to Marguerite Duthuit, 30 March 1933, cited in Flam, *Matisse: The
 Dance*, 72.

194 The very same criticism that had been served up to Manet.

195 Barnes and de Mazia, *The Art of Henri Matisse*, 208, 210, and 209.

are *non-picturesque*, since what Matisse is looking for are colours that can be positively associated with the idea of stone. The blue, black, and pink of the bands, like the grey of the bodies, no longer owe their expressive power to the transposition of a landscape or a dance, with that 'organic' sentiment of *community* that Barnes had been able to find in Matisse's preceding *Dances*. In this regard the Merion *Dance* also constitutes a break with those previous rounds, whether we think of the dance in the background of *La joie de vivre* (also acquired by Barnes) or the Moscow *Dance* inspired by it, or even the 1931 study for Merion that can today be seen at the Musée Matisse in Nice.[196] At Merion, if we are to believe Matisse himself, the 'frank contrasts [of colours], their decided relationships, give an equivalent of the hardness of the stone, and of the sharpness of the ribs of the vault, and give the work a grand mural quality'.[197] Their effect is all the more assured in that they respond and agree in painting to what is sober and elementary in the rigour of the architectural surfaces and volumes, but without sublimating them (unless in a grey sublimation that aims to 'express', to bring forth from wall and painting, adherent virtualities that will take their conjunction to a higher degree of immanent power).

The chromatic combinations and the tempo of the bands enter into accord with the play of the dancers: the parts that are both pink and blue, whose slopes are more oblique and more dynamic, correspond to the three couples involved in a violent melee beneath each of the three arches, while the two black bands into which the pendentives drop, more vertical and therefore more static, correspond to the seated nymphs who receive the drops of the vaults. Here the internal rhythm of the triple panel no longer has the gestural autonomy it boasted in the preceding version, since the large coloured bands are articulated with both the rhythm of the dancers and the pendentives of the vaults, but also with the alternation of the glass doors and the spaces between them. The articulation of all the surfaces, openings, and volumes of the wall, from the floor all the way to the arch mouldings, enters into an overall assemblage with the internal construction of *The Dance*, all the more diagrammatic for its machining of heterogeneous opposed or composed forces. The dark moulded frames of the high glass doors, which stand out from the lighter, more neutral fabric on the walls push the composition upwards, so to speak, their cornicing tending to further compress the contorted forms of the dancers. By contrast, the bright (decorative) cornice (which Matisse would have liked to have dispensed with) that tops

196 An observation made very convincingly in J. O'Brian, *Ruthless Hedonism: The American Reception of Matisse* (Chicago and London: The University of Chicago Press, 1999), 76–7 (with reproduction). However we do not follow this author when he identifies Matissean 'decoration' with a 'strict aestheticism' that participates in the limits of 'modernism'.

197 'Letters to Alexander Romm, 1934', in Flam (ed), *Matisse on Art* 114 [EPA 145].

off the walls of the two spaces between the windows renders more noticeable the vertical thrust of the pendentives and therefore the pressure that the curve of their powerful square mass exerts upon the rounded nymphs who receive them; a pressure their own curves absorb while reflecting the play of forces back upward. The dancer at the centre of the whole composition, recumbent but with her body arched upward, literally materialises the moment of this turn, of the inversion of the forces of gravity. But the most startling crossover of forces takes place between the leaping dancers and the curve of the arch mouldings. The bodies, with no feet, carried away by their movement, can only escape the arches upwards, so that the arch mouldings drawn toward the bottom by the pendentives seem in their turn to bounce back up. The alternation of descending and ascending bands enters into this generalised play of forces. Thus the architecture participates in the dynamic assemblage of the whole, in proportion to the dynamism that painting communicates to the architectural conditions within which it must work and which it sets to work.[198]

It was also by working particularly on the relation between the ambient light and the light produced by 'the severe ordering of colours' that Matisse succeeded in conjugating his monumental decorative panel with the complex architectural milieu he had to deal with. The principal difficulty lay in the contrast between the strong light coming from the windows and the shade of the vaulted zone reserved for the composition. Matisse explains that he 'carefully observed these particular lighting conditions' so that, 'guided by the necessity of giving [his] painting the visibility that the architectural setting denied it' and '[s]ufficiently overcoming the action of the light from the two doors which could have made [his] decoration impossible to see',[199] Matisse had the fortunate idea of brightening the upper zone by opposing the black (here playing the role of anti-light) and a slightly heightened pink and blue to the white of the arches, so as to create a stronger contrast than in the lower part.

Thus the liaison between the interior and exterior of the composition is not limited to the relations between the triple decorative panel and the ogive arch mouldings that enframe it; it involves the whole of the wall, its full height and bays included—a whole whose architectural conjunction is operated by *The Dance*. As Matisse emphasises:

The painting acts as a pediment to these three doors […] —a pediment placed in shadow and yet required, in continuing the large mural surface broken by the three great luminous bays, to maintain itself in all its luminosity; consequently its plastic eloquence (a surface

198 Need we point out that all of the photographs that present the Merion *Dance* cropped tend to denature its functioning?

199 Flam, *Matisse: The Dance*, 43, 57.

in shadow juxtaposed against a strongly lit bay without destroying the continuity of the surface), *is the result of modern achievements regarding the properties of colour.*[200]

He puts it even more precisely in an interview:

> Therefore all my art, all my efforts consisted in changing apparently the proportions of this band. I arrived then, through the lines, through the colors, through energetic directions, at giving to the spectator the sensation of flight, of elevation, which makes him forget the actual proportions, much too short to crown the three glass doors—with the idea always of creating the sky for the garden one sees through the glass doors.[201]

Upon which the journalist then asks: '*Then really your painting has corrected the architecture?* [Matisse] admitted that this had seemed to him imperative.'[202] Far from submitting to the 'frame', architectural painting thus proves itself inseparable from a *power of deframing* that opens up the house-panel onto a plane of composition that affects both architecture (which is altered, corrected, *de-* and *re-architected*) and painting (which is aerated, or even made aerian, by its absolute distancing from the 'easel') for a spectator-inhabitant whose body experiences aesthesically the play of tensions—and who feels himself 'on the point of flying up into the air'.[203]

In order for painting to affect in this way how architecture is inhabited, it must itself be affected by a twofold becoming-other: it must renounce pictoriality so as to acquire a 'mural quality' that is in some way substantial (and not merely formal or optical, as in the traditional decorative arts, which also respect the opacity and verticality of the plane); then the unprecedented opening to the site rendered possible by this substantial murality will procure it a 'social' and even 'cosmic' dimension. Short of this, as Matisse observes, 'the mural painter today makes paintings, not murals'.[204] He only makes *images* that extend the formalist illusion of the autonomy of the pictorial, and he translates architecture into painting only to end up sublimating both of them. The inversion is fully spelled out by Matisse: 'My aim has been to translate paint into architecture, to make of

200 'Letters to Alexander Romm, 1934', in Flam (ed), *Matisse on Art*, 114 [EPA 144] (emphasis ours).

201 H. Matisse, 'Interview with Dorothy Dudley, 1933', in Flam (ed), *Matisse on Art*, 107–113: 110 [EPA, 140].

202 Ibid., 110 [translation modified] [EPA 140].

203 The celebrated passage from *The Birth of Tragedy*, §1: 'It is through song and dance that man feels himself a member of a collective that goes beyond him. He has dislearned to walk and speak; he is on the point of flying up into the air while dancing...'.

204 Matisse, 'Interview with Dorothy Dudley, 1933', in Flam (ed), *Matisse on Art*, 109 [EPA, 140].

the fresco the equivalent of stone or cement.'[205] This unique grand plan(e), the flattening of colours *muralized* in this way, liberates the forces that will free decoration from what Matisse calls 'the human element'.

It is the Merion *Dance* that will bring Matisse to appreciate the need for a more radical overcoming of the organic: 'In architectural painting, which is the case in Merion, the human element has to be tempered, if not excluded'. For 'the spectator should not be arrested by this human character with which *he would identify, and which by stopping him there would keep him apart from the great harmonious, living, and animated association of the architecture and painting.*'[206] In mural painting, therefore, the human must retreat, in so far as the organicity of figures at once cuts them off from their surroundings yet in the same movement invites the spectator to identify with their humanity—which, by immobilising him, separates him in turn from the movement that should make him the agent of the constructive association of the work with its architectural surroundings and with the vector of the 'cosmic' (vital) opening up of those surroundings ('in this case,' explains Matisse, 'it is the spectator who becomes the human element of the work').[207]

This confirms for us that Matisse's vitalist constructivism is not just once but doubly irreducible to the *humanist* phenomenology of art in which Merleau-Ponty had embroiled the name of Cézanne (whose art is 'man added to nature')[208] by projecting him into a landscapist narcissism of vision where 'since the seer is caught up in what he sees, it is still himself he sees',[209] in an infinite play of mirror images. It is at this point that we perceive the resonance of Matisse's *Dance* with the Deleuzian (and Deleuzo-Guattarian) analysis of a Life-Art conceivable only through a surpassing of the human-all-too-human condition, by engaging Expression in a *social* construction hooked into an infinity of forces that is no longer that of the World (attached to the *lived body* [*corps vécu*]) but pertains to the Cosmos, the infinite forces detected by the 'huge *inorganic* body' that Bergson saw extending to the very stars in that startling page of *The Two Sources of Morality and Religion*, contemporaneous with the American *Dance*.[210]

205 Ibid.

206 'Letters to Alexander Romm, 1934' in Flam (ed), *Matisse on Art*, 115 [EPA 145].

207 Ibid., 116 [EPA 147].

208 M. Merleau-Ponty, 'Cézanne's Doubt', in *Sense and Nonsense*, tr. H.L. Dreyfus and P.A. Dreyfus (Evanston, IL: Northwestern University Press, 1964), 9–25: 16.

209 M. Merleau-Ponty, *The Visible and the Invisible*, tr. A. Lingis (Evanston, IL: Northwestern University Press, 1968), 139. For a *very different* analysis of Cézanne, see Alliez and Martin, *The Brain-Eye*, chapter 6, 'Ten Variations on Cézanne's Concentric Eye'.

210 Bergson, *The Two Sources*, 222. Recall that this book was published in 1932. In the very fine pages he dedicates to Bergson/Deleuze, Pierre Montebello expresses his surprise that Deleuze never cited this passage (P. Montebello, *Deleuze* [Paris: Vrin, 2008], 208).

The dancers are rendered in a uniform grey whose mural quality ensures the inhuman adhesion of the figures to the cement or stone—'The flesh grey between black and white, like the walls of the room in Merion'.[211] Matisse realises here that the pictorial character of the painterly touch would, in its mannerism, betray the spirit of 'decoration' as he projects it and that consequently the decision must be made to take leave of it altogether, to distance oneself materially from all manners of painting haunted by a formalism that ties it to its interiority. Impersonal, non-pictorial uniformity permits the *equality* of 'colours applied in a completely straightforward way so that it is their quantitative relation that produces their quality'.[212] A one-dimensional man, a man without qualities, the *house painter* (whom Matisse charges with applying the final colours onto the surfaces he has experimentally determined with the help of cut-out pieces of painted paper) can then make his forced entry into what had hitherto been 'the beauty parlor of civilization'—in the lapidary phrase of John Dewey,[213] adviser to Barnes (*Art as Experience* is 'dedicated' *to Albert C. Barnes, in gratitude*)[214] and the true intercessor between Matisse and the USA—a phrase that proves applicable precisely where it should not have been: at the Barnes Foundation, where 'paintings [...] taken out of their specialized niche' were supposed to provide the basis for an 'educational experience' liberating one from the 'compartmental divisions and rigid segregations which so confuse and nullify our present life'.[215]

(Note that the reception of the landmark book of pragmatist aesthetics, *Art as Experience*, goes in the direction of this Matissean application of Dewey *contra* Barnes. The energetic expansion of aesthetics promoted by the philosopher on the basis of an vitalist experiential/evental redefinition of the creative process—conceived as 'the turmoil [that] marks the place where inner impulse and contact with the environment [...] meet and create a ferment'—will, as we know, find a powerful echo in the American promoters of *action paintings* and *happenings*; not forgetting the role played by Meyer Schapiro and Harold Rosenberg, of course. However, prior to that, *Art as Experience*

211 Matisse, 'Interview with Dorothy Dudley, 1933', in Flam (ed), *Matisse on Art*, 110 [EPA, 140].

212 'Letters to Alexander Romm, 1934', in Flam (ed), *Matisse on Art*, 115 [EPA, 146].

213 J. Dewey, *Art as Experience* (New York: Berkley/Penguin, 2005), 344.

214 *In gratitude* for this institution with which Dewey had been directly associated from its very first origins, and which was designed to 'promote education' and the study of art in its relations to common life, keeping in view 'a category of people to whom these doors are usually closed' (as Barnes himself declared in *The New Republic*, March 1923)—an ambitious programme whose realisation has been far less unequivocal.

215 J. Dewey, 'Affective Thought in Logic and Painting', *Journal of the Barnes Foundation* 2:2 (April 1926); republished in 1929 in a collective volume published by the Foundation entitled *Art and Education: A Collection of Essays* (Merion, PA: The Barnes Foundation Press, 1929), 72 for the citation. Cited in D. Chateau, *John Dewey et Albert C. Barnes: philosophie pragmatique et arts plastiques* (Paris: Harmattan, 2003), 57–8.

had 'met with immediate response from European artists then in the United States', in the wake of Josef Albers and then Matta.[216] There is something like a Matissean *predestination* at work here, something also testified to by the projection of a *Matisse-outside-of-France*,[217] from the American *Dance* to the *Paper Cut-outs*. To put it as succinctly as possible: An art that serves life by intensifying the experience of life rather than by purifying its forms.)

The mural composition was also designed to 'serve as a sky to the verdant landscape' that would have remained visible through the windows, thus enabling a double relation between the composition, the interior of the room, and the external landscape (a decorative combination that had already been the theme—but precisely only the *theme*—of numerous easel paintings). This confirms the integral environmental meaning of the decorative (in the Matissean sense), since the latter now applies even to nature *taken up in the artifice of construction*. Once the panel has been installed, Matisse confirms the expansiveness of his composition:

> It has a splendour that one can't imagine unless one sees it—because both the whole ceiling and its arched vaults come alive through radiation and the main effect continues right down to the floor. [...] When I saw the canvas put in place, it was detached from me and became part of the building [...].[218]

The becoming-architecture of painting therefore does not imprison it in the 'house', for the becoming-painting of architecture opens the 'house' onto a universe which, from the inside, bears the spectator out toward the 'sky' into which the dancers are inhaled and, through the diffraction of the gaze so dear to Matisse's decorativity, opens it to this 'vaster' space described as 'cosmic'. In a 1946 note, Matisse wrote:

> Captured by the light [...] I mentally escaped the narrow space surrounding my *motif*, consciousness of such a space having, it seemed to me, been sufficient for painters in the past; thus I escaped the space in the background of the *motif* of my picture, attaining a sense that above me, above any *motif*, above the studio, even above the house, there was a cosmic space in which I was as unconscious of any walls as a fish in the sea.[219]

216 On this subject see Stewart Buettner's fine article, 'John Dewey and the Visual Arts in America', *Journal of Aesthetics and Art Criticism* 33 (1975), 383–91, here 389.

217 Cf L. Aragon, *Henri Matisse, roman* (Paris: Gallimard, 1971), tr. J. Stewart (2 vols. London: Collins, 1972), a work written over a period of thirty years (1941–1971), and which contains a chapter entitled 'Matisse in France'.

218 Letter to Simon Bussy, 17 May 1933, cited in Flam, *Matisse: The Dance*, 62.

219 Note from 1946 in the margin of one of Aragon's manuscripts, published in *Henri Matisse, roman*, vol 1, 208 (EPA 104n59) (emphasis ours) [translation modified].

This 'cosmic space' will open its doors to the inhabitant of the Sensation-House that incorporates the plan(e) of construction into a deterritorialization of expression of architecturally closed space (which is also the *enclosure of the Painting-Form*). Architectural painting, as Matisse emphasises, 'must give the space enclosed by the architecture the atmosphere of a wide and beautiful glade filled with sunlight, which encloses the spectator in a feeling of release in its rich profusion'.[220] *The Dance* therefore cannot be apprehended as the figuration of a dance; its title is a codename for the diagrammatic assemblage of *post*-pictorial and *trans*-architectural forces that exert themselves upon the spectator: The deterritorialized *Dance* that dances with architecture and makes it dance catches the spectator herself up in its movement and introduces her into the universe as into a dance.

In the Merion version, the composite architecture of the wall with its glass doors and its vaults, the oblique bands of colour, and the clashing dancers thus begin to share a common spatiotemporality, but one that also comes up against certain limits. The scale of the pendentives and the reduced visibility imposed by the depth of the moulded arches prompted Matisse to break the whole up into 'three centres of composition' quite distinct from one another: each comprises a couple of dancers whose attitudes differ from one panel to the next along with the rhythm of the pink and blue bands associated with them. The spatiotemporal unity Matisse sought to give to the whole conserves a certain narrative or descriptive-type structure, as in the preceding version. The three 'scenes' are linked, on one hand, by the seated nymphs who intercalate themselves between these scenes but without joining them together and, on the other, by a gradual declination of the dancers' confrontations. In the central scene, one dancer leaps above the other in a circular dynamic that seems like the central kernel or vortex of the composition, while the facing couples in the two panels on either side are constructed quasi-symmetrically on a general ground of a sort of fanning-out of the coloured bands, their slopes inverting from left to right. The couple in the right-hand panel are in fact shown in a more advanced stage of the same symmetrical ascending motion as the left-hand couple; an intensification also indicated in the accelerated rhythm and more dramatic gradients of the coloured bands (from left to right, we go from three bands to four, then five, and from almost parallel positions to bands that oppose one another, then cross over and penetrate into one other).

Considered (artificially) in itself, the painted dispositif has a certain orientation and a certain narrativity about it, and therefore a relative closure; but this closure is powerfully counterbalanced by the dynamic articulation of all of the painting's components with the architecture—and it is this articulation that gives the Merion version its radical originality and its force.

220 'Letters to Alexander Romm, 1934', in Flam (ed), *Matisse on Art,* 116 [EPA, 147].

Matisse finally takes the leap into a new space-time, into a *milieu* stripped of any kind of narrativity, in rupture with any kind of historicity, in the so-called *Paris Dance* [fig. 8, pp.56–7]. Completed after the Merion *Dance* and presented as a work in itself (at the Musée d'art moderne de la Ville de Paris), this version functions, independently of all 'site-specificity', as a paradigm of the inseparably dis-architecturing and pragmatic (because not contemplative) function of mural painting (which we might also call: *apainting*). The rhythm of this new composition with its powerful scansions is more regular, more continuous, and broader. There are now only six parallel figures, rather than eight diversely oriented ones. Their height has been increased so as to be in proportion to that of the coloured bands, which now form a periodic sequence of three colours (pink, blue, black) with only slight variations in height and gradient, the successive bands of each colour almost parallel. The blue and black bands are sequenced into a series of large dynamic chevrons into which the pink triangles are inserted according to a total (*all-over*) distribution that is strongly articulated yet entirely open (neither totalising nor totalizable, even relatively, as would be the case for any organic composition or historical structuration). The same can be said of the nymphs: their attitudes are not gesturally coordinated two by two, composing a series of confrontations that would form successive or alternating figures, in dramatic order, of the same ballet. The exceptional 'trans-architectural' force of the Paris *Dance* owes to the fact that these nymphs, become pseudo-bands, no longer grapple with a companion, but instead directly with the monumental system of bands, which themselves have become pseudo- or trans-human/transhumant actors. A mutual double-becoming that is not an assimilation to or an identification with an other but the vector of a becoming-other, not the conquest of a new 'being' (some new *state* into which the Art-Form could pass) but a higher vital intensivity of an (in principle) infinite conjunction achieved via the effect brought about by the crossing over of heterogeneous domains. The only transitivity here is that of the composite rhythm with which the dancers' limbs, alternating between flexion and extension, diagrammatise the composition of forces by entering into an *assemblage* with the dynamic of the bands. Become fully 'bodies without organs' since they are now entirely opened onto a rhythm that they share with the bands, but without merging with them, the figures are incarnated in just a minimal silhouette, which qualifies the mode of action of the quantum of colouring-coloured force that they exert in the multiplicity of forces in play. There is no longer either centre or symmetry, neither beginning nor end, no progression and no temporal development. Absolutely nothing that might be conceived under the notion of a narrative, only a pure becoming as movement of the differenciating repetition mobilising the Outside, making of this movement itself, outside of all representation and in all its processuality, a work, an operation, that is both operative and inoperative [*oeuvre oeuvrante autant que désoeuvrée*]. Correlatively, the gaze, caught

up in and by this processuality, no longer has to pause at three represented 'centres of composition' to grasp their singularity and the organico-temporal articulation between them. On the contrary, the apprehension of this construction—of which Matisse said at the time of Merion: 'From the floor of the gallery one will feel it rather than see it'[221]— is without focus, as if in passing and accompanying a passage, in the smooth time beat out by a *Dance* that invites the spectator to *become*, in his turn, the *vivified* actor of this intensive processuality, as an inhabitant of the *mi-lieu*—and not as contemplator of an artwork wherein the relation to the 'exterior' is always mediated by an interiority, dissolved in it. It is also when he undertakes the Merion project that Matisse, considering the public dimension of architectural painting,[222] takes to *dreaming* 'of turning painting into a collective activity, and of seeing all painters unite their efforts [...]'.[223] Later on, in answer to a question, he will declare: 'Art for the people? Certainly, if by people we understand the young spirits who are not fixed in an art of tradition. [...] I prefer ignorant students to students whose heads are full of old truths...', but 'the direction should not be given externally' as in propagandist art[224]—an art that can conceive only 'preconceived' goals, as a result of the anti-democratic 'absolutistic' logic bitterly denounced by John Dewey.[225]

All that remained was to confirm, through its generalisation, that the decorativo-pragmatic paradigm opened up by the Paris *Dance* outside of all 'site-specificity' would be viable for works that took possession of a defined space so as to 'vivify' it. This is what was made possible by the development of the so-called cut-out technique with paper and scissors: quantities of large sheets painted in advance with gouache by the anonymous hands of assistants are cut out with scissors by Matisse who, like a sculptor, cuts directly into colour.[226] It was while working on the Merion and then the Paris *Dance* that he had discovered the practical and constructive value of this technique: it allowed him to use a muralized colour (without effects of touch or of material, and in this sense *post-pictorial*) and to continually adjust the whole work without

221 Matisse, 'Interview with Dorothy Dudley, 1933', in Flam (ed.), *Matisse on Art*, 107–113: 109 [EPA, 140].

222 Let us signal that in 1927 Dewey had published *The Public and its Problems*, whose theme, at once democratic ('democracy [...] is the idea of community itself') and experimental (within the framework of a pragmatist thinking of experience and of politics as experimentation turned toward the 'development of individuality' by association and cooperation) had succeeded, in one way or another, in sensitizing Matisse to the question of the *public*.

223 Remark to Zervos in 1931, EPA 120n78.

224 Remark to Lejard in 1951, *Ibid.*

225 J. Dewey, *The Public and its Problems* (Chicago: Sage Books, 1927), 202 (and see all of chapter VI: 'The Problem of Method').

226 'Cutting directly into vivid colour reminds me of the direct carving of sculptors' (H. Matisse, *Jazz* [Paris: Tériade, 1947]; 'Jazz', in Flam (ed.), *Matisse on Art*, 169–75: 172 [EPA 237]).

having to repaint large surfaces. Matisse would eventually make them as works in themselves, not just as sketches or maquettes—works in painted paper cut into *forces-signs* we might call *bio-meta-morphic*, but only on condition that we think them as free of all imaging reference (whether figurative or abstract) to elementary forms or any kind of (biomorphic) organicity.[227] Adopting a neologism coined by Carl Einstein, we might risk the term *bio-metamorphotic*[228] to better describe a metabolism deterritorialized by its constant openness to new differenciating connections. (This is Matisse's fundamental difference from Hans Arp, in whose work it is the forms that metamorphose, in a dynamic of the envelopment of the human in nature: Arp's plastic romanticism).[229]

These signs-forces are capable of deploying, without all the (physical-formal) mediations of 'painting', the most *relational* reality of colour—colour thus being raised, through the intervention of the non-painter, to the rank of a 'critical activity':[230] *colour as pure composition of forces, rendered independent of the medium*[231] when it expresses *'the only light that really exists, that in the artist's brain'*.[232] Embarking upon what he himself conceives as 'a new departure',[233] Matisse will set out by pinning these elements onto the wall of his apartment-studio, playing with constant modifications of their forms and their reciprocal positions to reveal their becoming-sign in the continuous variation of assemblages always under construction.[234] (It is this processual dimension that is

227 In his presentation of the landmark exhibition 'Cubism and Abstract Art' at MoMA, Alfred H. Barr opposes a 'biomorphic' pole incarnated by Henry Moore to a 'geometric' pole—in decline, in his view—represented by Mondrian (and Nicholson). See A.H. Barr, *Cubism and Abstract Art*, exhibition catalogue (New York: Museum of Modern Art, 1936), 152, 201.

228 As Carl Einstein writes in his texts from the 1930s: *Metamorphotisch*.

229 Uwe Schramm perfectly summarises this romanticism placed under the aegis of Goethe and Rudolph Steiner as follows: 'To insert art into life [according to Arp, means] to assimilate its genesis to the natural processes of growth, to create an authentic life parallel to nature'. U. Schramm, 'Le concept de l'espace dans l'oeuvre de Jean Arp', in *Jean Arp. L'invention de la forme*, exhibition catalogue (Brussels: Palais des Beaux-Arts, 2004), 51.

230 'Color' as a critical activity: color as composition', in the words of J.H. Neff, 'Matisse, His Cut-Outs and The Ultimate Method', in J. Cowart, J.D. Flam, D. Fourcade, and J.H. Neff (eds.), *Henri Matisse: Paper Cut-Outs*, exhibition catalogue (St Louis, MO: St Louis Museum and Detroit Institute of Arts, 1977), 28.

231 Whence also the multiplicity of media *adopted* by the cut-out gouaches: from the book to ceramics, ballet costumes, and liturgical robes to tapestries....

232 H. Matisse, 'The Role and Modalities of Colour, 1945', in Flam (ed.), *Matisse on Art*, 154–6: 156 (*EPA*, 199) (emphasis ours).

233 H. Matisse, 'Interview with Verdet, 1952', in Flam (ed.), *Matisse on Art*, 209–17: 216 (*EPA*, 250).

234 'The forms therefore function as signs not only in the connotative, but in the syntactical sense', explains Jack Flam, in his article entitled 'Jazz' (in Cowart et al. [eds.], *Henri Matisse: Paper Cut-Outs*, 42). It is this absolute predominance of the 'syntactic' over the 'connotative' that expresses the *forcing* of forms and the development of signs-forces whose heterogenesis in colour we have demonstrated. In the same catalogue Dominique Fourcade regrets that Matisse 'distils' form to such a degree that all that remains is the sign (D. Fourcade,

arrested by the museal exhibiting of Matisse's cut-outs independently of the proces-suality 'internal' to each one of them.[235] And one might well be reminded here of Hélio Oiticica's remark on Mondrian: the plastic reality and the intention of his work would benefit from being extracted from any sort of museal aestheticization, and re-presented in the production 'environment', recreated from photos of the artist's studio.[236] But Mondrian is not Matisse, and the 'museum' is liable to come back in through the studio window...). In the movement of its constitutive multiplicity, the work is carried out as an experiment opened up by a machinic force (*a sort of perpetual cinema*, to use Matisse's expression)[237] that invests the site in free-direct manner by reconstructing it as a nomad space, a smooth space, afocal, *all-over/all-around*. It develops itself for itself, inventing itself at every instant, both assembled [*agencé*] and aleatory, with no idea of any global organization (whence the importance of jazz, which we have extended into *free jazz*).[238] This art is not so much 'popular' as it is the bearer of a 'community to come'[239] since it is the closest to *the means and forces of common expression* raised by Matisse to the level of a higher 'spontaneity' in which an *unconscious vital cerebrality* expresses and constructs itself.

An art that *does not want* to simply accommodate, or accommodate itself to, common experience, but on the contrary seeks to *take it out of itself by force* (by con-ferring upon it rather un-'common' singular forces), toward a more highly intensive ex-perience of the *milieu of life that it furnishes* (but does not 'decorate' in the usual sense of the word). It is a matter of elevating without sublimating, that is to say of *augmenting*

'Something Else', in Cowart et al. [eds.], *Henri Matisse: Paper Cut-Outs*, 52.) But it is Ma-tisse himself who ceaselessly places the question of the 'sign' at the heart of what he calls his 'second life', after his 'terrible operation' had 'completely rejuvenated' him and 'made him a philosopher' (Letter from Matisse to Marquet, 16 January 1942, *EPA* 288).

235 It would be impossible not to mention, in this connection, the exhibition at Tate Modern, London, and MoMA, New York, 'Henri Matisse: The Cut-Outs' (17 April–7 September 2014/ October 12, 2014–February 10, 2015), along with its catalogue (K. Buchberg, N. Cullinan, and J. Hauptman [eds.], *Henri Matisse: The Cut-Outs* [London: Tate Publishing, 2014]) in which many of the contributors are indeed obliged to confront this question.

236 Cf. H. Oiticica, 'A obra, seu carater objetal, o comportamento' (1968), reprinted in Figueiredo, Pape, and Salamão (eds.), *Aspiro ao grande labirinto*, 118. This passage is cited (in English translation) in M.C. Ramírez, 'Hélio's Double-Edged Challenge', in Ramírez (ed.), *Hélio Oiti-cica: The Body of Color*, 22.

237 'When I work, it is truly a sort of perpetual cinema' (remark reported by G. Diehl, *Henri Ma-tisse* [Paris: Tisné, 1954], *EPA* 152).

238 See the paragraph 'Jazz', in 'Jazz, 1947', in Flam (ed.), *Matisse on Art*, 174 (*EPA* 240); and Alliez and Bonne, *La Pensée-Matisse*, 320. Published during summer 1946, the text of *Jazz* coincides with the production of the first gouache cut-outs on a 'mural scale'.

239 This Emerson-inspired theme was at the heart of Dewey's social philosophy, in which he took great care to distinguish the community of the State from the 'politically organized commu-nity'. See Dewey, *The Public and its problems*, 14.

through intensification the cerebral-sensible quality of common life by rendering it as singular as possible in each 'experience' (a superior pragmatism). If the 'finished' (in both senses of the word) work places in continuous variation a space that is mural (non-pictorial) in nature and 'in principle infinite, open, and unlimited in every direction',[240] the important point is that it continues to compose itself, to assemble itself, to processualize itself, without ever producing a composition that would delimit with its Form (in expansion) the (expanded) place of art, a place inevitably haunted by the no longer so new 'esthetic of the wall' that would have taken up the baton of modernist 'technologies of the surface' (flatness) only to define the space of the White Cube.[241]

Matisse would then mean 'something else', 'elsewhere as well as anywhere', as Dominique Fourcade regretfully suggests, in response to the question which, to his mind, is posed by the cut-outs of a Matisse more 'American' than he is 'French': 'Did Matisse not open the door to art's leaping outside of itself, art's wrenching itself free from itself, in such a way that it is no longer in any way art?'[242]

<p style="text-align:center">*</p>

Only on a few exceptional occasions did Matisse have the opportunity to carry out an 'architectural painting' within an architecture that agreed with the vital-pragmatic conception of their conjunction that he had developed. And only one of these projects—and by this token an important one, however limited—merits comparison with the constructivists' most decisive experiments in conjugating architecture and mural decor. This is Matisse's intervention in the planning of a school complex constructed in his native village of Cateau-Cambresis, and in particular the immense window *The Bees* (3.50 × 10.33 m) which he had installed in the playroom of the kindergarten wing, in conformity with a sophisticated architectural dispositif that he had defined with great precision (1952–1955) [fig. 10, overleaf]. We shall compare this work, the appearance of which is rendered more geometrical than figurative by the coloured quadrilaterals that play a part in its construction, with the exemplary case of Theo van Doesburg.

It is notable that it was on the occasion of a commission for internal windows that (in 1917) the Dutch artist moved from a cubist-inspired painting whose figurative point of departure is still visible, to a radical (so-called geometrical) abstraction that integrated the ironwork of the support into the rhythm of the plastic work. The windows and projects for windows that he realised between 1917 and 1919 are still centred works and,

240 Deleuze and Guattari, *A Thousand Plateaus*, 475–6.

241 We borrow these two expressions from B. O'Doherty, *Inside the White Cube: The Ideology of the Gallery Space* (Berkeley, CA, Los Angeles, and London: University of California Press, 1999 [Expanded edition]), 22 ('technologies of flatness'), 29 ('esthetic of the wall').

242 Fourcade, 'Something Else', 55.

10. Henri Matisse, *The Bees*, 1952–1955, window, 3.5 x 10.33 m, kindergarten of the 'Henri Matisse' school complex, Cateau-Cambresis.

even when they are friezes, remain self-enclosed,[243] but the designing of these 'constructive compositions', made of small coloured rectangular planes, would drive Van Doesburg, in his subsequent work, to concentrate far more than his contemporaries on the place—decisive, he believed—of painting in modern architecture.[244] In 1917 he founded the journal *De Stijl*, the first issue of which contains an important manifesto-article in which Bart van der Leck denounces the subordination of painters to architects, foregrounding the essentially 'collaborative' nature of architecture.[245] The radical abstraction of Van Doesburg's painting—initially in step with Mondrian's neo-plasticism but later liberated, by the introduction of the 'dynamic diagonal', from the sole opposition between horizontal and vertical, which he judged too static—seemed to him, in accordance with the spirit of *De Stijl*, well disposed to having its pure rectangles and

243 F. Migayrou (ed.), *De Stijl, 1917–1931*, catalogue for the exhibition 'Mondrian/De Stijl' (December 2010–March 2011) (Paris: Centre Georges-Pompidou/Musée national d'Art moderne, 2010), figures 47–53.

244 It was in 1916, following encounters with architects including Pieter Oud (who commissioned windows for his constructions from him), that Van Doesburg co-founded with them the journal *De Sphinx*, whose stated aim was 'to promote relations between painting and architecture and to develop a monumental art'. (Migayrou [ed.], *De Stijl, 1917–1931*, 276). He would also, like Vilmos Huszár, produce 'colorizations' or maquettes of surfaces in primary colours for façades and interiors.

245 B. van der Leck, 'De plaats van het nieuwe schilderen in de architectuur [The place of modern painting in architecture]', *De Stijl* 1:1 (October 1917), 6–7.

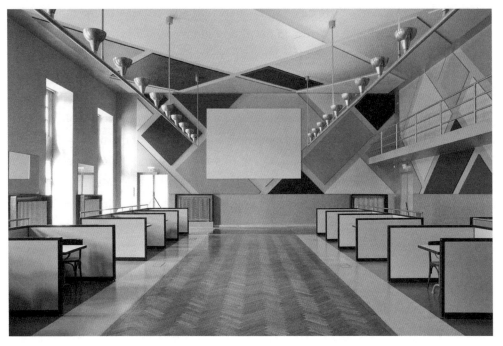

11. Theo van Doesburg, Cinema-Ballroom at L'Aubette, Strasbourg, 1927–1928, after restoration.

coloured lines—preferably in primary colours—placed in tension with the surfaces that architecture offered to the painter who himself was not an architect. In fact, on the strength of numerous projects and maquettes he had designed with the help of professional architects, Van Doesburg would swiftly claim this title—but conflict with the professionals was inevitable, as he would discover when he collaborated with Pieter Oud on a plan for the Spangen neighbourhood in Rotterdam (1918–1921). Oud found Van Doesburg's asymmetrical composition and dissonant colours rather too menacing a 'destructuration of the monumentality of the architecture'.[246] Not without reason, since this was indeed Van Doesburg's intention: following Bart van der Leck, during this period he theorised about the need for colour to act dynamically ('destructively') on the static ('constructive') heaviness proper to architecture, so as to promote a new 'rhythmical unity' with the latter (the ensuing quarrel between the two men was to prove terminal).

For our comparison with Matisse we will consider the most important concrete outcome of his ideal, namely the internal restructuring of L'Aubette (1927–1928), an immense building in Strasbourg that served as a multipurpose entertainment venue. Van Doesburg conceived of it as a synthesis of all the arts (mural decoration, music, furnishing, cinema, dance…) with architecture, with the aim of 'preparing for the total work of

246 Migayrou [ed.], *De Stijl, 1917–1931*, 38. Mondrian also considered, but for entirely different reasons, that Van Doesburg's painting was in contradiction with architecture (cf. infra).

art [*Gesamtkunstwerk*]'.[247] He believed he would be able to base this synthesis on a 'pure plastic architectonic' that would have to obliterate any independent decorative effect, since the 'in the case of a [traditional] *decorative use of colours*, we are simply dealing with the effect of a good taste for colours in space. With the use of [ornamental] colour, space is decorated, and this without any organic link with the construction. Colour serves only to dissimulate the construction.'[248] Here we will consider only the monumental and dynamic 'interior decor' he conceived for the function room and the cinema-ballroom [figs. 11, p.73, and 20, p.89]. In this type of work, driven by a 'coherent formal conception' militating against the idea of a 'temporary realisation',[249] Van Doesburg intended to surpass, if not formalism, at least the static equilibrium of classical neo-plasticism (but the late Mondrian would find a way out of this), as well as the inexpressive utilitarianism of architectural functionalism. Apart from the transformation of mural painting into a 'painting of space' (or 'space-time')[250] and the proclamation that 'painting separated from architectural construction has no reason to exist'[251] (for which the critique of the frame/framing of easel painting had paved the way),[252] what fundamentally authorises our comparison with Matisse is that, within a perspective that we must call vitalist, Van Doesburg conceived of the (dialectically affirmed) necessity of introducing the dynamic diagonal into the plastic architectonic. As he reasoned, in what must be among his first position statements (in 1915–1917), if 'art is not being but becoming', and if 'life is continual movement', then 'so is the art whose subject is the content of life'.[253] Through this art that thinks of itself in essentialist terms ('the beauty of pure art') while claiming for itself a 'new plastic' ('to produce the purely plastic artwork') that *sublates* 'aesthetics' in the form of a 'monumental art that is our future'[254]

247 According to the announcement of *Stijl Kursus* given by Van Doesburg from March to June 1922 at the Bauhaus (Weimar).

248 T. van Doesburg, 'La couleur dans l'espace et dans le temps [Colour in Space and Time]', published in 1928 in *De Stijl* 8:87–9.

249 Cf. Letter from Theo van Doesburg to Paul Horn, Strasbourg, 10 October 1927, reproduced in I. Ewig, M. Polman and E Van Straaten, *L'Aubette ou la couleur dans l'architecture* (Strasbourg: Association Theo van Doesburg et Musées de la Ville de Strasbourg, 2008), 73.

250 The expression 'painting of space-time' features as a fundamental notion in Theo van Doesburg's article 'La couleur dans l'espace et le temps', in Migayrou [ed.], *De Stijl, 1917–1931*, 262.

251 T. van Doesburg and C. Van Eesteren, '-□+-R4' [1923], *De Stijl* 6:6/7 (1924), 92, reprinted in Migayrou (ed.), *De Stijl, 1917–1931*, 256.

252 T. van Doesburg, 'Lijstenaesthetik [Aesthetic of the Frame]', *De Stijl*, 3:11 (1920).

253 Respectively in the review of an exhibition that appeared in the journal *Eenheid* (6 November 1915), cited in J. Joosten, 'Le contexte d'une évolution', in S. Lemoine (ed.), *Theo van Doesburg. Peinture, architecture, théorie* (Paris: Philippe Sers Éditeur, 1990), 61; and in 'De nieuwe beweging in de schilderkunst [The New Movement in Painting]', in the journal *De Beweging* (1916), cited in H. L.-C. Jaffé, 'Theo van Doesburg et la fondation du *Stijl*', ibid., 87.

254 Respectively in the introduction to the first issue of *De Stijl* dated October 1917; and in 'De

and 'in which a diversity of spiritual manifestations (architecture, sculpture, painting, music, and speech) will be realised harmoniously as a unity [because] each, in its own domain, will formally attain the summit with the help of the others',[255] what is therefore ambitiously envisioned—and very early on—is nothing less than 'the plastic rhythmic transformation of universal life'.[256] (In the trialogue published over three issues of the journal *De Stijl* [1919–1920], Mondrian in turn takes up the question of rhythm as 'plastic enunciation of life' in the movement toward the universal via which 'life, the real-material that it is, will become real-abstract', i.e. an absolutely *denaturalised* 'pure equilibrium of relations' expressing itself in the form of a 'cadence of straight lines and rectangular oppositions'.)[257] Van Doesburg will associate rhythm with the theme of dance, understood as 'the most dynamic expression of life and, consequently, as the most important subject for pure plastic art'.[258] Something that will lead him from *Heroic Movement (The Dance)* (1916),[259] very formally inspired by Matisse, to the production of his first and most successful windows: *Dance no 1 in Primary Colours, Dance no 2 in Secondary Colours* (1917),[260] and all the way to the pure, purely abstract plasticity of *Rhythm of a Russian Dance* (1918).[261] As for the mural paintings he made for the dancehall and function room at L'Aubette, although they no longer thematise dancing, their geometric plasticity brings together the walls and ceilings of the rooms with the intention of associating their abstract dynamic with that of the dancers. The realisation of this ideal and 'heroic' 'vision', inspired by the 'positive mysticism' of Schoenmaekers and his *New Image of the World*, translated into the *Principles of Plastic Mathematics*[262] (confirming

Beteekenis Van de kleur in binnen en buitenarchitectuur [The Significance of Colour in Interior and Exterior Architecture]', *Bouwkundig Weekblad* 44:21 (1923), 235 (cited by E. Van Straaten, '"La couleur dans l'espace et le temps' de Theo van Doesburg', in *L'Aubette ou la couleur dans l'architecture*, 107).

255 A remark in 'De nieuwe beweging in de schilderkunst [The New Movement in Painting]'. And yet the future unity will no longer be termed 'monumental art'—it is an 'architectonic forming of space' ('La couleur dans l'espace et le temps', 262).

256 Letter to Bart van der Leck, 31 December 1916, cited in Joosten, 'Le contexte d'une évolution', 68.

257 P. Mondrian, *Réalité naturelle et réalité abstraite* (1956) (Paris: Éditions du Centre Pompidou, 2010), 21, 72–3.

258 Letter from Van Doesburg to Kok, 14 July 1917, cited by C. Blotkamp, 'Reconsidérations sur l'oeuvre de Theo van Doesburg (jusqu'en 1923)', in Lemoine (ed.), *Theo van Doesburg. Peinture, architecture, théorie*, 27.

259 Reproduction in *Constructing a New World. Van Doesburg and the International Avant-Garde*, exhibition catalogue (London: Tate Publishing, 2009), 81.

260 These two *Dances* are reproduced in Migayrou (ed.), *De Stijl 1917–1931*, 47 (ibid, 46, for reproduction of another 1916 painting, *Dancers*, in two rhythmically complementary panels).

261 Reproductions in *Theo van Doesburg. Peinture, architecture, théorie*, 90.

262 Schoenmaekers's two works were published in 1915 and 1916. For an initial look at the importance of his work for *De Stijl*, see Marek Weiczorek's stimulating article 'Le paradigme De Stijl', in Migayrou (ed.), *De Stijl, 1917–1931*, in particular 70–71.

Van Doesburg's interest in the fourth dimension), supposes 'that an essential renewal of the contemporary mentality can take place'[263]—in a 'disinterested' sense that allies the '*suprasensible*'[264] with the dynamic vision of life relayed by the new scientific conceptions of space and time so as to celebrate 'the grace of neo-plasticism'.[265]

At the outset of neo-plasticism, Van Doesburg posits that space be animated by 'the idea of extent' that the artist aims to *format [mettre en forme]* from a 'purely aesthetic' point of view constitutive—with and beyond Mondrian—of the *nieuwe beelding/ Neue Gestaltung* (as incorporated into the German title of the original edition of the *Fundamental Principles of Plastic Art*, published in 1925 in the *Bauhausbücher* collection: *Grundbegriffe der neuen gestaltenden Kunst*).[266] So that if '[e]verything that surrounds us is an expression of life' and as such implies an experience of the 'environment', then it falls to the work of art to propose its formation, in the form of an 'intellectual *active* experience of reality' whose aesthetic purity is supposed to attain a universality adequate to the cosmos 'within the bounds of the expressional means proper to each art'.[267]

263		T. van Doesburg, 'L'élémentarisme et son origine', *De Stijl*, 8:87–89, special issue on *L'Aubette*, Series XV, 1928, in Migayrou (ed.), *De Stijl 1917–1931*, in particular 263. At this point it is a question of 'constructing a new work from the residues of the old world' in an avant-gardist dialectic of destruction-construction raised to a '*suprasensible* reality' (emphasis the author's). The first editorial of the journal explained, more modestly, that it 'aimed to better alert our contemporaries to what is new in the domain of the arts', precisely from the point of view of its relation with 'the spirit of the times'.

264		The same text speaks of 'a disinterest and an heroic spontaneity'. In one of his last articles, 'The Rebirth of Art and Architecture in Europe' (published in 1931 in Serbo-Croat in the journal *Hrvatska Revija*), Van Doesburg calls for a 'style of a heroic monumentality' as the 'style of the total man' (French translation in E. Van Straaten, *Theo van Doesburg peintre et architecte* [Paris: Gallimard–Electa, 1993], 36).

265		T. van Doesburg, 'Moderne wendingen in het kunstonderwijs [The Modern Turn in the Teaching of Art]', *De Stijl 2:3* (1919). A year later, Mondrian would define the *New Plastic* as 'the expression of the *vital reality of the abstract*' (italics the author's), specifying that Neo-plasticism 'could also be called *Real Abstract Painting* because *the abstract* (just like the mathematical sciences, but without attaining the absolute as they do) can be expressed via a plastic reality' (P. Mondrian, *Le Néo-Plasticisme. Principe général d'équivalence plastique* [Paris: Éditions de l'effort moderne, 1920]; republished in Migayrou (ed.), *De Stijl* 4:2 [1921]; P. Mondrian, *Écrits français* [Paris: Éditions du Centre Pompidou, 2010], 32, 35).

266		T. van Doesburg, *Principles of Neo-Plastic Art*, tr. J. Seligman (London: Lund Humphries, 1969), 7 (for the 'forming' of 'the idea of extent'), 14–39 (on aesthetics as 'formative unity of the whole' of art). In opening, Van Doesburg signals that '[t]he original manuscript was completed in about 1917 from notes made as long ago as 1915'. At this time, van Doesburg proposed an analysis of cubism whose 'mathematical order, relations of measure, equilibrium and content' make it the precursor of the 'plastic painting' of the future (cf. T. van Doesburg, 'De ontwikkeling der moderne schilderkunst [The Evolution of Modern Art]', published in the journal *Eenheid,* June 1915, reprinted in T. van Doesburg, *Drie voordrachten over de nieuwe beeldende kunst [Three Lectures on the New Visual Arts]* [Amsterdam: Maatschappij voor Goedkoope Lectuur, 1919]).

267		Van Doesburg, *Principles of Neo-Plastic Art*, 10–13, 14–15. 'The artist will expose universal cosmic relationships and values (balance, position, dimension, number, etc., which are

But the essential point remains *the purification of plastic means* (this is the condition of a pure plastic art, i.e. one that is purely aesthetic), a purification that privileges painting (as a plastic art 'flat on the plan(e) [*plane dans le plan*]', as Mondrian, *at his most modernist*, says of Van Doesburg)[268] in the architectonic movement that is supposed to negate it as object by projecting it into the *three-dimensional* purity of colour planes that open up space to the temporal dimension of existence. For Van Doesburg this is where the entire 'importance of colour qua *element of architecture*' lies,[269] at the end of a movement in which 'the "idea" of "art" as an illusion separate from real life must disappear'.[270] (In his critique Van Doesburg associated Mondrianesque static flatness with a purely abstract relation to life that he saw as the essential limit of the painter: 'He thinks life, but does not live it').[271]

It is difficult to know just how involved Matisse was in the final design of the Cateau school complex (in August 1953), but it was so different from the previous projects of Ernest Gaillard, the official architect of the Département du Nord, that one is justified in supposing that he must have played a significant role.[272] Certainly Matisse himself would not have been responsible for the architecture of the buildings, but the strict control he exerted over the placement, design, and future purpose of the room where the window was to be situated led to profound changes in the plan and the aspect of the whole [fig. 12, overleaf]. Firstly, a number of buildings facing onto the road and staggered (in height, form, overhang or setback...) were replaced by a single long building, to be used as the boys' and girls' primary school, set back from a large courtyard opening to the outside. Rather than a solid construction, it presents a continuous façade of large windowed bays whose metallic frames are painted with a sustained blue, and which dispense with any hierarchy of elements. This blue, which emphasises the rhythm of the facades, is also no doubt something Matisse requested on account of its interplay

obscured or veiled by the accidents of the individual case) [...] by *abstracting* all the chance singularities of the object' (ibid., 21).

268 P. Mondrian, 'L'expression plastique nouvelle dans la peinture', *Cahiers d'Art* 22:7 (1926); republished in P. Mondrian, *Écrits français*, 132 sq.

269 T. van Doesburg, 'Les couleurs dans l'espace et le temps', *De Stijl* 8:87–79, 261.

270 T. van Doesburg and C. Van Eesteren, 'Vers une construction collective', *De Stijl* 6:6–7, 1924, 'Towards a Collective Construction', in H.L.C. Jaffe, R.R. Symonds and M. Whitall, *De Stijl* (London: Thames and Hudson, 1970), 190–91.

271 In a letter to Oud, 12 September 1921, cited by N.J. Troy, *The De Stijl Environment* (Cambridge, MA and London: MIT Press, 1983), 70.

272 We borrow much of the architectural information on the Cateau-Cambresis school complex from the dossier assembled, illustrated, and analysed in R. Percheron, C. Brouder, *Matisse. De la couleur à l'architecture* (Paris: Citadelles & Mazenod, 2002), 281–320.

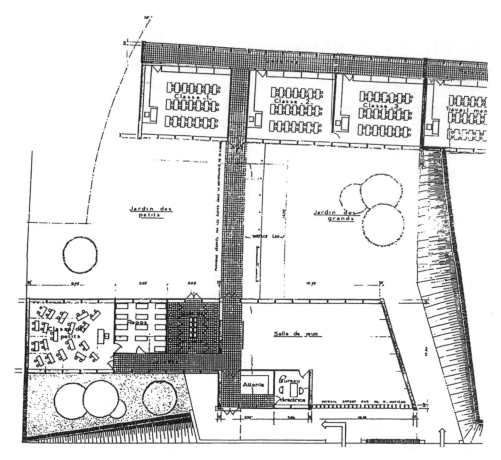

12. 'Henri Matisse' school complex, Cateau-Cambresis, partial plan (in front, the kindergarten; on the right, the playroom with Matisse's window; in the centre, the walkway connecting the kindergarten to the primary school, below it; the hatched area to the right is the bank separating the playgrounds.

with the colours of the school.[273] On the other hand, the kindergarten was kept facing onto the road, but placed completely to the left of the plot where it was originally placed, slightly below the primary school yard (because of the slope of the ground) [fig. 13].[274] A colonnaded walkway was added, also with blue bay windows, extending across the courtyard and dividing it in two, linking the rear of the kindergarten with the primary school building [fig. 14]. It is most unlikely that Gaillard alone was responsible for an alteration so radical, the refined conception of which, completely unlike the previous plans, does not seem in contradiction with an architecture of somewhat 'modernist' spirit. In any case, the geometry of the structures is more in agreement with the

273 According to a note by Ernest Gaillard, Matisse 'followed the studies [...], counselled the architects, chose the quality and tone of certain materials' (cited in ibid., 292). A well-researched technical study on the project by Dominique Szymusiak has established that Matisse 'redefined the architecture of the school and the decoration of the room' (ibid.).

274 The extent of the modifications can be gauged by comparing the various projects, ibid., 282–3.

13. 'Henri Matisse' school complex, Cateau-Cambresis, kindergarten: on the right, the armature of the window *The Bees*.

14. 'Henri Matisse' school complex, Cateau-Cambresis, exterior view onto the gallery connecting the kindergarten to the primary school, to the right.

15. 'Henri Matisse' school complex, Cateau-Cambresis, view of Matisse's *Bees* from the playground.

16. 'Henri Matisse' school complex, Cateau-Cambresis, interior of the walkway linking the kindergarten to the primary school.

composition of the window in so far as the latter is also designed to produce a dynamic counterpoint—that is, precisely the type of 'destructive-constructive' function which, according to Van Doesburg, the architectonic plastic of colour planes should play in regard to (if not against) architecture in order to open up and animate or activate 'the spatially limiting flatness of architecture'[275] (here *expansion* is the keyword). And this in the expectation that the architect-painter of the future will no longer have to intervene in predefined spaces, but will be able to define them according to the expansive vision of a pure architectonic at once pictorial and architectural, one whose paradigm Gerrit Rietveld succeeds in introducing with his Schröder house (1924), whose play of mobile partitions, negating the closure-function of the wall, activates a space whose colour, playing on its *optical partition*, punctuates and dynamizes its functional potentialities.

Matisse presided over an architectural dispositif that not only included his window, but had been shaped 'on the scale of the entire kindergarten'[276] to lead to and to introduce it. He had carefully determined the conditions of a progressive access to the window, whose large dimensions might have intimidated the children had they come upon it too directly. From the street one can make out its reverse side, strongly punctuated by the high-relief pillars of its cement frame [fig. 13]. Their tight verticals, along with the large blue bays, cut into the white transoms of the two buildings of the kindergarten and, even though the height of the window room's facade on the street is the same as that of the neighbouring facade with which it is aligned, the thrust of its pillars makes it seem higher. The 'plastic' and chromatic singularity of the building and its solidarity with the rest of the school are therefore clearly affirmed. To enter into the kindergarten, one must first travel along its right flank and then go around it; through two glass doors arranged at an angle and a glass wall, the window is already visible, at first from the side, then head on, before one enters the gallery through the yard [fig. 15]. When a child comes into the school, the first building they enter, like a bridgehead, is entirely non-threatening, not at all stern and school-like—they know and can see that it is a playroom, constructed of the same red bricks as the houses of the region, in contrast to the blue walls of 'school'. Similarly, the adjoining gallery is bright, largely transparent, and suffused with light, since the bottom of the large bays is in cathedral glass and the ceiling, supported by a row of thin white columns, is pierced by large, square translucent skylights [figs. 14 and 16]. These openings, which follow the rhythm of the bays, run the whole length of the gallery ceiling but only half its width

275 In the words of Bart van der Leck's pioneering article 'De plaats Van hat nieuwe schilderen in de architectuur [The Place of Modern Painting in Architecture]'), *De Stijl* 1:1 (1917), 6–7, which we alluded to above.

276 Percheron and Brouder (eds.), *Matisse. De la couleur à l'architecture*, 285 (see also 298).

(on the door side),[277] creating a very subtle interpenetration of interior and exterior. There is something playful in the geometrical elegance of this place of welcome and passage—in some sense it is a consummately Matissean lesson on the good use of 'modernism' and 'classicism', since these are the two categories in relation to which Matisse clearly positions himself here, if only by operating a détournement of both. On one hand, he takes up the 'forms' and 'structures' of geometrical modernism without falling into the idealism of a pure plastic, nor into the cold severity of in-ternational-style architecture (which, on the contrary, is manifestly the origin of the massive slab of the primary school building, in which Matisse no doubt had little say). In the walkway, the elementary geometricism of the glass structures lightens the functionality, stripping it of all emphasis. On the other hand, the slenderness of the columns and the wide spacing between them prevents them, properly speaking, from playing the (aesthetic) role of a 'colonnade' or mini-portico (with an optical enfilade effect)—not simply a matter of decorum (as if the children should also be entitled to columns, according to the postmodernist principle of the ostentatious re-exhibiting of classicism). Above all, the succession of these columns between the large bays, their clear offsetting from the glass wall, and their whiteness standing out from the blue, establish the constructive rhythm of the loadbearing elements. Their functional seriality is strongly highlighted yet perfectly integrated into the overall architectural dispositif. The ordering of this passageway open to the exterior allows space to be at once punctuated and fluid and, as such, vivified.

The gallery opens onto a large vestibule, itself also open to the exterior and giving access, at right angles, to the window room. The latter must be large enough to sit comfortably with the considerable (although not 'monumental') size of the work and to allow the necessary space to stand back to fully take in its ex-pansive force. Still, the window cannot be seen all at once, since the internal wall of the vestibule forms a strong salient angle (to accommodate the service spaces) which at first conceals it from complete view (the whole vestibule-playroom is a very broad L-shape). The site is therefore conceived so as to ensure that the win-dow can only be discovered—can only be *constructed*—little by little, from the side and from left to right, as if it were anticipating the person who approaches it [fig. 17].[278] But what is seen is ambiguous, or rather ambivalent: should we read i the two major curves as descending toward the left, or as ascending toward the right, and

277 As is shown by the plan of the school from 10 August 1953, Matisse had, at this time, planned 'two different floorings', one bright for the welcome side, the other 'with chequered colours' for the corridor side (ibid., 300, 283 for the plan).

278 The window does not take up the whole width of its wall, and is staggered on the right (and not centered) so that what one first sees is the fragment of the wall to the left of the window.

17. Henri Matisse, *The Bees*, approaching the window from right to left.

vice-versa for the lines of coloured elements that cross over them? Either would be possible, but one cannot predict the ensuing 'trajectories', although one assumes they will extend further. Each stage in the approach already constitutes a fully effective part of the process *and of the work* in which the spectator-operator plays a part. But the pertinence of the fragment he perceives does not depend on a 'synoptic effect': the process is one of the material re-construction of/in the work, not the re-presentation of its formal elaboration from the spectator's point of view. Moreover, the volume of the room grows toward the window because the white ceiling has a slope, already noticeable in the vestibule, that rises towards it, whereas the wall that faces the visitor as he advances into the vestibule broadens out in the same direction. The volume of the room and its completely irregular plan are therefore directly and comprehensively governed by the conditions of the *space-time* (to use Van Doesburg's terminology) within which Matisse wished to inscribe the virtualities of his machine-work so that the body would coenaesthesically sense its expansiveness through the movement that it mobilises. Thanks to the offsetting of the two complexes, the two glass doors in the angled walls of the window room benefit from a view out toward the exterior—in particular onto a few trees and green slopes (connected to the gradient of the terrain

18. 'Henri Matisse' school complex, Cateau-Cambresis, view from the window room onto the embankment, the two school yards, and the primary school.

upon which the window room lies in relation to the primary school yard) [fig. 18]. With these two bays Matisse took to the limit, *in both directions*, his principle of the interpenetration of interior and exterior, not forgetting the variations of light that the (south-facing) window undergoes with the movement of the sun. A floor of hexagonal red tiles (recently installed, according to Matisse's wishes) contrasts with the green of the slopes, while the white walls (which have not been realised) would have diffused the colours.[279]

In its efficacy, in the rigour of its multiple components, in its extraordinary ingenuity, this dispositif has nothing to envy the productions of Van Doesburg. Certainly, Matisse cannot compare with the inventiveness of the latter and his numerous projects (although in truth most remained theoretical), in terms of plans, maquettes, and schemas for the distribution of colours on partitions, floors, and ceilings; with his knowledgeable axonometric projections of nested, staggered, and broken volumes with fixed or mobile walls, and his 'counter-constructions' with floating surfaces of colour.

279 In a letter to Ernest Gaillard, 10 February 1955, Marguerite Duthuit, daughter of the painter, recalls the *imperative* requirements of Matisse (who died in November 1954) in relation to the colours of the space: 'a room with entirely white walls ("a milky white") the only colour in the room coming from the dark red floor tiles, which have the tone of *southern* hexagonal floor tiles' (emphasis ours)—the idea being that the floor, also, should bring a bit of *le Midi* into the Northern light (letter cited in Percheron and Brouder [eds.], *Matisse. De la couleur à l'architecture*, 317).

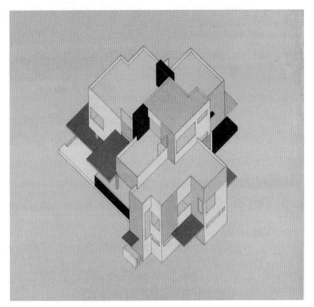

19. Theo van Doesburg, Cornelis van Eesteren, Axonometric projection of a planned house, 1923, lithograph on paper, 55 x 54 cm (Van Doesburg Archives).

Axonometry, as practiced by Van Doesburg (with the young architect Cornelis van Eesteren, and after their collaboration) did not simply function as a way to describe with greater precision his will to put planes 'in tension' [fig. 19]. Axonometric abstraction and transparency (deploying an integral, continuous volume) also responded, from a (mathematical-idealist) theoretical point of view, to the concern for the purity and universality of the plastic architectonic, reducing it (in the eidetic sense) to its graphic and coloured essence, *delivering it from the constructive and functional problems of architecture* in favour of pure 'spatial diagrams' in which colour was meant to reveal time as the fourth dimension *of space*.[280] For Van Doesburg conceives his diagrams as being projected into the 'fourth dimension' of a hyperspace, the hypercube or 'tesseract' (meaning 'four rays' in Greek), which he defines as the 'representation of a new space of centripetal and centrifugal architectonic form/formation [*Gestaltung*]'[281]—a space that must be described as 'optical, autonomous, and isotropic'.[282] One could not

280 For a theoretical formulation, see 'Vers une architecture plastique [Toward a Plastic Architecture]', *De Stijl* 6: 6–7 [1924], Migayrou (ed.); *De Stijl, 1917–1931*, 255). For an example of the 'construction of colours in the fourth dimension of space-time', see Lemoine (ed.), *Theo van Doesburg. Peinture, architecture, théorie*, 113.

281 T. van Doesburg, 'Die Neue Architektur und ihre Folgen [The New Architecture and its Consequences]', *Wasmuths Monatshefte für Baukunst* 1 (1925), 502; see Migayrou (ed.), *De Stijl, 1917–1931*, 150–51.

282 We take these terms from V. Guillaume, 'Un échafaudage de mouvements: approches et concepts opératoires de Gerry Rietveld', in Migayrou (ed.), *De Stijl, 1917–1931*, 143.

conceive of a more radical difference from the vital/ist pragmatism with which Matisse redefines the architectural space dedicated to certain ('vital') functions of the Cateau kindergarten—welcome, circulation, play—by assembling it together *with* the energetic diagrammatism of his window. In his principal intervention at L'Aubette, whose renovation he coordinated from an architectonic and aesthetic point of view (with the help of Sophie Taeuber and Hans Arp), Van Doesburg certainly concerned himself with the free circulation of people and of light between the multiple functional spaces whose lighting and furnishings he defined, along with the decor of their walls and floors...but without departing from his principled purism. The whole had to converge in the 'forming [*Gestaltung*] of the space', as the opening of Van Doesburg's programmatic text has it.

Matisse's window, initially designed for the south wall of the Vence Chapel, the cut-out maquette for which is dated 1948–1949, was to be called *The River of Life*—after the description of the celestial Jerusalem in Apocalypse. For its new destination it was debaptised and renamed *The Bees*—a lighter, more buzzy 'theme' for children. One might also emphasise the energetic charge of the 'attack': such a title makes it impossible to think that Matisse wanted to harness the harmonisation of forces so as to 'hover in space without moving',[283] in the words of El Lissitzky which were a strong influence on Van Doesburg, and which might even have made sense in Merion. Such a radical change of title and venue proves that the signification and symbolism of this work are of no real relevance to its fierce energetic expressivity. (To come back to the wheel of metaphors encountered in our analysis of Ernesto Neto's *Leviathan Toth*:[284] it is not this wheel that makes diagrammatism function; on the contrary, it is diagrammatism which, with its deterritorializing power, makes the wheel of metaphors possible.) We confirm that diagrammatism frees us at once from 'the imperialism of the signifier-signified couplet' and from the Image-Form, but that it is quite capable of tolerating all alliances with signifiance and metaphor, on condition of short-circuiting 'formation [*Gestaltung*]'—including that formation relating to 'the "plastic" [*gestaltend*] usage of colour in space' extolled by Van Doesburg.

It remains for us to show what kind of conjunction Matisse's window sets up between the decorative assemblage of its small colour planes and the architectonic articulation of the wall [see. fig. 10, p.72]. The glazed part is made up of nineteen narrow

283 See El Lissitzky, 'Wheel, Propeller and What Will Follow: Our Form-Production Is a Function of Our System of Movement' (1923), tr. S. Lindberg and M. I. Christian in D. Mertins and M. W. Jennings (eds.), *G: An Avant-garde Journal of Art, Architecture, Design, and Film, 1923–1926* (Los Angeles: Getty Research Institute, 2010), 106.

284 See Volume 1, 37–8.

panels, separated by white uprights less than half their width, which lends them a robust gravity. The surface of the stained glass is cut across by lines of colours-forces that interact with one other and with the continual rhythmic pulsing of the pillars. Matisse plays with the tension, differential at every point, between a gentle black and white curve that descends having 'climbed' from the lowest point across the uprights, and a similar curve which, at its highest point, drops almost imperceptibly before continuing on its way (falling back down only very slightly). These two curves are made up of re-peating right-angled pairs of small white quadrilaterals between two small black squares. The orientation and dimensions of this assemblage are subjected to progressive or dis-continuous variation: on the left, where the curve and therefore the gradient are stron-gest, the lower white quadrilaterals are squares, but as they rise toward the right, the black squares give way to triangles. The vibrant contrast of black and white, which slices (through) the other colours and interferes with their fluxes, produces in the stained glass a strong artificial light that cuts and (re)machines the 'natural' light (from the exterior). These two curves, which rise transversally from left to right, also function in the other direction—*artifice oblige*—since the angles formed by the pairs of white rectangles point and gently jab to the left (like a swarm of stings, to follow the meta-phor). The two curves are therefore worked from within by inverse tensions.

If we describe this work, entirely a matter of forces, as diagrammatic, it is to sig-nify that, in spite of their exceptional visual force, the angular couplings of white rectan-gles and black squares do not constitute a sequence of 'motifs' in the sense of signs-forms describing semi-abstractly or semi-analogically a beating of wings or a pure trajectory...but a machinism that precisely determines a trenchant and cutting succes-sion of plastic, chromatic, directional... fluxes whose cuts actualise as 'signs-forces' the differential intensities the fluxes collect, concentrate, and reinvigorate. Each black and white pair receives the impact of the preceding one and transmits its own impact on to the next, as one moment of a becoming of and in the generalised (and thus virtual) in-tensive differential that articulates them with one other and with all the other coloured lines of force upon which they exert, from all the blackness of their whiteness, a *scis-soring* in one direction, a *spiking* in the other. For their curves cross a broad range of oblique lines, starting from the central axis of the composition and sweeping from one side of its surface to the other with their coloured sheafs, which become more dazzling in the higher part of the window and toward the right. Essentially, eighteen rays of high-ly luminous lemon-yellow diamonds alternate with one or many rays of brown, red, and blue quasi-squares. Matisse took great care to control the quality of the glass used (particularly the yellow) and the network of cut-outs (which he wanted to all be recti-linear). Each of these rays is made up of a sequence of similarly coloured squares, some-times diagonally joined at the corner, sometimes slightly distorted or offset in height and

tipped over, compressing or overlapping their differently-coloured neighbours. These elementary coloured shapes do not provide the formal coloured units of a gridded fabric of more or less irregular design with a purely spatial dynamism; they are grains receiving and emitting energy, *affecting* one another in a field of heterogeneous forces whose forms are reciprocally defined by their linear vectors via the placing-in-tension of an aleatory materialism and a processual constructivism. Like the reticulated pseudo-column that Neto suspended in counter-tension to the geometrical rigidity of the Panthéon's cupola with its regular caissons,[285] the pseudo-grid (de-)generated by the juxtaposition of the squares is everywhere tipping over, chaotising, prey at every point to multiple pressures, threatened with cascading collapses or slippages which the black and white quadrilaterals seem to accelerate with their pulsing, or halt and turn around with their taut curvature. As exemplified and intensified by the yellow lines, the centrifugal radiation of the coloured sheafs bombards and cuts against the curves of rectangles and black and white squares toward the left, but sharpens and bolsters them toward the right; we might also say that these sheafs fall from left to right before bouncing back. But whether falling or rising back up, in any case immersed in the virtual differential of insensible forces that both underlie and menace[286] from every direction the sensible (coenaesthesic) forces that work them, these squares, rigorously delimited by the lead of the windows, become, *through their very singularities, the signs of the forces that constitute and traverse their singularities so as to assemble them in their disunion* (a swarm). For if the linear geometrical components imply a certain deductivity and a clear legibility, the force of the general assemblage comes from the systematic placing-in-tension of *lines* with the integral *non-linearity* of their course; a tension between them and the two great curves they cross; and also a tension between the potential geometrism and the *de-regulations* of the gridding which everywhere necessitate irregular *patchworks*; and finally, a tension between the linear network and the chromatic assemblages that superimpose upon it a division between darker zones and the brighter zones above and to the right. What is more, here Matisse succeeded in a complete conjoining of architectural rhythm with decorative rhythm, perhaps the most successful he ever attempted: the rapid multiplication of the columns between the glass panels scans exactly with the pulsing of their (winged) black and white motifs, and sets the fan of luminous rays vibrating by amplifying its expansion. To achieve this, rather than simply (like Van Doesburg) adapting the cut of his window to the technical demands of the ironwork (here only horizontal) so as to take advantage of its linear network, Matisse

285 See Volume 1, 49–55.

286 In their distance to the absolute limit of insensibility, or sensible=0 (on this point, see Volume 1, 54).

20. Theo van Doesburg, function room at L'Aubette, Strasbourg, 1927–1928, after restoration.

determined with exactitude every parameter of the pillars—width, spacing, rectangularity, colour, material, continuity with the wall—in complete coordination with the construction of the stained glass itself.

L'Aubette had offered Van Doesburg the opportunity to implement his architectonic conception of painting in a space which, unlike the room in Cateau, was globally predefined in advance, and which he sought to animate by counteracting its stasis in two different ways.[287] In the function room (or small dancehall) he used an orthogonal modular grid adapted to the surfaces of the room—a geometrical solution that demanded a rigorous jointing of the colour planes totally alien to Matisse's window, gridding the walls and ceiling with couples of juxtaposed squares (of side 120 cm) or rectangles (length doubled) of the same brilliant colours, reds, blues, and yellows, but alternately bright and dark, and combined with white, black, and grey surfaces [fig. 20]. The rectangular planes or pairs of planes are oriented now horizontally, now vertically, all clearly separated by 30 cm wide bands of 4 cm relief, prohibiting any chromatic interference and detaching local from global combinations of colours. In addition, 'neutral, grey

287 'What is [...] exactly Theo van Doesburg's contribution to architecture? He could have intervened in decisions bearing upon the fine tuning of volumes, on the use of certain volumes and their designation, and very probably still on circulation. The real part played by Van Doesburg in the coordination and execution of the work seems less than he sometimes claimed.' (F. Pétry, 'Les frères Horn et L'Aubette', in *L'Aubette ou la couleur dans l'architecture*, 35).

surfaces have been set out at the level of the public'[288] surrounding all the service spaces (even below the doors on the entrance side), forming vertical bands in some corners of the room and on the sides of some of the windows, whose curtains are also grey.[289] On the ceiling and walls, panels covered with spotlights and ventilation grilles are integrated into the modular dispositif. The clear alternations in the colour, contrast, direction, and even rotation of planes (particularly around the largest decentred squares on the ceiling) induce a rhythmic, all-enveloping kaleidoscopic movement, saccadic rather than modulated: the spectator, a 'user' of the place who drinks at the bar next door, chats, looks around, circulates, and above all the dancer, grasp only the singular but perpetually changing or repeating scansions (hence Van Doesburg's construction of the notion of a PAINTING THAT CREATES TIME-SPACE).[290] Van Doesburg 'had planned a room in two parts: at the centre, a square podium designed for the orchestra was to separate two circular parquet dancefloors. [...] In the end, the whole floor [on order of the commissioners] was executed in parquet, even though he hated this solution' because it disrupted his 'plan of circulation'[291] for this room, which stipulated 'a coloured floor, whose motifs enter into conflict with the squares on the walls: large yellow circles [for the dancefloors] on a neutral but not natural ground'.[292] It was up to the movements of the dancers to stimulate the animation of the coloured panels in this room, the modularity of which is very much orthogonal—unlike the cinema-ballroom, it features no 'oblique dynamic'. Van Doesburg proposed to 'place' what he called 'the moving man' '*in* the painting, rather than in front of the painting', submitting him to the '*synoptic effect* of painting and architecture'[293]—not a bad rendering of the idea of an 'immersive modernity',[294] one in which this immersion all the more evident in that, while the room is not huge in size, its decor is highly enveloping.

In the cinema-ballroom (or large dancehall) which, on the contrary, is huge [see fig. 11, p.73], Van Doesburg took an entirely different position than in the function room: rather than animating the space by playing with its 'cubicness', or putting it to work so as to try and make it 'float', he decided to take it broadside by placing under maximal

288 'Transformation de L'Aubette', in Van Straaten, *Theo van Doesburg peintre et architecte*, 179.

289 Photos of the reconstructed room in Ewig et al. (eds.), *L'Aubette ou la couleur dans l'architecture*, 6–9. On the original colours (which sources say were from Ripolin), their mode of application, their high-gloss varnish, and their reconstruction, see M. Polman, 'La couleur et les monuments du mouvement moderne', ibid., 206 (and more generally the whole part 'La restauration').

290 Van Doesburg, 'La couleur dans l'espace et le temps', 262.

291 Van Doesburg, 'Transformation de l'Aubette', in *Theo van Doesburg peintre et architecte*, 179.

292 Polman, 'La couleur et les monuments du mouvement moderne', 207.

293 Van Doesburg, 'La couleur dans l'espace et le temps', 262 (emphasis the author's).

294 A. Betsky, 'Le modernisme immersif: vers le café Aubette', in Ewig et al. (eds.), *L'Aubette ou la couleur dans l'architecture*, 174–77.

tension, on a grand scale, surfaces that oppose the inertia of the room with the dynamic diagonality of a modular grid of colour planes separated by 4cm-deep, 35cm-wide grey bands.

> Now, since the architectonic elements were based upon orthogonal relationships, this room had to accommodate itself [...] to a counter-composition which, by its nature, was to resist all the tension of the architecture. [...] If I were asked what I had in mind when I constructed this room, I should be able to reply: to oppose to the material room in three dimensions a super-material and pictorial, diagonal space.[295]

A manifestation of Elementarism in action,[296] the result is all the more startling in that the oblique quadrilaterals are abruptly cut through by the bands that materialise the limits of the partitions, no longer 'tiling' their surfaces regularly, particularly in the corners where the subsidiary partitions have unusual truncated forms that contrast strongly with the large rectangles obliquely embracing the walls to a considerable height, making the room pitch and plunge. The long wall pierced with high windows hung with black curtains is painted in a light grey and features square mirrors that reflect, reshuffle, and break up the room's colour planes. Enhanced by pronounced oppositions of colours (which, for further accentuation, in three peripheral spots include an unorthodox green alongside a blue) the composition manages to span, without diminishing their presence, all of the obstacles it cuts through (doors, a walkway midway up the long windowless wall) or integrates (the cinema screen, which reinforces the dispositif of the annulling of perspective) 'to combine everything to create the atmosphere of a plastic architecture'.[297] It impels an incontestable and vigorous dynamic that is perhaps without precedent,[298] through the 'new dimension' of an 'obliqueness' supposed to express the

295 T. van Doesburg, 'Notes on L'Aubette at Strasbourg', tr. H.L.C. Jaffe, in *De Stijl* (New York: H.N. Abrams, 1971), 232–37 [translation modified]. The 'overmaterial and pictorial' aspect is rendered particularly clear by the relief execution of the painting. In these 'Notes' Van Doesburg furnishes a great deal of information on the 'partitioning of the rooms', the 'materials', the proportions and arrangements of the colour planes, etc.

296 Recall that Van Doesburg's landmark text 'Elementarism and its Origin' was published in the special 1928 issue of *De Stijl* on L'Aubette. The very term 'elementarism' echos the 'Aufruf zur elementaren Kunst [Call for an Elementary Art]' signed by Arp, Hausmann, Pougny and Moholy-Nagy, in *De Stijl* 4:10 (1921).

297 T. van Doesburg, 'Architectuurvernieuwingen in het buitenland. De ombeelding Van de *Aùbette* in Straatsburg [The Renovation of Architecture Abroad. The Transformation of the Aubette in Strasbourg]', *Het Bouwbedrifj* 6 (1929), 122 (cited by Van Straaten, '"La couleur dans l'espace et le temps" de Theo van Doesburg', in Ewig et al. (eds.), *L'Aubette ou la couleur dans l'architecture*), English translation in *On European Architecture: Complete Essays from Het Bouwbedrifj, 1924–1931* (Berlin: Birkhauser, 1990), 213–22.

298 Fabrice Hergott claims that 'the decors of the *Aubette* [...] could be considered as the great ancestors of op-art and kinetic art.' (Preface to the catalogue *L'Oeil Moteur: Art optique et cinétique 1950–1975* [Strasbourg: Musées de Strasbourg, 2005], 11.)

at once corporeal and spiritual liberation of a modern man who 'sees the universe only in projection and in cross-section'.[299] (Which is why 'the elementarist experiences life as a perpetual transformation').[300]

In principle, the future function of these two rooms implies that their user is unlikely to be a 'contemplator'. And yet, holding fast to his 'pictorial conception of architecture' (in Oud's inaugural phrase),[301] Van Doesburg still wants the spectator, without having to stand still, to achieve a systematic perception, as 'pure' as possible, of the pictorial architecture that was his true objective. But this is 'not a matter [...] of leading someone along the surface of the painted wall', since then 'the synoptic effect' might escape them.[302] From this point of view it is not surprising that, in practice, and despite the force of its conception and execution, the experiment would ultimately fail, for it implied from the outset an incompatibility of the aesthetic (albeit mobile) gaze and a ludic deambulation. And in this respect there is a complete difference with Matisse's window, whose overall vectoriality does not call for a 'pure' aesthetic vision; it is discovered in and through the very movement by which one approaches it, a movement that multiplies transversal and/or radiative directions as one progressively renders oneself (coenaesthesically) sensitive to these virtualities. There can therefore be no possible contradiction between the different modes of grasping the work, even if naturally they admit of differences of degree, since the window can be the mere environmental and energetic accompaniment to children's' games (it is difficult to see how it could 'perturb' them in the same way that users of L'Aubette were perturbed by Van Doesburg's intervention). Neither have commentators omitted to point out the serious theoretical ambiguities that compromised Van Doesburg's conception of the relations between painting and architecture. El Lissitzky declares in a 1926 letter: 'Doesburg has already betrayed architecture, he says that it is only instrumental, unlike art, and he wants to be a painter.' Along the same lines, Fritz Bless states that

> [p]ainting is given such a central place that neo-plastic architecture presents itself as painting in space. [...] Both the theory and 'practice' of neo-plastic architecture ignore architecture. [...] the wall is regarded as a plane on which to project a painting.[303]

299 T. van Doesburg, 'L'élémentarisme et son origine [Elementarism and its Origin]', *De Stijl* 8:87–89, 263. 'The universe for him is only a system of relations', concludes Van Doesburg, here coming back to the fundamental theme of his first theoretical interventions.

300 Ibid.

301 J.J.P. Oud, 'Orientatie [Orientation]', *De Stijl* 3/2 (December 1919), 'Orientation', in Jaffé, Symonds and Whitall (eds.), *De Stijl*, 132–42.

302 Van Doesburg, 'La couleur dans l'espace et le temps', 262.

303 F. Bless, 'À propos de Van Doesburg. Rietveld et l'architecture néo-plastique', in Lemoine (ed.), *Theo van Doesburg. Peinture, Architecture, théorie*, 123.

The rooms decorated by Van Doesburg were probably perceived by their users as too
intrusive because of the loss of bearings induced by their 'antigravitational' ambience
(not without certain Dada-effects, it has been remarked).[304] Along with the rest of the
interior, they were to be swiftly redecorated (after having been damaged 'by the brutal
manners of the Strasbourgian public'—they have now been reconstructed). For Van
Doesburg, it was a cruel disappointment to experience the rapid degradation of his work,
unveiled in February 1928 (to the soundtrack of the Sambre et Meuse military march
and a newsreel showing the triumphant entry of French troops into Strasbourg! The
Arps would have loved it...). In May of the same year, he writes:

> What has preoccupied me [...] above all since the opening of L'Aubette [...] is the fol-
> lowing: it has been shown that a new plastic, even on a large scale, cannot hold its own
> against practice [meaning the 'technique of the animal life of the masses' (sic)], and
> thinking about this leads us to the following conviction: architecture must be neutral,
> nonfigurative and, in any case, without the addition of pictorial means.[305]

This will lead him to return to a 'pure' painting of 'counter-compositions' totally discon-
nected from any concern for dialectical integration into architecture, which is now per-
ceived as 'a road to perdition, just like the applied arts'.[306] A bitter lesson for a man who
had insisted that one of the 'vocations' of the modern artist was to 'render the public
receptive to the beauty of pure art',[307] and who had conceived of architecture as the
'plastic unity' of all the arts and the 'organic link' between them: 'In L'Aubette in Stras-
bourg I learned that the time of "total creation" has not yet arrived.'[308] (Van Doesburg
thus came around to the same position as Mondrian, who had ended up immersing
himself in the space of his studio, to the detriment of more 'public' projects).

304 As emphasised by G. Fabre, 'Towards a Spatio-Temporality in Painting', in G. Fabre, D.W. Hotte,
 M. White (eds.), *Constructing a New World: Van Doesburg and the Internaitonal Avant-Garde*,
 59, and, earlier, F. Morellet, 'Doctor De Stijl and mister Bonset', in Lemoine (ed.), *Theo van
 Doesburg: Peinture, architecture, théorie*, 181. Moreover, Dada was conceived by Van Does-
 burg (alias I.-K. Bonset, editor of the Dada journal *Mecano*) as a manifestation of the fourth
 dimension (see 'What is Dada???', published as a pamphlet in the Hague in 1923).

305 A note by Van Doesburg cited (without reference) by S. Polano, 'Theo van Doesburg, théoric-
 ien de l'architecture comme synthèse des arts', in Lemoine (ed.), *Theo van Doesburg. Pein-
 ture, architecture, théorie*, 131.

306 Letter from Van Doesburg to Adolf Behne, 7 November 1928 (cited in Ewig et al. [eds.],
 L'Aubette ou la couleur dans l'architecture, 75). In the same letter, Van Doesburg, evidently
 very wound up, explains that 'the public cannot let go of its "brown" world, and obstinately
 refuses the new "white" world'; and blurts out: 'The public wants to live in shit and they will
 just have to die in shit'.

307 As affirmed by Van Doesburg in the introduction to the first issue of *De Stijl* dated October 1917.

308 Ibid.

A repudiation all the more profound in that, in the issue of the journal *De Stijl* dedicated to L'Aubette, Van Doesburg had defined the ideal for he was aiming in this site as follows:

> Once [...] painting ceased to be an individual, self-enclosed form of our private experiences, painting entered into contact with space and, more importantly, with MAN. Thus was born a relation of colour to space, and of man to colour. Through this relation of 'moving man' to space, a new sensation appeared in architecture, the sensation of time. Man's movements through space [...] have been of essential importance for painting in architecture. [...] The PAINTING OF SPACE-TIME must [...] allow [man] to sense pictorially (optically and aesthetically) the entire CONTENT of space.[309]

Here Van Doesburg clearly exhibits the limits (at least the theoretical limits) of his pictorial and architectonic plastic in relation to Matisse's aesthesic energetics, which is neither optical nor aesthetic—and which in virtue of this is 'constructivist' in an entirely different manner. But must we go so far as to claim that 'for Van Doesburg, L'Aubette [was] the long dreamt-of occasion for him to realise a series of giant paintings in a great pre-existing architectonic complex. Real difficulties arose in relating the pictorial hypertrophy to the space in architectonic terms: Van Doesburg resolved it by enlarging the "counter-compositions" to the point where they became gigantic parietal paintings'?[310] Although it is true that, because of the formalism of his painting, he largely lacked the 'destructive-constructive' relation to architecture that he wished to promote, the dynamics of this formalism is nevertheless implicitly inhabited by a virtual and vital energetics such that it has been possible, with due argument, to project Van Doesburg into the origins of 1950s op-art and kinetic art—precisely in order to argue that this art was concerned less with exploring the optics of movement than with the 'notion of vital energy'.[311] A vital energy which, stripped of all formalism, is at once the motor and the very object of Matisse's work (which Van Doesburg surely has in his sights when he denounces a 'tendentious decoration' that he associates with an 'animal spontaneity' definitively excluded by the neo-plastic style).[312] Hence it is important to remember that, at Cateau, Matisse does not *formally lock* the coloured quadrilaterals of his windows into a modular grid, nor even one *alongside* the other. Their dynamism is not, as in Van

309 Van Doesburg, 'La couleur dans l'espace et le temps', 262.

310 S. Polano, 'Theo van Doesburg, théoricien de l'architecture', 130–31.

311 Anna Dezeuze can therefore put forward that 'the introduction of the participation of the spectator into the geometrical abstraction of the 1950s came from a rereading of concrete art defined by Theo van Doesburg...' A. Dezeuze, '« Cinématisme du corps » et participation du spectateur', in *L'Oeil Moteur*, 85–86.

312 Van Doesburg, 'La renaissance de l'art et de l'architecture en Europe' (1931), in Van Straaten (ed.), *Theo van Doesburg peintre et architecte*, 36.

Doesburg, founded on the movement induced by the directions that could be taken by coloured forms inscribed in a geometrical network, nor by the 'purely' optical-aesthetic exhibition of two overpowering curves that set the charge for the construction and transversally tension it. The squares follow a movement of *decline* and *declension* one *against* the other, as if they obstructed one another or threw themselves against one another. So that it is the general diagrammatic regime—composed of the lines of colouring forces (to use Cézanne's term) that maintain them precariously aligned and which are assembled [*agencé*] with the two aforementioned curves—that alone wields all the constructive power (that of a contingent reason). On the contrary, Van Doesburg seeks this power on the side of a forming Form (that *Gestaltung* he preferred to the original *beelding,* substituting a *Neue Gestaltung* for the *nieuwe beelding*)[313] at once plastic, organic, unifying, abstract, relational (rather than substantial) and dimensional: the sufficient reason of a 'universal form' opposed to 'image makers'.[314] The internal dynamic instability and the expansion of the painted (fresco or painting) beyond delimited forms and into counter-compositions, relates to what we might call an energetic formalism[315] charged with accomplishing this *architectonic of relations* to which architecture, in its turn, must submit itself.

<p align="center">*</p>

Although Mondrian also aspired to a painting that would be a 'plastic manifestation of vital force'[316] capable of *radiating* through the environment and creating an 'ambience' within it, unlike Van Doesburg he maintained a distance between the tension internal to the painting, the source of a more meditative attention, and the architecture into which it was to 'expand'; but only in expectation of their coming fusion, as prefigured but not yet completed in the assemblages of coloured rectangles he made on the walls of his studio.[317] This work in parallel on the painting and its environment took on a new

313 Cf. F. Migayrou, 'Néoplasticisme, *Nieuwe Beelding*, Neue Gestaltung: configurations de l'élémentaire', in Migayrou (ed.), *De Stijl 1917–1931*, 15–18: 23.

314 In a letter of 23 January 1930 addressed to the poet Antony Kok, cited in P. Lowe, 'La composition arithmétique—un pas vers la composition sérielle dans la peinture de Theo van Doesburg', in Lemoine (ed.), *Theo van Doesburg. Peinture, architecture, théorie*, 232.

315 Which is why it is ultimately *practically* incorrect, even if *theoretically* true (if we might formulate in this way the contradiction in which Van Doesburg ends up trapping himself) to describe his mural paintings in *L'Aubette* as 'giant paintings'.

316 P. Mondrian, *Réalité naturelle et réalité abstraite* (Paris: Éditions de Centre Georges-Pompidou, 2010), 82. The vitalist motif is very insistent in these texts, right up to the end of his life (cf. J.-C. Lebensztejn, 'Monde riant', *Les Cahiers du Musée national d'art moderne* 114–115 [winter 2010–spring 2011], 21).

317 Cf. Y.-A. Bois, 'Introduction' to *L'Atelier de Mondrian. Recherches et dessins* (Paris: Macula, 1982), 7. 'The room is conceived as an experimental extension of the work and a condition of its completion' (ibid., 6).

21. Photograph by Charles Karsten of Mondrian's studio in Paris, 1929.

significance when Mondrian moved to New York. If it is appropriate to mention it here, it is because his last painting, *Victory Boogie-Woogie* (1943–1944), with the constructive function of its multiple coloured quadrilaterals, invites comparison with Matisse's window; and also because, during this period, the assemblages of painted rectangles that he continually shifted around the walls of his studio took on an unprecedented allure which also merits comparison with Matisse's practice of pinning coloured cut-outs onto the walls of his apartment-studio.

In his studios, and particularly in the rue du Départ in Paris, Mondrian had long established a dialogue—now an echo, now a contrast—between the tense compositions of his neo-plastic paintings and the freer assemblages of pinned cardboard squares that he could juxtapose and rearrange at will [fig. 21]. These assemblages, which complemented some of his paintings of different periods and styles, and which the mirrors set to fluctuating, would eventually end up covering the entire wall surface. Mondrian developed the habit of using them as a backdrop—an active counterpoint—for temporary stagings in which his actual paintings were, literally, foregrounded—scenes designed for photographic publications or for the attention of visitors. A rigorous but more elementary neo-plasticism was extended to the furniture and even the arrangement of objects (Nelly Van Doesburg commented that one dared not move anything for fear of upsetting the *equilibrium* of the whole 'decor'). It is important to emphasise that the coloured rectangles fixed to the wall are never separated

22. Piet Mondrian, *Design for a Salon for Madame B... in Dresden*, 1926, ink and gouache, 37.5 x 56.5 cm (Kupferstich-Kabinett, Staatliche Kunstsammlungen Dresden).

by the strong black orthogonal bands that lend Mondrian's neo-plastic paintings their specific tension[318]—as if he had sensed that, in spite of all his declarations, he could not simply 'carry over' into the environment the rigorous structure of the paintings.[319] Accordingly, to avoid (or limit) the chromatic interferences he shunned, Mondrian never placed cardboard pieces of primary colours directly side by side on the wall.[320] These two points are echoed in the only environmental architectural project that he designed, in two axonometric views and one exploded view, and which, along with his studios, manifests his commitment to integral neo-plasticism: the *Designs for a Salon for Madame B... in Dresden* (1926) [fig. 22], in which all the surfaces, floor and ceiling included, are covered with compositions of coloured rectangles and squares with

318 Here and below, for convenience we employ the notion of orthogonality, in relation to Mondrian, solely to denote the articulation at right angles of the horizontal and vertical (in actual fact, Van Doesburg's obliques are no less orthogonal).

319 'The realist-abstract painting could disappear immediately as soon as we could carry over its plastic beauty around us through the division of the room into colours'. Mondrian, *Réalité naturelle*, 70.

320 Judging from the photos of the studio on rue du Départ. The shallow relief of the cardboard pieces must also play a separative role here. The contrast between the mural assemblages and Mondrian's paintings is clearly accentuated when the paintings multiply or bring together black lines, as we see in comparing the studio photos from 1926 with those from 1933 (Bois [ed.], *L'Atelier de Mondrian*, ill. 62 to 69).

no visible black bands.[321] It is worth reporting El Lissitzky's horrified reaction upon discovering Mondrian's designs: 'It is really a still life of a room, for viewing through the keyhole'.[322]

Victory Boogie-Woogie is a square painting set on its corner and measuring 178.4 cm diagonally, made in Mondrian's final large studio in New York [fig. 23]. It is certainly not by chance that Mondrian comes back to the diamond shape here, since it allows him to obtain longer vertical and horizontal lines and a more dynamic equilibrium that favours the centrifugal expansion of the painting, at the very moment when he is trying to create a new type of 'mural composition' in his studio.[323] The notion of *equilibrium*, inspired by a metaphysics of universal duality and expressed in neo-plasticism through the search for *equivalences in rectangular relations*, was always fundamental for Mondrian, who, in a 1943 etter to J.J. Sweeney, recalls again how Van Doesburg's oblique compositions run contrary to a 'feeling of physical equilibrium' (and also 'spiritual' equilibrium, he adds elsewhere) of man and 'his relation to the dominant verticals and horizontals of architecture'.[324] (The work of the 1920s had led to the break with Van Doesburg, when the latter had introduced the 'dynamic diagonal'[325] *into* his compositions, whereas in Mondrian an obliqueness *of format only* lent a more forceful expansion to the perpendicularity of the horizontal and vertical). In the letter to Sweeney, Mondrian, who in 1934 had theorised the opposition between 'static equilibrium' and 'the dynamic equilibrium of life',[326] recognised that static balance constituted the essential limit of his painting:

321 See the photos of the *Project* in *Mondrian*, exhibition catalogue (Paris: Centre national d'art et de culture Georges-Pompidou, 2010), 234–5, and Nancy J. Troy's study 'Mondrian's Designs for the Salon de Madame B... at Dresden', *The Art Bulletin* 62: 4 (December 1980), 640–47; republished in Troy (ed.), *The De Stijl Environment* 142–50.

322 El Lissitzky, letter to Sophie Küppers, 2 March 1926 (cited in Troy (ed.), *The De Stijl Environment*, 151).

323 Mondrian had produced diamond-shaped paintings during the period (1925–1926) when he 'was very particularly preoccupied with the creation of an abstract neo-plastic environment, and not only in his studio' (Troy, 'Le 26, rue du Départ', in Bois (ed.), *L'Atelier de Mondrian*, 73). The (problematic) expression 'mural compositions' is Harry Holtzman's (in 'L'atelier de New York', in *ibid*, 87) who was very much present around Mondrian during all of the last period of his life in New York.

324 'An Interview with Mondrian', 1943, in H. Holtzmann and M.S. James (eds.), *The New Art—The New Life: The Collected Writings of Piet Mondrian*, (London: Thames and Hudson, 1987), 356–7.

325 For the record: 'After your arbitrary correction of neo-plasticism, all collaboration whatsoever is impossible for me.' (1924 letter to Van Doesburg, cited by M. Seuphor, *Piet Mondrian. Sa vie, son oeuvre* [Paris: Flammarion, 1956], 149).

326 P. Mondrian, 'La vraie valeur des oppositions' (1934, published in 1947), reprinted in Mondrian, *Écrits français*, 212.

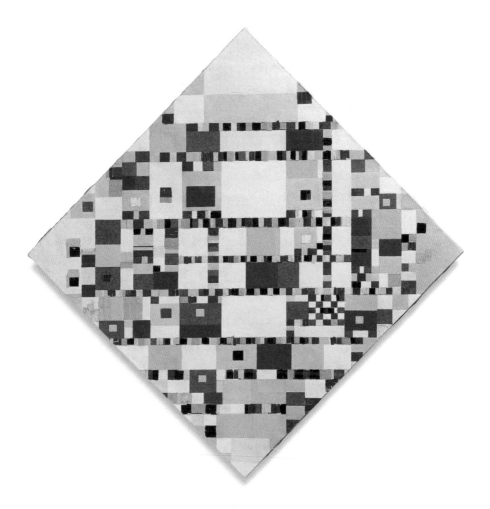

23. Piet Mondrian, *Victory Boogie-Woogie*, 1942–1944, oil, coloured adhesive tape, charcoal, and pencil on canvas, 178.4 cm diagonal (Gemeentemuseum, The Hague).

Many appreciate in my earlier work precisely what I did not wish to express but ended up producing through an inability to express what I wanted to express—dynamic movement in equilibrium. But a continual struggle brought me nearer to it. This is what I was trying to do in *Victory Boogie-Woogie*.'[327]

The painting initially took the form of a criss-crossing of coloured bands (as in *New York City*) and, although Mondrian's work had largely consisted in making the grid effect retreat, the perpendicular infrastructure is flush to the surface in the coloured gridlines and crossings of two (partial) vertical bands with a series of horizontal, rhythmically

327 'An Interview with Mondrian', 357. In June 1942, Mondrian declared to Charmion von Wiegand: 'I want to balance things too much' (cited by E.A. Carmean Jr., 'La fabrique de *Victory Boogie-Woogie*, in Bois (ed.), *L'Atelier de Mondrian*, 54).

staggered horizontal bands.[328] What is essential here, though, is the way in which colour dialectically sublates[329] the grid, whose bands are no longer homogeneous and black, nor painted in primary colours, as in the series of *New York City* paintings (1941–1942), nor even punctuated at irregular intervals by blue, red, or grey squares, as in the yellow grid of *Broadway Boogie-Woogie* (1942–1943, oil on canvas, 127 × 127 cm): the bands are instead now made up entirely of small unequal quadrilaterals of primary colours or 'non-colours' (grey, black, white) juxtaposed in a frenzied staccato which sets the plane vibrating with myriad pulsations and chromatic interferences (of a kind that had begun to appear at the crossing points of the coloured bands in the New York works).[330] This new type of chromatic construction of bands represents a response to a(nother) severe autocritique Mondrian had formulated, on a postcard, also addressed to Sweeney:

Only now ('43) I become conscious that my work in black, white and little color planes has been merely 'drawing' in oil color.

In drawing, the lines are the principal means of expression; in painting, the color planes.

In painting, however, the lines are absorbed by the color planes; but the limitation of the planes show themselves as lines and conserve their great value.[331]

The pictorial consequence of this is as follows: paint the limits (of planes) as lines, but lines (or bands) that are themselves composed of little colour planes.[332]

Onto the now fluctuating weave of multi-coloured bands pushing and pulling from all sides is superimposed the chromatic rocking of multiple rectangular blocs of colour, some narrow, some not, square or horizontal, sometimes punctuated with a small square of contrasting colour. Abolishing the opposition between figure and ground, these coloured blocs activate the whites and greys by interlacing with them, while their fidgeting planes make the canvas vibrate in wider criss-crossing rhythms; some of them create pile-ups, jamming the horizontal bands even while seeming to slip in-between them. The metastable state in which *Victory Boogie-Woogie* remained (a neo-plastical-ly chaosmotic state, we might say) owes largely to Mondrian's almost frenetic use of

328 The rhythm is more marked on the vertical axis which presents, from bottom to top, an tightly-spaced alternation of horizontal bands and large white rectangles. Of the eight horizontal bands, five cross the painting from one side to the other, or nearly so.

329 Mondrian thinks of the development of his art in teleological terms, with successive sublations of one opposition by another, more abstract and more universal opposition.

330 In his description of *Victory Boogie-Woogie*, Carel Blotkamp uses the metaphor of the swarm, equally appropriate to Matisse's *Bees* (*Mondrian: The Art of Destruction* [London: Reaktion, 1994], 237).

331 24 May 1943, cited in *The New Art–The New Life*, 356.

332 We therefore cannot agree that 'in his last two paintings', Mondrian 'abandoned the line as structuring principle of the composition' (Blotkamp, *Mondrian: The Art of Destruction*, 240).

commercial adhesive tapes and coloured paper.[333] John Russell makes a very pertinent remark on this subject: having emphasised the evident pleasure Mondrian took in manipulating these tapes, setting their effects of rupture against the other 'textures' in the painting, and multiplying the 'permutations' between tapes and painting ('machining' them together), Russell puts forward the idea that 'even in its unfinished state, *Victory Boogie-Woogie* is the apotheosis of their joint potential'.[334] Although Mondrian had declared that all he now needed to do was to paint it, he would no doubt have made yet more changes in the final painting. The linearity of construction, the limited spectrum of small painted units, and the homogeneity of pigments would probably have helped to better ensure the play of chromatic oscillations within the limits of a *flat thickness* placed in strong frontal tension by the colour contrasts which, although liberating the painting from the rigid interweavings of the plane, are still visibly related to it. This is a terrain upon which Mondrian ends up, unexpectedly, converging with *certain elements of Matisse* (who plays systematically with *all-over* chromatic relations and tensions between planes).

The mutation in Mondrian's practice heralded by this painting can be gauged by comparing it with the 'orthodox' neo-plastic conception of colour,[335] which Yve-Alain Bois has situated in relation to Matisse's own conception:

Mondrian sought to give each band of colour or 'non-colour' a maximum of intensity, without any *chromatic* regard to its neighbours. Whence the exclusive use of primary colours [colours taken (preferably) to their maximum degree of saturation and contained between black bands designed to isolate them] In neo-plasticism, we find ourselves before a new conception of colour—colour as weight [i.e. as 'relations between quantities of intensity']—that no longer owes anything to the concept of chromaticism in its exacerbated Matissean version'.[336]

333 'Many of the pieces of tape are irregular, hastily ripped off and pasted one alongside another' (Carmean, 'La fabrique de *Victory Boogie-Woogie*', 57). It was in 'at most five days', just before his death, that Mondrian precipitated the radical transformation of his painting (ibid.); we must therefore suppose that the assemblages of coloured cardboard on the walls (cf. infra) played a part in inciting this last transformation.

334 J. Russell, 'Mondrian's New York Years at the Modern', review of an exhibition at MoMA, *New York Times*, 15 July 1983. Perhaps here we should cite Leo Steinberg's shock verdict: 'Is this picture plane necessarily homogeneous, or is it irritable and unpredictably fickle, characterised only by reactivity, all things to all men, open wide to all comers? Let's face it, your picture plane is a whore' (L. Steinberg, 'Touring the Stockholm Collage', in *Cubist Picasso*, 175).

335 To Charmion von Wiegande, who observes that 'placing a yellow rectangle in the middle of a red plane' *does not fit into the framework of his theory*, Mondrian responds that 'it works', and that 'perhaps now we'll change the theory' (cited in E.A.Carmean, 'La fabrique de *Victory Boogie-Woogie*', 56).

336 Y.-A. Bois, 'Du projet au procès', in *L'Atelier de Mondrian*, 37.

But, as we have seen, it was also Matisse who, in revolutionary fashion, defined colour in terms of intensive quantity (indeed, Bois was the first to insist on this).[337] To resolve this apparent contradiction, we must distinguish between two types of intensity. For Mondrian, it is a matter of intuitively establishing a relation of equilibrium or reequilibri-ation between the strongest possible (asymmetrical) orthogonal oppositions between planes of primary colours by using planes or bands of 'non-colours', and by playing with their orientation, their placement, their dimensions, and their rhythm. This equilibrium must also *weigh up* the 'value' of colours, for maximal saturation is achieved at different degrees of luminosity for different colours: blue becomes saturated at a far darker value than red and especially yellow, which is saturated at a slightly higher value than red.

> *Equivalence* in the dimension and color of the plastic means is necessary. Although vary-ing in dimension and color [but also in format, position, orientation...], the plastic means will nevertheless have an equal value. Generally, equilibrium implies a large area of noncol-or or empty space opposed to a comparatively small area of color or material.[338]

This proportion is not always respected in his paintings. Generally speaking, the 'equilib-rium' to be obtained by this 'exact determination of space' to which Mondrian aspires relates to a 'trial and error' decision achieved through a series of compensations of op-posing tensions: rather than an assignable result, it is an aim that the virtual, embracing and deranging the actual, renders asymptotic.[339] In Mondrian, therefore, intensity must result from oppositions between planes of colour or 'non-colour'—oppositions we might call quantitative-extensive (since they are ultimately founded upon perpendicularity, which is just a determination of extension). Now, in *Victory Boogie-Woogie*, the 'dynam-ic' multitude of planes and their chromatic interferences no longer authorise the quest for an 'equilibrium'; instead they imply what is, even though partial and local, a true en-ergetic diagrammatism (acting through the application of tensorial forces), radiating from the painting in a kind of expansive auto-spatialization that brings Mondrian close to Matisse, albeit without abolishing perpendicularity qua extensive formal criterion pre-constraining the orthogonal organisation of the painting by threatening to make the

337 Y.-A. Bois, 'Matisse and "Arche-drawing"', in *Painting as Model*, 3–63. For our own argu-ments on this question, and more generally our critique of Bois's Matisse, see *La Pensée-Ma-tisse*, 75–84, and, in English, E. Alliez and J.-C. Bonne, 'Unframing Painting, "Pushing Back the Walls"', tr. R. Mackay, *Journal of Contemporary Painting* 5.1 (forthcoming).

338 P. Mondrian, 'Home—Street—City' (1926), in *The New Art—The New Life*, 209 (although the word 'value' here does not only mean the luminous value of the colour, it includes this sense).

339 'The ever recommenced search for equilibrium fuelling itself on its always recommenced destruction', Damisch, *Fenêtre jaune cadmium*, 62.

diagram fall back onto a *schema*. But the diagram, via the system of mobilised tensions, tends to cut across this schema, conserving its trace, since the de-schematisation is never complete—so that the diagram gives rise to a pulsation of the plane that is not so much vital as dialectical, via the orthogonality that it dis-architects, but not without in some sense *sublating* it by extending the plane into a volume, so exorbitant in regard to Mondrian's earlier production.

The transformation of the aspect of the environment is no less remarkable, if we compare the 'full walls' (dixit Miró) of the Paris studio which, at the limit, induce an oppressive and merciless division of space (as in the *Project for the Salon of Madame B.... in Dresden*) to those of the New York studio, where the pieces of coloured cardboard are no longer closely juxtaposed but are instead spaced out, floating in airy disseminated groups on three walls (off-white) and on the furniture (some of which Mondrian himself made out of crates), even overlapping the fireplace, skirting board, and pipework; only a few, rare coloured panels are still placed side by side [fig. 24, overleaf]. Harry Holtzman photographed the whole studio with the assistance of Fritz Glarner and made 'a precise report' on it, distinguishing eight 'mural compositions' in the long room forming the studio (with further groups in the office).[340] The walls, covered with little holes, attest to the continual displacements of the coloured cards. As in Cézanne, the ground (here, the wall) is not a passive surface, but enters actively into the play of differences and renders sensible the tensivity linked to the new way in which the coloured panels are spaced out.[341] It is a matter of open agglomerations that no longer make up 'units' or 'compositions'—that is to say, 'paintings' (to use Mondrian's own classical categories). These ensembles resonate in proximity to and at a distance from one another, rather than constituting a series of distinct units—a sort of long score that musicalizes the space, turning around the room with silences, mutely accompanied all the while by the geometrism of the white-painted wooden furniture. Need we point out that the jazzy rhythm of the whole studio as accompaniment to the painting definitively dooms Mondrian's (purely metaphysical) will to abolish time from his work by way of a (supposedly) simultaneous apprehension of rhythm?[342]

340 See the plan of the distribution of these eight ensembles made by Harry Holtzman, in *The New Art–The New Life*, plate 252 and photos by Holtzman and Eeva-keri, plates 248–51 and 253–4. Harry Holzman gave a short description of this studio accompanied with some other photographs of the studio and the office-room in 'L'atelier de New York', in Bois (ed.), *L'Atelier de Mondrian*, 86–92 and *in fine*.

341 Mondrian extends to the scale of the room and out of the frame a problematic of space that he had tackled in 1917 in his 'compositions with colour planes'.

342 In 'A Folder of Notes (ca. 1938–44)', discovered after his death, Mondrian maintains that 'The deepest Content of Art is the expression / of vitality / free from Time' ('Life, Time, Evolution', part of 'A Folder of Notes' [ca. 1938–44], in *The New Art–The New Life*, 358–92: 360–62).

24. Photograph by Harry Holtzman of coloured cardboard squares on the walls of Piet Mondrian's New York Studio, 1944.

25. Photograph by Harry Holtzman of Piet Mondrian's New York Studio, with *Victory Boogie-Woogie* and cardboard squares.

Placed alongside *Victory Boogie-Woogie* (in a famous, much-reproduced photograph),[343]
the coloured cardboard pieces assembled on the walls of the studio exemplify, along
with the painting, the two extremes of a debate in which Mondrian is caught up and in
which lies the entire interest of his work during the New York period [fig. 25]. On one
hand the painting, with its extensive tension in the direction of its outside, points toward
the environment of the room, but without exiting from the painting-form that relates it
to itself; while the new energetics suggested by the *all-over* dynamic of the bands and
colour planes invites us to go outside of it, exploding any idea of unity of composition
and dynamic equilibrium. On the other hand, the colour planes of the mural assemblag-
es seem to have escaped from the painting, freeing themselves of the constraints of the
bands, the jointing of the rectangles, and the format (mostly diamond shape during this
period), but they continue to virtualise its underlying grid, which still remains noticeable
in the floating gravity of the horizontal and vertical alignments, even while it makes
Mondrian's painting dance as never before. And this, in fact, implies the rejection of the
metaphysics of the universal opposition of contraries, even if it does not yet
formally call into question the in-principle orthogonal and rectangular nature of the
neo-plastic *schema*.

Ultimately, the Mondrian-moment in painting therefore remains highly ambigu-
ous: it is divided between two divergent paths—but this is precisely what constitutes
its 'historical' importance. The bare formalist studio with its white walls will appear to
those who visit it after his death as 'a temple of pure art to which [they] came to pay a
last homage' and in which *Victory Boogie-Woogie* 'stood there like an altar'.[344] Which, in
a less dramatic context, might correspond well enough to Mondrian's investment in the
studio as the *installation* of what we might call a *proto-gallery*. If we sideline *as little as
possible* the importance of the 'vitalist' motif in Mondrian as he develops it in the cha-
osmotic colour energetics of his last paintings and in the rhythm of his mural assemblag-
es which allow the 'autocritique' of his earlier work its fullest scope, then we will be
justified in maintaining that the spatialization of *schematisation* in the activation of the
planar relation of painting to murality opens the way, as Brian O'Doherty argues, to the

343 Harry Holtzman states that this was 'the sole painting displayed in the studio [...] on his easel'
 and that it was placed 'at right angles to the [...] long east wall' upon which featured 'the
 largest wall work' (H. Holtzman, 'Piet Mondrian: The Man and His Work', in *The New Art—
 The New Life*, 5). Holzman describes on the same page the furniture made by Mondrian and
 the materials he used.

344 Cf. H. James, 'Notes on Piet Mondrian', *Arts & Architecture* 62:1 (1945), 49: Mondrian's last
 painting 'stood like an altar, alone at the end of the almost barren room'; cited by Troy, *The
 De Stijl Environment*, 189. Troy remarks: 'The effect was much like a temple of pure art to
 which visitors were making a final pilgrimage'.

modernism of the 'White Cube'[345] through the pure aesthetic that it projects into it (on the basis of the immaculate white of the studio).[346] The obliteration of the diagram by the schema stands in the way of a machinic expression of prospective virtualities that would have been able to bring out, on this transformational trajectory, the relation between the late Mondrian and the late Matisse—between the swarming of the little colour planes that seem to dance on the surface of *Victory Boogie-Woogie*[347] and the dense constructivist cloud of *The Bees*.

What is extensive-expansive in Matisse's window, unlike in Mondrian's mural (but not architectural) assemblages, is the creatively artificial and (for Form) deterritorializing result of a differential of sensible intensities that embrace the very conception of architecture. For in this, his most immediately constructivist (and most rigorously a-geometrical) work, Matisse assembles a generalised machinic crossing of chromatico-luminous fluxes and cuts into fluxes in multidirectional expansion together with the quite architectonic cuts that the white uprights operate within it as their pulsation, regular as a metronome, holds back the runaway (the flight!) of the machine for just an instant, all the better to launch it again, thus keeping it at the chaosmotic limit of a big bang with the insistent return of its cuts. And this relaunching implies in its turn the a-structural diagrammatism of colours-signs-forces which—contrary to Van Doesburg's dialectic, which was fatal for architecture—manages to architect the construction by adapting it to its deterritorialized function. *The Bees*: Matisse performs his *Victory Boogie-Woogie* upon having succeeded in his (deterritorializing) conjunction with architecture by conjointly (counter-)investing—by whatever means necessary—the formalism of expression (the tradition of modernism) and the formalism of content (the school-form).

All that remains is to take up architecture, in all its field-effects and in all its social components, into a veritable *political diagrammatics*[348] capable of undoing the whole set of stratifications that it assembles in terms of form and structure. The experiment

345 B. O'Doherty, *Studio and Cube: On the Relationship Between Where Art Is Made and Where Art is Displayed* (New York: Columbia University, 2007), 36: 'Mondrian's studio was, I believe, one of the factors that influenced the proud sterility and isolate hanging of art within the white cube'.

346 It is on the subject of the 'immaculate, glowing white' used by Mondrian to repaint the kitchen furniture of his London studio (where he moved in 1938) that Ben Nicholson wrote: 'No one could make a white more white than Mondrian' ('Mondrian in London, Reminiscence of Mondrian', in *Studio International* 172:884 [December 1966], 289).

347 To return to the citation to which we alluded above: 'In [...] *Victory Boogie-Woogie*, [...] the grid of lines has receded right into the ground, overpowered as it is by a swarming mass *of larger and smaller colour planes which seem to dance over the surface of the painting*, drawing the non-colours white, grey and black into their dance' Blotkamp, *Mondrian: The Art of Destruction*, 237 (italics ours).

348 An expression we borrow from Félix Guattari, *L'Inconscient machinique. Essais de schizo-analyse* (Paris: Encres-Recherches, 1979), 180.

of a stripping-bare of architecture itself, inseparable from an experimentation that brings into play socially and existentially mutant real-abstract machines—it is this experiment which, in an after-Matisse that arises from an inevitable after-Duchamp, will be undertaken during the 1968 years by Gordon Matta-Clark, among others.[349]

349 See Volume 4, *Three Entries in the Form of Escape Diagrams*.

Bibliography

Alliez, Éric, and Jean-Claude Bonne. *La Pensée-Matisse. Portrait de l'artiste en hyper-fauve*. Paris: Le Passage, 2005.

—— and Jean-Claude Bonne. 'Matisse with Dewey with Deleuze', in Holland, Eugene W., Daniel W. Smith and Charles J. Stivale (eds.), *Gilles Deleuze: Image and Text*. London and New York: Continuum, 2009.

—— and Jean-Claude Bonne. 'Matisse-Thought and the Strict Quantitative Ordering of Fauvism', tr. R. Mackay, in R. Mackay (ed.), *Collapse* vol. 3. Falmouth: Urbanomic, 2012.

—— with the collaboration of Jean-Clet Martin. *The Brain-Eye: New Histories of Modern Painting*, tr. R. Mackay. London: Rowman and Littlefield, 2016.

—— and Jean-Claude Bonne. 'Unframing Painting, "Pushing Back the Walls"', tr. R. Mackay, *Journal of Contemporary Painting* 5:1. 2018.

Antkliff, Mark. 'The Rhythms of Duration: Bergson and the Art of Matisse', in J. Mullarkey (ed.), *The New Bergson*. Manchester: Manchester University Press, 1999, 184–208.

Aragon, Louis. *Henri Matisse, roman*. Paris: Gallimard, tr. J. Stewart. 2 vols. London: Collins, 1972.

—— *Les Collages*. Paris: Hermann, 1980.

Arp, Hans, and Raoul Hausmann, Jean Pougny, László Moholy-Nagy. 'Call for an Elementary Art', *De Stijl* 4:10. 1921.

Audinet, Gérard (ed.). *Le Fauvisme ou « l'épreuve du feu ». Éruption de la modernité en Europe*. Paris: Éditions Paris musées, 1999.

Azouvi, François. *La Gloire de Bergson. Essai sur le magistère philosophique*. Paris: Gallimard, 2007.

Barnes, Albert C. *The Art in Painting*. Merion, PA: Barnes Foundation Press, 1925.

—— with Violette de Mazia. *The Art of Henri Matisse*. Merion, PA: The Barnes Foundation Press, 1933.

Barr, Alfred H. *Cubism and Abstract Art*. New York: Museum of Modern Art, 1936.

Benrubi, Isaak. *Essais et témoignages inédits*. Neuchâtel: La Baconnière, 1941.

—— *Souvenirs sur Henri Bergson*. Paris and Neuchâtel: Delachaux and Niestlé, 1942.

Bergson, Henri. *The Two Sources of Morality and Religion*, tr. R. Ashley Audra and C. Brereton. London: MacMillan, 1935.

—— *Creative Evolution*, tr. A. Mitchell. New York: The Modern Library, 1944.

—— *Mélanges*. Paris: PUF, 1972.

—— *Matter and Memory*, tr. N.M. Paul and W. Scott Palmer. New York: Zone, 1991.

—— *Time and Free Will*, tr. F.K. Pogson. New York: Dover, 2001.

—— *Laughter*, tr. C. Brereton and F. Rothwell. New York: Dover, 2005.

—— *The Creative Mind*, tr. M. L. Andison. New York: Dover, 2007.

Bernstein, Herman. *With Master Minds*. New York: Universal Series, 1913.

Bernstein, Jay M. 'In Praise of Pure Violence (Matisse's War)', in D. Costello and D. Willsdon (eds.), *The Life and Death of Images: Ethics and Aesthetics*. London: Tate Publishing, 2008.

Betsky, Aaron. 'Le modernisme immersif: vers le café Aubette', in Ewig et al., *L'Aubette ou la couleur dans l'architecture*.

Bless, Frits. 'À propos de Van Doesburg. Rietveld et l'architecture néo-plastique', in Lemoine (ed.), *Theo Van Doesburg. Peinture, architecture, théorie*.

Blotkamp, Carel. 'Reconsidérations sur l'oeuvre de Theo Van Doesburg (jusqu'en 1923)', in Lemoine (ed.), *Theo Van Doesburg. Peinture, architecture, théorie*.

—— *Mondrian: The Art of Destruction*. London: Reaktion, 1994.

Bois, Yve-Alain (ed.). *L'Atelier de Mondrian. Recherches et dessins*. Paris: Macula, 1982.

—— *Painting as Model*. Cambridge, MA and London: MIT Press, 1990.

—— 'On Matisse: The Blinding'. *October* 68 (Spring 1994).

—— *Matisse and Picasso*. Paris: Flammarion, 1999.

—— 'The Semiology of Cubism', in Zelevansky (ed.), *Picasso and Braque: A Symposium*.

Bouillon, Jean-Paul. 'Le cubisme et l'avant-garde russe', in 'Actes du premier Colloque d'Histoire de l'Art Contemporain tenu au Musée d'Art et d'Industrie, Saint-Étienne, les 19, 20, 21 novembre 1971', *Le Cubisme*. Centre Interdisciplinaire d'Études et de Recherches sur l'expression contemporaine, *Travaux* IV, Université de Saint-Étienne, 1973, 153–223.

Buchberg, Karl, and Nicholas Cullinan, Jodi Hauptman (eds.). *Henri Matisse: The Cut-Outs*. London: Tate Publishing, 2014.

Buettner, Stewart. 'John Dewey and the Visual Arts in America', *Journal of Aesthetics and Art Criticism* 33 (1975).

Chateau, Dominique. *John Dewey et Albert C. Barnes: philosophie pragmatique et arts plastiques*. Paris: Harmattan, 2003.

Clark, T.J. *Farewell to an Idea: Episodes from a History of Modernism*. New Haven, CT and London: Yale University Press, 1999.

Costello, Diarmuid, and Dominic Willsdon (eds.). *The Life and Death of Images: Ethics and Aesthetics*. London: Tate Publishing, 2008.

Courthion, Pierre, and Serge Guilbaut (eds.). *Chatting with Henri Matisse: The Lost 1941 Interview*, tr. C. Miller. London: Tate Publishing, 2013.

Cowart, Jack, and Jack D. Flam, Dominique Fourcade, John Hallmark Neff (eds.). *Henri Matisse: Paper Cut-Outs*. St. Louis, MO: St. Louis Museum and Detroit Institute of Arts, 1977.

Dagen, Philippe. *Pour ou contre le fauvisme*. Paris: Éditions d'art Somogy, 1994.

Daix, Pierre, and Jean Rosselet. *Le Cubisme de Picasso. Catalogue raisonné de l'oeuvre du peintre: 1907–1916*. Paris: Ides et Calendes, 1979.

Damisch, Hubert. *Fenêtre jaune cadmium ou les dessous de la peinture*. Paris: Seuil, 1984.

Deleuze, Gilles, and Félix Guattari. *A Thousand Plateaus*, tr. B. Massumi. Minneapolis: University of Minnesota Press, 1987.

—— *Negotiations*, tr. M. Joughin. New York: Columbia University Press, 1995.

—— *Proust and Signs: The Complete Text*, tr. R. Howard. London: Athlone, 2000.

—— *Desert Islands and Other Texts 1953–74.* Los Angeles: Semiotext(e), 2004.

—— *Difference and Repetition*, tr. P. Patton. London: Bloomsbury, 2014.

Derain, André. *Lettres à Vlaminck*, ed. Philippe Dagen. Paris: Flammarion, 1994.

Dewey, John. 'Affective Thought in Logic and Painting', *Journal of the Barnes Foundation* 2:2 (April 1926).

—— *The Public and its Problems*. Chicago: Sage Books, 1927.

—— and Albert Barnes (eds.). *Art and Education: A Collection of Essays*. Merion, PA: The Barnes Foundation Press, 1929.

—— *Art as Experience*. New York: Berkley/Penguin, 2005.

Dezeuze, Anna. '« Cinématisme du corps » et participation du spectateur', in Hergott (ed.), *L'Oeil Moteur: Art optique et cinétique 1950–1975*.

Didi-Huberman, Georges. *Devant l'image*. Paris: Minuit, 1990.

—— *Quand les images prennent position, L'oeil de l'histoire,* 1. Paris: Minuit, 2009.

Diehl, Gaston. *Henri Matisse*. Paris: Tisné, 1954.

Duthuit, Georges. *The Fauvist Painters.* New York: Wittenborn, Schultz, 1950.

—— *Représentation et présence. Premiers écrits et travaux 1923–1952*. Paris: Flammarion, 1974.

—— *Écrits sur Matisse*. Paris: Rémi Labrusse, 1992.

Einstein, Carl. *Georges Braque*. Brussels: La Part de l'oeil, 2003.

Elderfield, John. *The 'Wild Beasts': Fauvism and its Affinities*. New York: Museum of Modern Art, 1976.

—— and Stephanie d'Alessandro. *Matisse: Radical Invention 1913–1917.* New Haven, CT and London: Art Institute of Chicago/Yale University Press, 2010.

Ewig, Isabelle, Mariël Polman, and Evert Van Straaten. *L'Aubette ou la couleur dans l'architecture*. Strasbourg: Association Theo Van Doesburg/Musées de la Ville de Strasbourg, 2008.

Fabre, Gladys, Doris Wintgens Hotte, and Michael White (eds.). *Constructing a New World: Van Doesburg and the International Avant-Garde.* London: Tate Publishing, 2009.

Fels, Florent. *Henri Matisse*. Paris: Chroniques du Jour, 1929.

Fiedler, Konrad. *Schriften zur Kunst*. 2 vols. Munich: Fink, 1971.

Flam, Jack D. *Matisse: The Man and his Art, 1869–1918.* London: Thames and Hudson, 1986.

—— *Matisse: The Dance.* Washington DC: National Gallery of Art, 1993.

Foster, Hal, and Rosalind Krauss, Yve-Alain Bois, Benjamin Buchloh. *Art Since 1900: Modernism, Antimodernism, Postmodernism.* London: Thames and Hudson, 2004.

Fourcade, Dominique. 'Rêver à trois aubergines', *Critique* 324 (May 1974).

—— 'Something Else', in Cowart et al. (eds.), *Henri Matisse: Paper Cut-Outs.*

Fried, Michael. *Art and Objecthood.* Chicago: University of Chicago Press, 1998.

Gide, André. 'Promenade au Salon d'Automne', *Gazette des Beaux-Arts* 582 (December 1905).

Gilot, Francoise, and Carlton Lake. *Life with Picasso.* New York: Anchor/Doubleday, 1964.

Gleizes, Albert. 'L'Art et ses représentants—Jean Metzinger', *Revue indépendante* 4 (September 1911).

Grammont, Claudine. 'Les yeux fermés—Henri Matisse et les dessins en aveugle', in *Une fête en Cimmérie. Représentation du visage dans l'oeuvre de Matisse.* Nice: RMN/Mairie de Nice, 2003.

Greenberg, Clement. *Matisse.* New York: Abrams, 1953.

—— *Art and Culture.* Boston: Beacon Press, 1961.

—— *Collected Essays and Criticism, vol. 1, Perceptions and Judgments: 1939–1944,* ed. John O'Brian. Chicago and London: University of Chicago Press, 1988.

—— *Collected Essays and Criticism, vol. 2, Arrogant Purpose: 1945–1949,* ed. John O'Brian. Chicago and London: Chicago University Press, 1986.

—— *Collected Essays and Criticism, vol. 4, Modernism with a Vengeance: 1957–1969,* ed. John O'Brian. Chicago and London: University of Chicago Press, 1993.

—— *Late Writings,* ed. R.C. Morgan. Minneapolis and London: University of Minnesota Press, 2003.

Greenfield, Howard. *The Devil and Dr. Barnes: Portrait of an American Art Collector.* New York and London: Penguin Books, 1987.

Guattari, Félix. *L'Inconscient machinique. Essais de schizoanalyse.* Paris: Encres-Recherches, 1979.

Guillaume, Valérie. 'Un échafaudage de mouvements: approches et concepts opératoires de Gerry Rietveld', in Migayrou (ed.), *De Stijl, 1917–1931.*

Hergott, Fabrice. *L'Oeil Moteur: Art optique et cinétique 1950–1975.* Strasbourg: Musée d'art moderne et contemporain de Strasbourg, 2005.

Jaffe, H.L.C. (ed.). *De Stijl.* New York: H.N. Abrams, 1971.

James, Harriet. 'Notes on Piet Mondrian', *Arts & Architecture*, 62:1 (1945).

Jones, Caroline A. *Eyesight Alone: Clement Greenberg's Modernism and the Bureaucratization of the Senses.* Chicago and London: University of Chicago Press, 2005.

Krauss, Rosalind. *The Picasso Papers.* London: Thames and Hudson, 1998.

—— 'The Motivation of the Sign', in Zelevansky (ed.), *Picasso and Braque: A Symposium*.

—— 'The Semiology of Criticism', in Zelevansky (ed.), *Picasso and Braque: A Symposium*.

Labrusse, Rémi. *Les Fauves*. Paris: Éditions Michalon, 2006.

Lebensztejn, Jean-Claude. 'Tournant', in Audinet (ed.), *Le Fauvisme ou « l'épreuve du feu »*.

—— 'Monde riant', *Les Cahiers du Musée national d'art moderne* 114–115 (2010–2011).

Lemoine, Serge (ed.). *Theo Van Doesburg. Peinture, architecture, théorie*. Paris: Philippe Sers Éditeur, 1990.

Leymarie, Jean. 'Les grandes gouaches découpées de Matisse à la Kunsthalle de Berne', *Quadrum* VII (1959).

Lissitzky, Lazar Markovitch (El Lissitzy). 'Wheel, Propeller and What Will Follow: Our Form-Production Is a Function of Our System of Movement', tr. S. Lindberg and M. I. Christian, in Detlef and Jennings (eds.), *G: An Avant-garde Journal of Art, Architecture, Design, and Film*.

Lowe, Peter. 'La composition arithmétique—un pas vers la composition sérielle dans la peinture de Theo Van Doesburg', in Van Straaten, *Theo Van Doesburg peintre et architecte*.

Mallarmé, Stéphane. *Oeuvres complètes*. 2 vols. Paris: Gallimard, 2003.

Matisse, Henri. *Jazz*. Paris: Tériade, 1947.

—— *Écrits et propos sur l'art*, ed. D. Fourcade. Paris: Hermann, 1972.

—— *Matisse on Art*, ed. J.D. Flam. Berkeley and Los Angeles, CA: University of California Press, 1995.

Merleau-Ponty, Maurice. 'Cézanne's Doubt', in *Sense and Nonsense*, tr. H.L. Dreyfus and P.A. Dreyfus. Evanston, IL: Northwestern University Press, 1964.

—— *The Visible and the Invisible*, tr. A. Lingis. Evanston, IL: Northwestern University Press, 1968.

Mertins, Detlef, and Michael W. Jennings (eds.). *G: An Avant-garde Journal of Art, Architecture, Design, and Film, 1923–1926*. Los Angeles: Getty Research Institute, 2010.

Metzinger, Jean. 'Note sur la peinture', *Pan*, October–November 1910.

Migayrou, Frederic (ed.). *De Stijl, 1917–1931*. Paris: Centre Georges-Pompidou/Musée national d'Art moderne, 2010.

—— 'Néoplasticisme, *Nieuwe Beelding*, Neue Gestaltung: configurations de l'élémentaire', in Migayrou (ed.), *De Stijl 1917–1931*.

Mondrian, Piet. *Le Néo-Plasticisme. Principe général d'équivalence plastique*. Paris: Éditions de l'effort moderne, 1920.

—— and Harry Holtzman, Martin S. James (eds.), *The New Art—The New Life: The Collected Writings of Piet Mondrian*. London: Thames and Hudson, 1987.

—— *Réalité naturelle et réalité abstraite*. Paris: Éditions du Centre Pompidou, 2010.

—— *Écrits français*. Paris: Éditions du Centre Pompidou, 2010.

Monod, François. 'Le salon d'Automne', *Art et décoration* 12 (December 1905).

Montebello, Pierre. *Deleuze*. Paris: Vrin, 2008.

Morellet, François. 'Doctor De Stijl and mister Bonset', in Lemoine (ed.), *Theo Van Doesburg. Peinture, architecture, théorie.*

Mullarkey, John (ed.), *The New Bergson*. Manchester: Manchester University Press, 1999.

Neff, John H. 'Matisse, His Cut-Outs and The Ultimate Method', in Cowart et al (eds.), *Henri Matisse: Paper Cut-Outs.*

Nicholson, Ben. 'Mondrian in London, Reminiscence of Mondrian', *Studio International* 172:884 (December 1966).

Nietzsche, Friedrich. *The Birth of Tragedy and Other Writings*, tr. Ronald Speirs. Cambridge: Cambridge University Press, 1999.

—— *On the Genealogy of Morality*, ed. Keith Ansell Pearson, tr. Carol Diethe. Cambridge: Cambridge University Press, 2011.

—— *The Will to Power*, tr. Michael A. Scarpitti and R. Kevin Hill. London: Penguin Classics, 2017.

O'Brian, John. *Ruthless Hedonism: The American Reception of Matisse*. Chicago and London: The University of Chicago Press, 1999.

O'Doherty, Brian. *Inside the White Cube: The Ideology of the Gallery Space.* Berkeley, CA, Los Angeles, and London: University of California Press, 1999.

—— *Studio and Cube. On the Relationship Between Where Art Is Made and Where Art is Displayed.* New York: Columbia University, 2007.

Oiticica, Hélio. *Aspiro ao Grande Labirinto. (Selecão de textos)*, ed. L. Figueiredo, L. Pape, W. Salomão. Rio de Janeiro: Rocco, 1986.

—— 'Neoconcretist Manifesto', in D. Ades (ed.), *Art in Latin America: The Modern Era 1820–1980*. New Haven and London: Yale University Press, 1989.

—— *Hélio Oiticica*. Paris: Jeu de Paume, 1992.

—— and Luciano Figueiredo, Mari Carmen Ramírez (eds.). *Hélio Oiticica: The Body of Color*. London and Houston: Tate Publishing, 2007.

Oud, Jacobus Johannes Pieter. 'Orientatie' ('Orientation'), *De Stijl* 3/2 (1919).

Percheron, René, and Christian Brouder. *Matisse. De la couleur à l'architecture.* Paris: Citadelles & Mazenod, 2002.

Pétry, François. 'Les frères Horn et L'Aubette', in Ewig et al. (eds.), *L'Aubette ou la couleur dans l'architecture.*

Polano, Sergio. 'Theo Van Doesburg, théoricien de l'architecture comme synthèse des arts', in Lemoine (ed.), *Theo Van Doesburg. Peinture, architecture, théorie.*

Polman, Mariël. 'La couleur et les monuments du mouvement moderne', in Ewig et al. (eds.), *L'Aubette ou la couleur dans l'architecture.*

Puy, Michel. 'Les fauves', in Phillipe Dagen (ed.), *Pour ou contre le fauvisme*. Paris: Éditions d'art Somogy, 1994.

Ramírez, M.C. 'The Embodiment of Color "From the Inside Out"', in Ramírez (ed.), *Hélio Oiticica: The Body of Color*.

Rowell, Magrit. *The Planar Dimension: Europe, 1921–1932*. New York: Solomon R. Guggenheim Foundation, 1979.

Rubin, William. *Picasso and Braque: Pioneering Cubism*. New York: Museum of Modern Art, 1989.

Russel, John. 'Mondrian's New York Years at the Modern', *New York Times*, 15 July 1983.

Schramm, Uwe. 'Le concept de l'espace dans l'oeuvre de Jean Arp', in Maria Lluïsa Borràs (ed.), *Jean Arp. L'invention de la forme*. Brussels: Palais des Beaux-Arts, 2004.

Seuphor, Michel. *Piet Mondrian. Sa vie, son oeuvre*. Paris: Flammarion, 1956.

Soulez, Philippe, and Frédéric Worms. *Bergson. Biographie*. Paris: Flammarion, 1997.

Steinberg, Leo. *Other Criteria: Confrontations with Twentieth-Century Art*. Oxford: Oxford University Press, 1975.

—— *Cubist Picasso*. Paris and London: RMN/Flammarion/Thames & Hudson, 2007.

Troy, Nancy J. *The De Stijl Environment*. Cambridge, MA and London: MIT Press, 1983.

—— 'Mondrian's Designs for the Salon de Madame B... at Dresden', *The Art Bulletin* 62: 4 (December 1980).

Thibaudet, Albert. *Le Bergsonisme*. 2 vols. Paris: Gallimard, 1923.

Van Doesburg, Theo. 'De ontwikkeling der moderne schilderkunst', *Eenheid*, June 1915.

—— *Drie voordrachten over de nieuwe beeldende kunst*. Amsterdam: Maatschappij voor Goedkoope Lectuur, 1919.

—— 'Moderne wendingen in het kunstonderwijs', *De Stijl* 2:3 (1919).

—— 'Lijstenaesthetik', *De Stijl* 3:11 (1920).

—— 'De Beteekenis Van de kleur in binnen en buitenarchitectuur', *Bouwkundig Weekblad*, 44: 21 (1923).

—— and Cornelius van Eesteren. 'Vers une construction collective', *De Stijl* 6:6/7 (1924).

—— 'Vers une architecture plastique', *De Stijl* 6:6/7 (1924).

—— and Cornelis Van Eesteren. '-□+-R4', *De Stijl* 6:6/7 (1924).

—— 'Die Neue Architektur und ihre Folgen', *Wasmuths Monatshefte für Baukunst* 1 (1925).

—— 'La couleur dans l'espace et dans le temps', *De Stijl* 8:87-9 (1928).

—— 'L'élémentarisme et son origine', *De Stijl*, 8:87–89 (1928).

—— 'Architectuurvernieuwingen in het buitenland. De ombeelding Van de Aubette in Straatsburg', *Het Bouwbedrijf* 6 (1929).

—— 'La renaissance de l'art et de l'architecture en Europe', in Van Straaten, *Theo Van Doesburg peintre et architecte*.

116 —— 'Notes on L'Aubette at Strasbourg', in Jaffe (ed.), *De Stijl*.

—— 'The Rebirth of Art and Architecture in Europe', *Hrvatska Revija*, 1931.

—— *Principles of Neo-Plastic Art*, tr. Janet Seligman. London: Lund Humphries, 1969.

—— 'The Renovation of Architecture Abroad. The Transformation of the Aubette in Strasbourg', in *On European Architecture: Complete Essays from Het Bouwbedrifj, 1924–1931*. Berlin: Birkhauser, 1990.

Van Der Leck, Bart. 'De plaats van het nieuwe schilderen in de architectuur', *De Stijl* 1:1 (October 1917).

Van Straaten, Evert. *Theo Van Doesburg peintre et architecte*. Paris: Gallimard–Electa, 1993.

—— '"La couleur dans l'espace et le temps" de Theo Van Doesburg', in Ewig et al. (eds.), *L'Aubette ou la couleur dans l'architecture*.

—— Vauxcelles, Louis. 'Le Salon d'Automne', in Dagen, *Pour ou contre le fauvisme*.

Verne, Maurice. 'Un jour de pluie chez M. Bergson', *L'Intransigent*, 26 November 1911.

Villanova. 'Celui qui ignore les cubistes', *L'Éclair*, 29 June 1913.

Wright, Alastair. 'Arche-tectures: Matisse and the End of (Art) History', *October* 84 (Spring 1998).

—— *Matisse and the Subject of Modernism*. Princeton, NJ and Oxford: Princeton University Press, 2004.

Zelevansky, Lynn (ed). *Picasso and Braque: A Symposium*. New York: Museum of Modern Art/Abrams, 1992.

List of Figures

1. Henri Matisse, *Interior with Aubergines*, 1911, tempera on canvas, 212 × 246 cm (Musée de Grenoble). Artwork © Succession H. Matisse/DACS 2018. Photo © Ville de Grenoble/Musée de Grenoble/J.L. Lacroix.

2. Pablo Picasso, *Guitar, Sheet Music and Wine Glass*, November 1912, papier collé, gouache, and charcoal on paper, 48 × 36.5 cm (McNay Art Museum, San Antonio). Artwork © Succession Picasso/DACS 2018. Photo © SCALA, Florence.

3. Pablo Picasso, *Violin*, 1912, papiers collés and charcoal on paper, 62 × 47 cm (Musée national d'Art moderne, Paris). Artwork © Succession Picasso/DACS 2018. Photo © Centre Pompidou, MNAM-CCI, Dist. RMN-Grand Palais/Image Centre Pompidou, MNAM-CCI.

4. Henri Matisse, *The Unfinished Dance*, 1931, oil on canvas, 3 panels (Musée d'Art moderne de la Ville de Paris). Artwork © Succession Matisse/DACS 2018. Photo © RMN-Grand Palais/Agence Bulloz.

5. Henri Matisse, *The Dance*, in situ at the Barnes Foundation. Ensemble view, main Room, south wall, Philadelphia, 2012. Artwork © Succession H. Matisse/DACS 2018. Photo © 2018 The Barnes Foundation.

6. Pablo Picasso, *Peasants*, 1906, oil on canvas, 220 × 131 cm (Barnes Foundation, Philadelphia). Artwork © Succession Picasso/DACS 2018. Photo © 2018 The Barnes Foundation.

7. Henri Matisse, *The Merion Dance*, 1932–1933, oil on canvas, 3 panels, 339 × 441 cm; 365 × 503 cm; 308.8 × 439 cm (Barnes Foundation, Philadelphia). Artwork © Succession H. Matisse/DACS 2018. Photo © 2018 The Barnes Foundation.

8. Henri Matisse, *The Paris Dance*, 1931–1933, oil on canvas, 3 panels, 340 × 387 cm; 355 × 498 cm; 335 × 391 cm (Musée d'Art moderne de la Ville de Paris). Artwork © Succession H. Matisse/DACS 2018. Photo © Centre Pompidou, MNAM-CCI, Dist. RMN-Grand Palais/Jacques Faujour/Adam Rzepka.

9. Henri Matisse, *Seated Riffian*, 1912–1913, oil on canvas, 200 × 160 cm (Barnes Foundation, Philadelphia). Artwork © Succession H. Matisse/DACS 2018. Photo © 2018 The Barnes Foundation.

10. Henri Matisse, *The Bees*, 1952–1955, window, 3.5 × 10.33 m, kindergarten of the 'Henri Matisse' school complex, Cateau-Cambresis. Artwork © Succession H. Matisse/DACS 2018. Photo © Jean-Claude Bonne.

11. Theo Van Doesburg, Cinema-ballroom at L'Aubette, Strasbourg, 1927–1928, after restoration. © Photo Musées de Strasbourg/M. Bertola.

12. 'Henri Matisse' school complex, Cateau-Cambresis, partial plan. Artwork © Succession Henri Matisse/DACS 2018. Photo © Jean-Claude Bonne.

13. 'Henri Matisse' school complex, Cateau-Cambresis, kindergarten. Photo © Jean-Claude Bonne.

14. 'Henri Matisse' school complex, Cateau-Cambresis, exterior view. Photo © Jean-Claude Bonne.

15. 'Henri Matisse' school complex, Cateau-Cambresis, view of Matisse's *Bees* from the playground. Artwork © Succession H. Matisse/DACS 2018. Photo © Jean-Claude Bonne.

16. 'Henri Matisse' school complex, Cateau-Cambresis, interior of the walkway linking the kindergarten to the primary school. Photo © Jean-Claude Bonne.

17. Henri Matisse, *The Bees*, approaching the window from right to left. Artwork © Succession H. Matisse/DACS 2018. Photo © Jean-Claude Bonne.

18. 'Henri Matisse' school complex, Cateau-Cambresis, view from the window room. Photo © Jean-Claude Bonne.

19. Theo Van Doesburg, Cornelis van Eesteren, *Axonometric projection of a planned house*, 1923, lithograph on paper, 55 x 54 cm. Collection Het Nieuwe Instituut, donation Van Moorsel/DOES, AB5123.

20. Theo Van Doesburg, function room, L'Aubette, Strasbourg, 1927–1928, after restoration. © Photo Musées de Strasbourg/M. Bertola.

21. Photograph by Charles Karsten of Mondrian's Paris studio, 1929. Artwork © 2018 Mondrian/Holtzman Trust. Photo © RKD (Netherlands Institute for Art History), The Hague.

22. Piet Mondrian, *Design for a Salon for Madame B... in Dresden*, 1926, ink and gouache, 37.5 x 56.5 cm (Kupeferstich Kabinett, Staatliche Kunstsammlungen Dresden). © 2018 Mondrian/Holtzman Trust. Photo © Herbert Boswank.

23. Piet Mondrian, *Victory Boogie-Woogie*, 1942–1944, oil, coloured adhesive tape, charcoal, and pencil on canvas, 178.4 cm diagonal (Gemeentemuseum, The Hague). Artwork © 2018 Mondrian/Holtzman Trust. Photo © Gemeentemuseum, The Hague.

24. Photograph by Harry Holzman of coloured cardboard squares on the walls of Piet Mondrian's New York Studio, 1944. © 2018 Mondrian/Holtzman Trust.

25. Photograph by Harry Holzman of Piet Mondrian's New York Studio, with *Victory Boogie-Woogie* and cardboard squares. © 2018 Mondrian/Holtzman Trust.

Index

Albers, Josef 65

Antkliff, Mark 44n

Apollinaire, Guillaume 20

Aragon, Louis 65n

Arp, Hans 69

Aurier, Gabriel-Albert 3n

Azouvi, François 40n

Barnes, Albert 50, 53, 54, 58–59, 64

Behne, Adolf 93n

Bell, Clive 53

Benjamin, Walter 35

Bergson, Henri 37–47, 48n, 49, 63

Bernstein, J.M. 16n

Bill, Max 48

Blanche, Jacques-Émile 41

Bless, Fritz 92

Bois, Yve-Alain 15n, 18n, 19n, 22n, 23n, 26, 95n, 101, 101–102

Braque, Georges 16n, 18, 29n

Cézanne, Paul 63, 95, 103

Clark, T.J. 30

Corot, Jean-Baptiste-Camille 41

Courthion, Pierre 11n

Damisch, Hubert 21

da Vinci, Leonardo 31

Deleuze, Gilles 28n, 41n, 63

Denis, Maurice 4n

Derain, André 36n, 37, 39

Dewey, John 44–45, 49, 64, 68n

Didi-Huberman, Georges 35

Duchamp, Marcel 24, 27, 29n, 107

Duthuit, Georges 36n, 43n

Einstein, Carl 29, 69

Elderfield, John 11n

Emerson, Ralph Waldo 70n

Fiedler, Konrad 6n

Flam, Jack D. 16, 18, 69n

Fourcade, Dominique 11n, 33n, 34n, 69–70n, 71

Fried, Michael 7n

Fry, Edward 3n, 53

Gaillard, Ernest 77–78, 84n

Gauguin, Paul 17, 55

Gide, André 4n

Giotto 59

Gleizes, Albert 17, 28n

Greenberg, Clement 4–5, 6n, 19n, 29

Gris, Juan 18n

Guattari, Félix 63, 106n

Gullar, Ferreira 47n, 49

Holtzman, Harry 103, *104*, 105n

James, William 45

Kandinsky, Wassily 17n

Karsten, Charles *96*

Klee, Paul 4n

Krauss, Rosalind 19n, 20, 22n, 23–24, 26

Laude, Jean 16

Leighten, Patricia 17

Leymarie, Jean 15

Lissitzky, Lazar Markovich (El Lissitzky) 86n, 92, 98

120

Malevich, Kazimir 6
Mallarmé, Stéphane 20
Matisse, Henri 3–17, 18, 27, 28, 29, 30–39, 40, 41, 43–46, 49–71, 72, 73, 76, 77–89, 92, 94, 96, 101, 102, 106–108, *9, 50, 51, 56–7, 58, 72, 80, 83*
Matta, Roberto 65
Matta-Clark, Gordon 18n, 107
Meier-Graefe, Julius 44n
Merleau-Ponty, Maurice 16n, 63n
Metzinger, Jean 17, 28n
Miró, Jean 103
Mondrian, Piet 47n, 69n, 70, 72, 75, 76–77, 95–106, *96, 97, 99, 104*
Moore, Henry 69n
Motherwell, Robert 37n

Neto, Ernesto 46, 86
Nicholson, Ben 69n
Nietzsche, Friedrich 42, 43–44

O'Doherty, Brian 71n, 105–106
Oiticica, Hélio 46–49, 70
Oud, Pieter 72n, 73, 92

Picasso, Pablo 16–30, 53, 54–55, *17, 22, 54*
Puget, Pierre 14n

Rancière, Jacques 27
Rembrandt 41
Rietveld, Gerrit 81
Rosenberg, Harold 64
Rouart, Louis 4n
Rubin, William 18n
Russell, John 101
Schapiro, Meyer 64
Schoenmaekers, M.H.J. 75

Schramm, Uwe 69n
Spencer, Herbert 39
Steinberg, Leo 19n, 27n, 101n
Sweeney, J.J. 98, 100

Tatlin, Vladimir 7
Thibaudet, Albert 42–43n
Turner, J.M.W. 41

Van der Leck, Bart 72, 73, 81n
Van Doesburg, Nelly 96
Van Doesburg, Theo 71–77, *73*, 81, 83, 84–86, 89–95, 98, 106, *85, 89*
Van Eesteren, Cornelis 74n, 85, *85*
Van Gogh, Vincent 35
Vlaminck, Maurice de 37, 39, 100n